Mikhail

Larionov

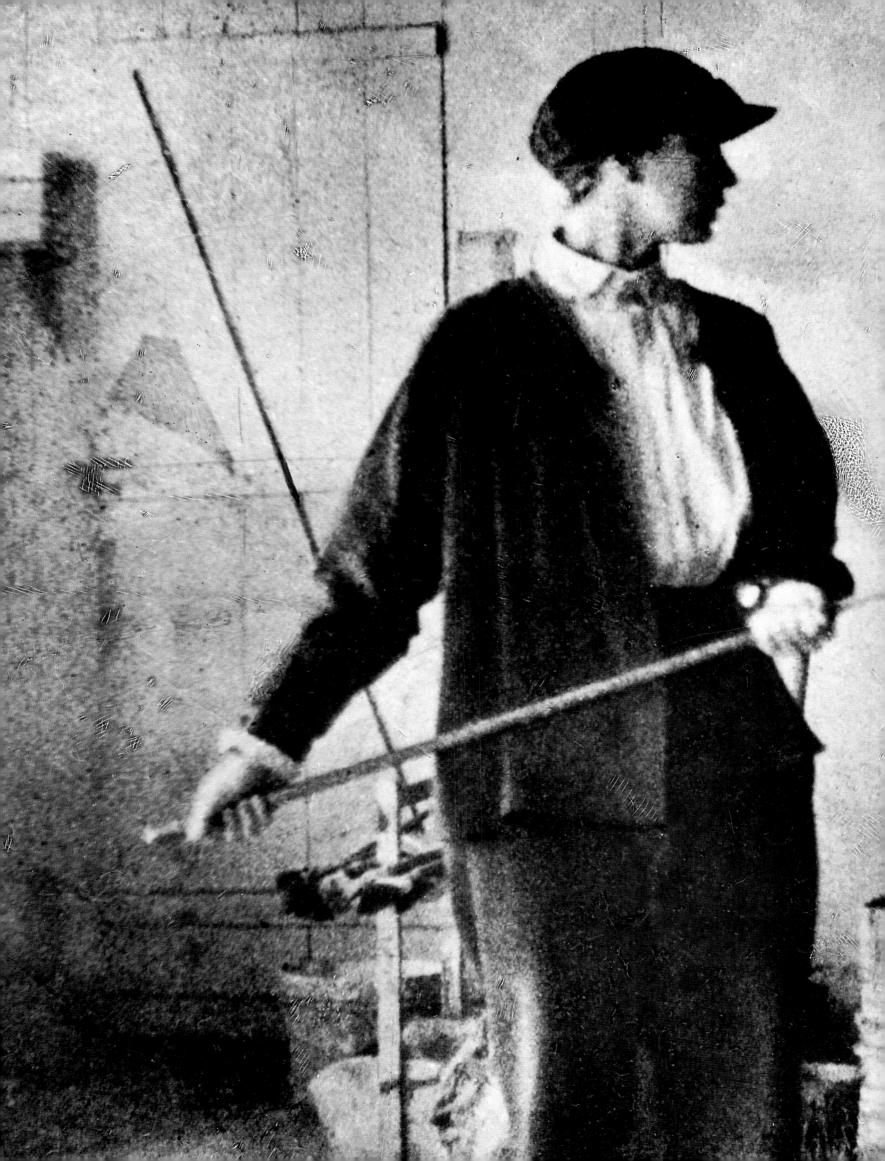

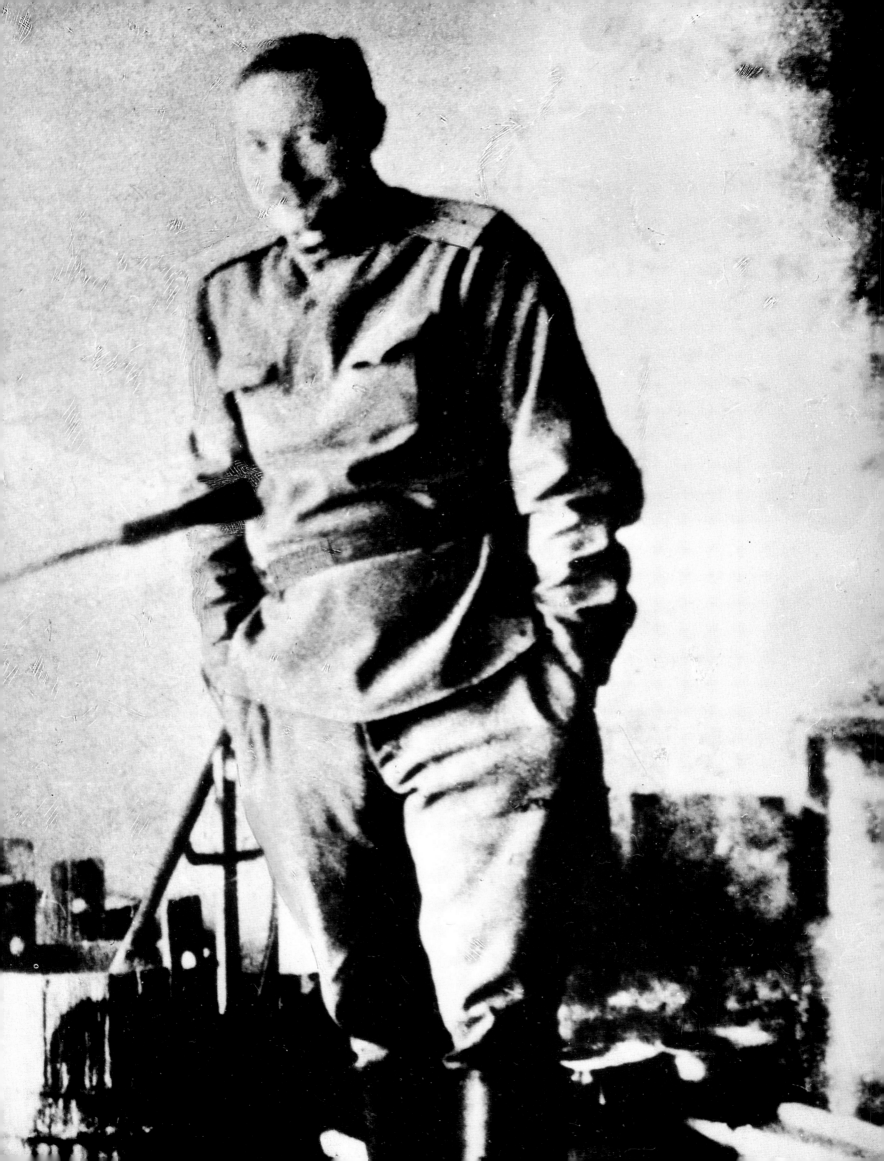

Publishing Director: Paul André
Texts by *Yevgeny Kovtun*
prepared for publication by *Liudmila Vostretsova*
Designed by *Sergei Dyachenko*
Translated from the Russian by *Paul Williams*
Edited by *Olga Pirumova* and *Valery Fateyev* (English text)
Editor's assistant *Yelena Shipova*
Typesetting by: *Nina Sokolova*
Coordination : *Chantal Jameux*

Printed and bound in Europe
ISBN 1 85995 296 8
© Parkstone Publishers, Bournemouth, England, 1998

Mikhail LARIONOV

1881 - 1964

Yevgeny Kovtun

PARKSTONE PRESS

CONTENTS

Foreword

When examining the course of Russian art at the turn of the twentieth century, one inevitably notices that Larionov begins where Mikhail Vrubel and Victor Borisov-Musatov end[1]. Borisov-Musatov was ahead of other Russian artists in experiencing the productive effect of Impressionist principles, which he profoundly grasped and transformed in his own distinctive manner. "At a time when the future World of Art group were still finding a foundation for their searchings in the Munich *Jugendstil* and the paintings of Böcklin, while their understanding of Impressionism went no further than Whistler and Zorn, Borisov-Musatov turned with fixed attention to the founders of the new French manner of painting."[2] By the start of the twentieth century he had reached the peak of his idiosyncratic "poetic" Impressionism, which was as genuine as the French variety but profoundly different, and began to feel himself drawn towards synthesis, to the quest for large, plastic form (*Spring*; *The Reservoir*). Within a brief span of time many young Russian artists became caught up in the movement towards painterly synthesis and beyond it to constructional approaches that Borisov-Musatov mapped out.

Borisov-Musatov's work undoubtedly had a great influence on Larionov's early, Impressionistic painting. Larionov took up and pursued in his own way the searchings after "painterly realism" that his elder contemporary had begun.

Equally symptomatic of the latest tendencies in Russian painting was the work of Vrubel, who was perceived as a troubled outsider in the peaceful and contented atmosphere of the World of Art. His late painted and graphic works display a heightening distortion of form such as can only be understood when viewed through the prism of subsequent events in Russian art. Those shifts and sharp-edged shapes that disturbed people at the time were distant crashes of thunder from the storm that was brewing in Russian painting.

Imitation of Vrubel proved fruitless (a number of attempts demonstrate this), but his influence on the generation that followed him was immense. His late work that swept aside deep-rooted dogma and perceptions about art had a liberating effect on the minds of artists, preparing them to receive the new aesthetic notions that came snowballing one after another in early-twentieth-century Russia. The "explosion of shape" to be seen in Vrubel's last works, both painted and drawn, called the customary artistic canons in doubt, demonstrated the possibility of other treatments of three-dimensional objects, put forward a new conception of proportions and space, and anticipated the new, twentieth-century forms of painting.

It should be noted that even before the end of the first decade of the century the most perceptive critics were linking Vrubel and Borisov-Musatov with the new tendencies in Russian art. The foreword to the catalogue of the 1908 *Zolotoye Runo* [*The Golden Fleece*] exhibition pointed to the common roots of the new searchings by "young art" in Russia and in France: "If the founding-fathers of this movement in France were Cézanne, Gauguin and Van Gogh, the first impetus in Russia was provided by Vrubel and Borisov-Musatov."[3] We do not know the author of those lines, but we do know that Larionov was the initiator and inspiration behind the *Zolotoye Runo* exhibitions at which both Russian and French artists displayed their works and we would probably not be wrong in assuming that the thoughts expressed in the foreword belonged to Larionov. In the ten years before the First World War Larionov went through a swift evolution as a painter, outstripping his fellow-artists. They measured themselves against him, followed him and imitated him. Larionov became the acknowledged head of the innovative Moscow artists.

[1] This was discussed in detail by Gleb Pospelov. See: G. G. Pospelov, "M. F. Larionov", *Sovietskoye iskusstvoznaniye '79* [*Soviet Art Studies '79*], Issue 2, Moscow, 1980
[2] V. N. Petrov, "V. E. Borisov-Musatov", in *Istoriya russkogo iskusstva* [*The History of Russian Art*], vol. X, book 1, Moscow, 1968, pp. 488f
[3] Catalogue of the *Zolotoye Runo* Exhibition, Moscow, 1908

The Impressionist Years

Mikhail Fiodorovich Larionov was born in 1881 in Tiraspol on the River Dniester (in present-day Moldavia), a place that would play an enormous role in his creative life. Larionov's father was a military pharmacist in Archangel, the northern city where his grandfather was mayor.

The artist spent his childhood in Tiraspol, in the home of his maternal grandmother. There, in a house surrounded by an immense garden, the boy learnt to draw and paint in oils. Every year he returned to Tiraspol and worked in the open air. There he would paint his best Impressionist canvases, that were displayed at exhibitions in Moscow.

At the age of ten Larionov moved to Moscow, where he entered Voskresensky's secondary modern school, and then, in 1898, the College of Painting, Sculpture and Architecture, from which he graduated in 1910. His teachers were Konstantin Korovin and Valentin Serov. In 1900 Larionov met Natalia Goncharova, a pupil in the sculpture department. Their creative life together lasted over half a century.

Studies of Larionov's oeuvre usually begin with his Impressionist works, that is to say roughly from 1902–03. But what came before that? After all, he began working back in the nineteenth century, in the 1890s. An exhibition held in the Russian Museum in 1980 first provided a proper answer to this question. The organizers managed to assemble a large number of Larionov's earliest oils, gouaches, pastels and drawings, dating from the 1890s and the first years of the new century. In this early period the artist painted nature and life around him, especially city motifs. He worked from life and hardly ever invented subjects, in contrast to his mature years. Visitors to the exhibition found landscape studies and little urban or theatrical scenes, revealing the young Larionov's keen, one might even say, avid interest in the humdrum and everyday. This not only remained a characteristic, but developed to an exceptional extent in his mature years. Larionov is, after all, noted for having been the first to have introduced a large number of "low genre" motifs and themes (barbers, soldiers, domestic animals).

Another distinctive feature of the early works that persists throughout Larionov's output is their surprising picturesque quality. They reveal an organic feeling for colour, an ability on the artist's part to create chromatic harmonies in a free, unforced manner. This is certainly true of *Snowy Landscape* (1899), featuring an old house and a man with a sack. It is possible to base a colour scheme on a combination of tense and resonant chromatic relationships, contrasting and complementing each other (as the artist would do at the time when he produced his Primitivist canvases). In the early paintings and pastels, however, the effect is based on subtle vibration and the complex juxtaposition of kindred tones.

The movement of colour, the exploitation of the chromatic range as a means of painterly expression remained throughout Larionov's artistic career. It is interesting that at the end of his life, after the period of "riotous colour", the artist again returned to the complex painterly harmonies that characterized his early works.

A Turkey-Cock. 1905
Oil on canvas mounted on cardboard.
64.5 x 73 cm
Art Museum of Northern Ossetia,
Vladikavkaz

Unknown artist
Sign for a butcher's shop. First quarter
of the 20th century. Detail

Larionov began participating in exhibitions very early, while still at college. The first occasion was in 1898. If one carefully examines these early works by Larionov, it is possible to find there the artistic impulses that led him to take a different course from that followed by the World of Art group, who represented the mainstream of development in Russian art at the time. As Nikolai Punin rightly noted, "in these early pieces of his one can already observe the great artistically revolutionary will that subsequently made Larionov the head of a new school."[1]

The Impressionist period (1902–06), which fell entirely within Larionov's years at college, was one of the high spots in his career. It was the time of closest contact with French artistic culture, first and foremost the painting of Claude Monet, which Larionov knew from Sergei Shchukin's collection. In 1905 Larionov presented at the students' exhibition[2] twenty-nine canvases that revealed his creative direction.

Mikhail Vrubel
Oriental Tale. 1886

They comprised three series of paintings: *The Corner of the Barn. The Evening Hours; Rose Bush;* and *The Sea.* In the first series he presented changes of colour each hour in the course of the evening. Interest in the impressions arising from the changing coloration of the world about him is also reflected in the names of the paintings: *The First Hour: A Combination of Amethysts and Emeralds; The Second Hour: A Combination of Topaz and Agate.* In the *Sea* series, the artist called his paintings *A Combination of the Colours of Mother-of-Pearl; Marble; Jasper;* and *Sapphire.* Like Monet, Larionov was striving to catch the shifting amalgam of colour, and to convey a fleeting state of nature through it.

The year 1904 produced such masterpieces of Larionov's Impressionism as *Acacias in Spring (The Tops of Acacias)* and *Rose Bush after a Rain Shower.* The pale blue sky in *The Tops of Acacias* is permeated with a silvery shimmer of spring branches. The painting is astonishingly translucent and tender when the artist depicts the tops of trees touching the sky. Short strokes, jabs of the brush create a background of painterly tonal vibration. The sky seems to pulsate with life, to breath. One is put in mind of words by Yelena Guro, who revelled in similar states in her verse and her painting: "There is in the top-most twigs, that exist in the sky, such a joy and lightness. If our soul can reach the light and break away from weight, that is probably the way it will feel."[3]

"Joy" and "lightness" are two states inherent in Larionov's painting and his sense of the world. His art is alien to the multiplicity of meaning found in the work of the Symbolist artists; it is direct, often ingenuous and with a child-like impulsiveness. Larionov was fascinated by aspects of life that the Symbolists regarded with indifference. Larionov's canvases from this period show that, following the lessons provided by Monet and Borisov-Musatov, the artist had found his own "voice" and "timbre". A heightened lyrical character apart from the works of the French Impressionists.

[1] N. Punin, "Impressionisticheskiy period v tvorchestve M. F. Larionova" ["The Impressionist Period in M. F. Larionov's Work"], in *Materialy po russkomu iskusstvu. Sbornik* [*Material on Russian Art. A Collection of Essays*], Leningrad, 1928, p. 287
[2] The Twenty-Seventh Exhibition of Paintings by Students of the College of Painting, Sculpture and Architecture, Moscow, 1905 (Nos 51–80)
[3] Ye. G. Guro, *Diary entry for 5 June 1911*, MSS Dept., National Library of Russia, fund 1116, item 1, folio 78

The tremulous vibrating colour of Larionov's "gardens" draws on and develops qualities found in the painting of Borisov-Musatov. Punin wrote: *"The Tops of Acacias is a profoundly lyrical, national work and no analogues to it will be found in French art."*[1]

In 1905 Borisov-Musatov and Larionov both participated in one exhibition. At the event organized by the Union of Russian Artists, Larionov presented his *Garden* and Borisov-Musatov *Hazel Bush* and *Wreaths of Cornflowers* — examples of animated Impressionism, light, quivering and profound works. The Impressionist line Borisov-Musatov–Larionov with its painterly value and authenticity emerges as the antipode of the pseudo-Impressionism extensively

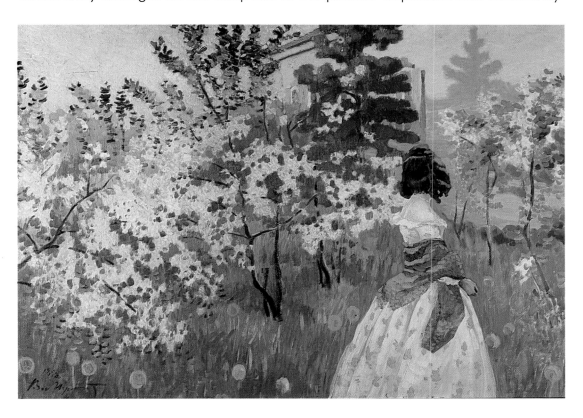

Victor Borisov-Musatov
Spring. 1898–1901
Russian Museum, St Petersburg

encountered at Union of Russian Artists exhibitions. That "second-hand Impressionism", adopted via Munich and Scandinavia, took the form of striking painting with abundant colour effects. Punin precisely defined the boundary that separated Larionov's work from "Impressionism" of that type: "While the majority of Russian Impressionists, having mastered only the outward devices of Impressionism, either froze at that point or passed on to other devices (or manners) without the consistency of continuity, Larionov spontaneously and inwardly mastered that painterly culture in all its fullness and by that ensured himself a long and rich course of development."[2]

"Larionov did not paint, but saw in an Impressionistic way."[3] The keynote of Larionov's Impressionism is heightened colour-painting and not vivid light-painting. The light-bearing impression inherent in Larionov's canvases does not arise because the artist conveys colour effects. The impression is evoked by the colours themselves, by the chromatic organization of the picture (*Rose Bush, Oxen at Rest*).

In the *Domestic Animals* cycle of 1906, the last year of the Impressionist period, Larionov attained an exceptional chromatic tension, bringing together contrasting and kindred colours — red, green, pink, lilac (*Pigs*) — and leading

[1] N. Punin, "Impressionisticheskiy period v tvorchestve M. F. Larionova", p. 291
[2] *Ibid.*, p. 289
[3] *Ibid.*

them to unexpected harmonies. This is truly courageous painting, opening up new combinations of colour. Only an artist with an unerring sense of colour could permit himself to take such a "professional risk".

Another peculiarity of Larionov's Impressionism is the exceptional wealth of textures in his painting. It is as if granules of colour one alongside the other come together to form an image that scintillates with the iridescence of precious stones (*A Turkey-Cock*, 1905). In this context mention must be made of the oil-paintings and watercolours by Vrubel that evoke the same kind of associations. The young artist paid close attention to his elder's work. As with Vrubel, in Larionov's canvases the paint is not laid onto an already prepared shape; on the contrary, shape itself and spatial relationships arise out of the formations of paint and the coloured textures. This "colour dust" (Larionov's expression) that creates form manifests itself particularly clearly in *A Turkey-Hen* (1905).

In 1906 Larionov visited Paris at the invitation of Sergei Diaghilev and took part in the display of Russian art that was included in the Salon d'Automne. He was already acquainted with the latest French painting, but now it revealed itself to him in all its great variety. Researchers often link the radical change in Larionov's work with this journey to France, but that is not correct. Some of his works from 1904–05 already suggest a shift towards a Fauve-like intensification of colour. The essence of this process could be defined as a move from spontaneous, direct painting to painting with a constructional arranged organization of colour. The Impressionist vibration gradually disappeared. Colour became purer, more resonant and more local. A tendency towards abstraction, "generalization" in colour revealed itself. These features emerged clearly in the study *Through a Net* (1905) and in *A Gypsy Woman in Tiraspol* (1906). In *Bathers at Sunset* (1904) we can see a different principle of colour invading the plastic structure of Impressionism. There is in the red figures of the bathers, stressed by the green of the sea, a chromatic tension and "generalization" that foreshadow the new approaches that were to replace Impressionism. We are, as it were, present at the birth of a new painterly manner. Larionov's series of female bathers was the first Post-Impressionist statement in Russian art, and one that was quite definite. We must therefore necessarily agree with D. V. Sarabyanov who wrote "thus an intermediate link can be observed between the Impressionist and Synthetist periods in Larionov's work, which persuades one of the gradual nature of the evolution that prepared for the leap that took place in 1907."[1]

Snowy Landscape. 1899
Oil on cardboard. 39 x 57 cm
From the former A. K. Tomilina-Larionova collection, Paris

Trees Against the Background of a House. Ca. 1900
Pastel and gouache on paper. 32.8 x 51 cm
Russian Museum, St Petersburg

[1] D. Sarabyanov, *Russkaya zhivopis' kontsa 1900-kh – nachala 1910-kh godov* [*Russian Painting of the Late 1900s and Early 1910s*], Moscow, 1971, p. 102

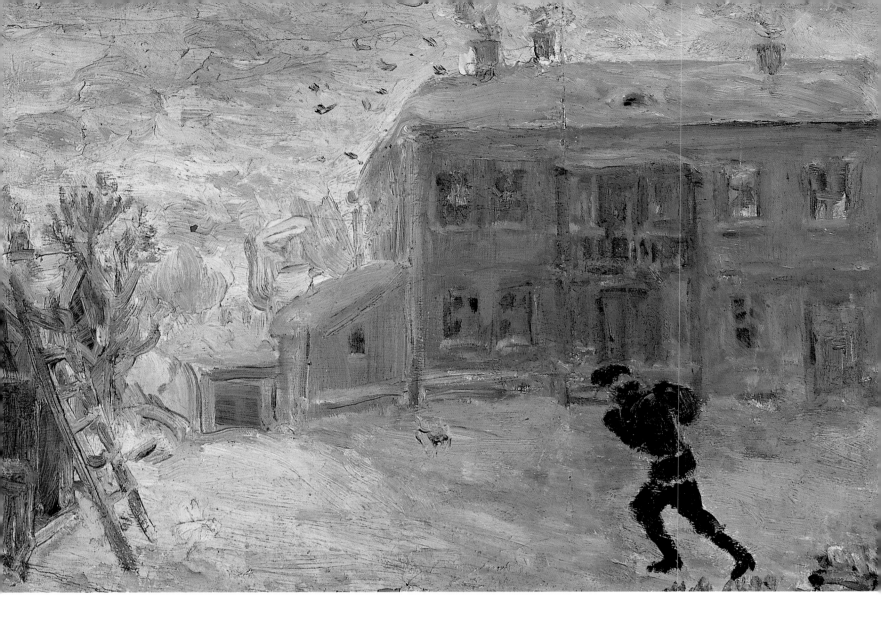
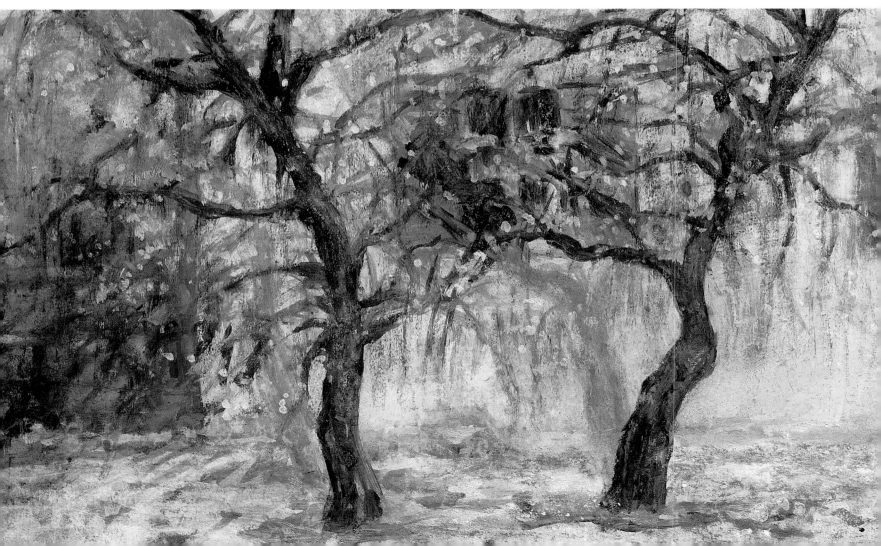

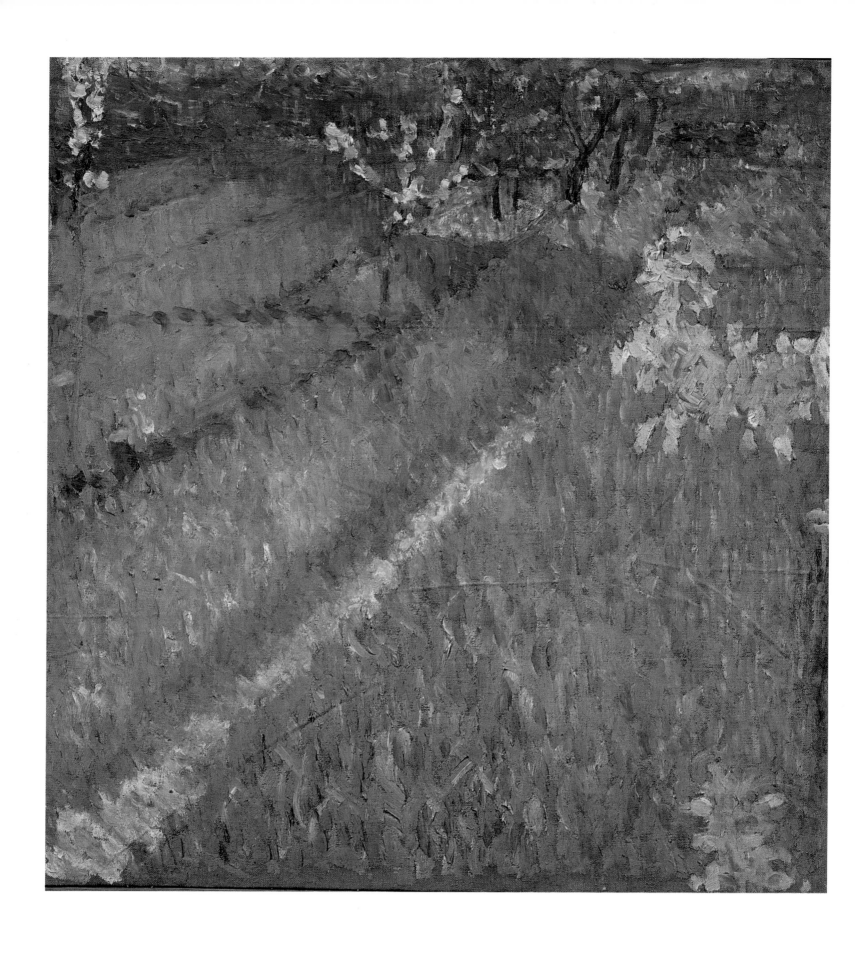

Garden. 1904
Oil on canvas. 72.5 x 66 cm
Russian Museum, St Petersburg

Trees in the Sunlight. 1905
Oil on canvas. 138.5 x 95 cm
Musée national d'art moderne,
Centre Georges Pompidou, Paris

→
Rose Bush after a Rain Shower.
1904
Oil on canvas. 98 x 144 cm
Russian Museum, St Petersburg

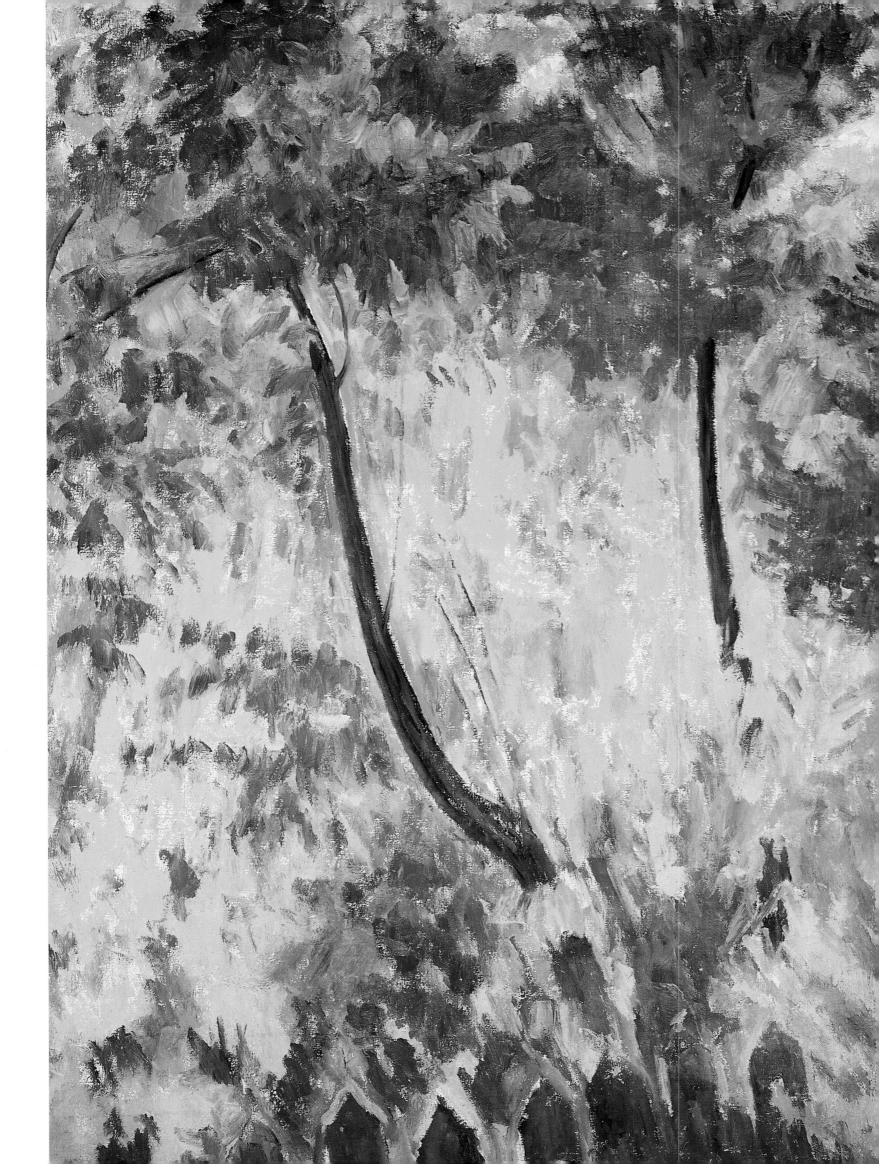

A Boulevard in Tiraspol
(Landscape in the Moonlight). 1911
Oil on canvas. 74 x 73 cm
Musée national d'art moderne,
Centre Georges Pompidou, Paris

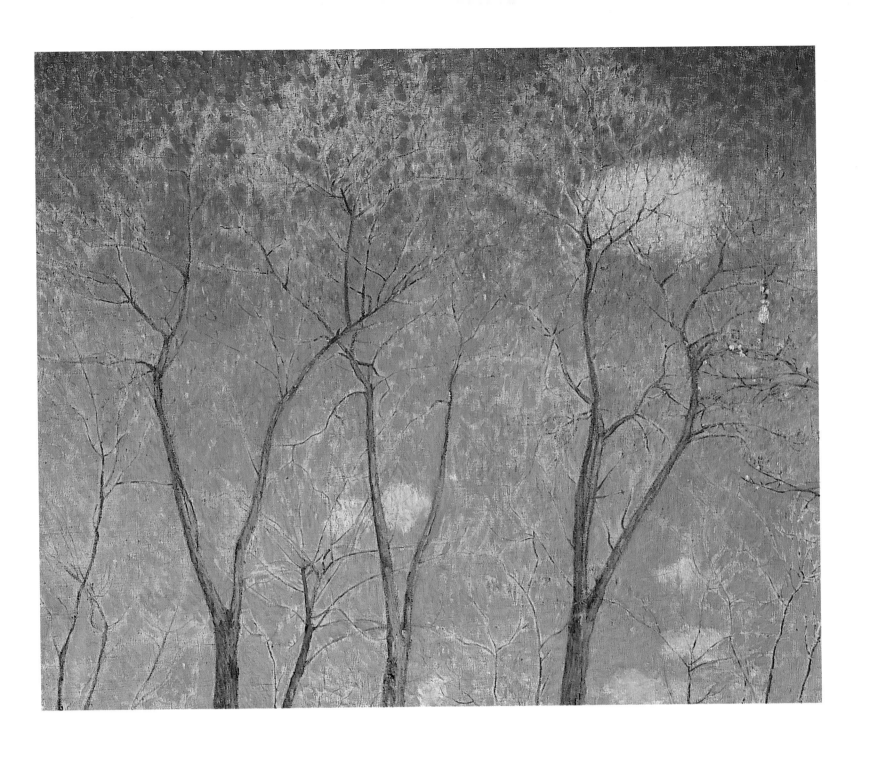

Acacias in Spring (The Tops of Acacias).
1904
Oil on canvas. 118 x 130 cm
Russian Museum, St Petersburg

Flowers (Two Bouquets). 1904
Oil on canvas. 49 x 47 cm
From the former collection
of A. K. Tomilina-Larionova, Paris

Beer Still Life. 1904
Oil on canvas. 40 x 48 cm
Russian Museum, St Petersburg

Pears. 1906–07
Oil on canvas. 45.5 x 76 cm
Russian Museum, St Petersburg

24

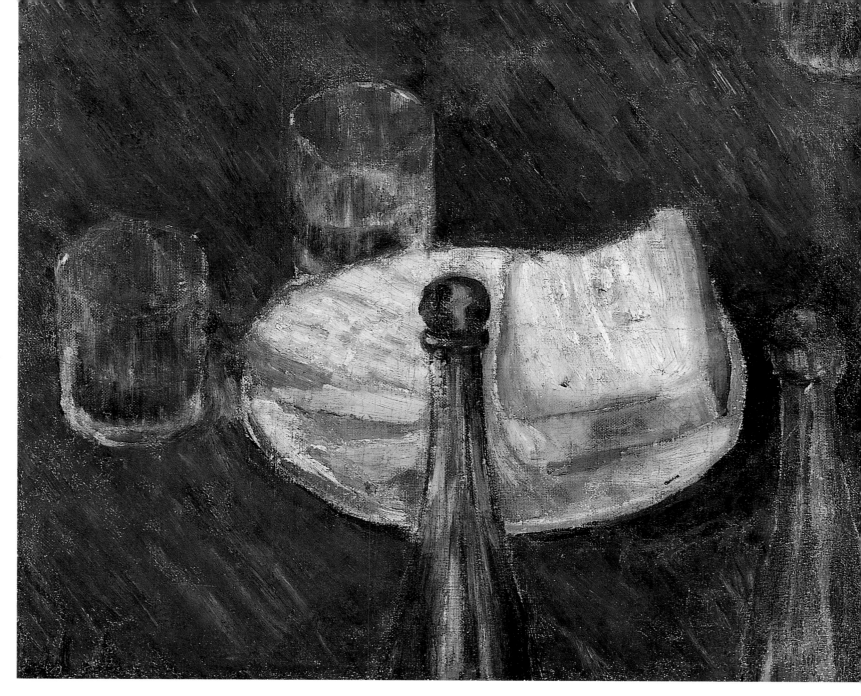
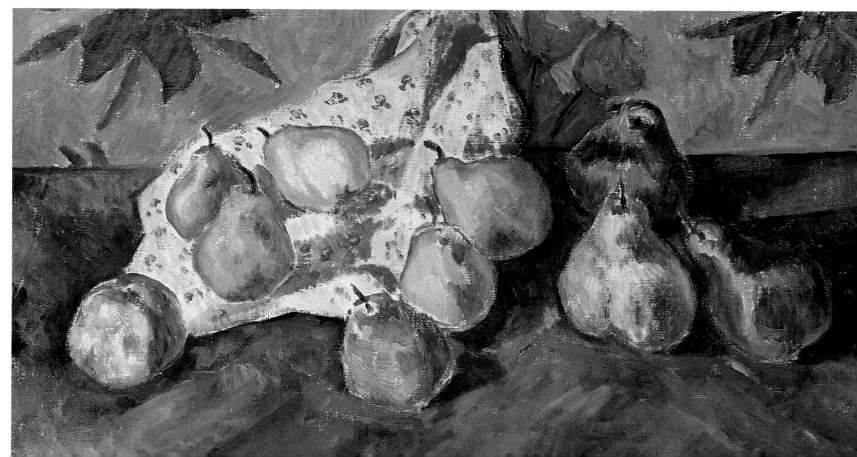

Bathers at Sunset. Odessa. 1904
Oil on canvas. 46 x 55 cm
From the former collection
of A. K. Tomilina-Larionova, Paris

A *Puppet Theatre.* Late 1890s
Tempera on paper. 25 x 27.5 cm
Russian Museum, St Petersburg

Women. Late 1890s
Pastel and graphite on paper. 46 x 57.5 cm
Russian Museum, St Petersburg

Lady with a Muff. Late 1890s
Pastel and graphite on paper. 50 x 41 cm
Russian Museum, St Petersburg

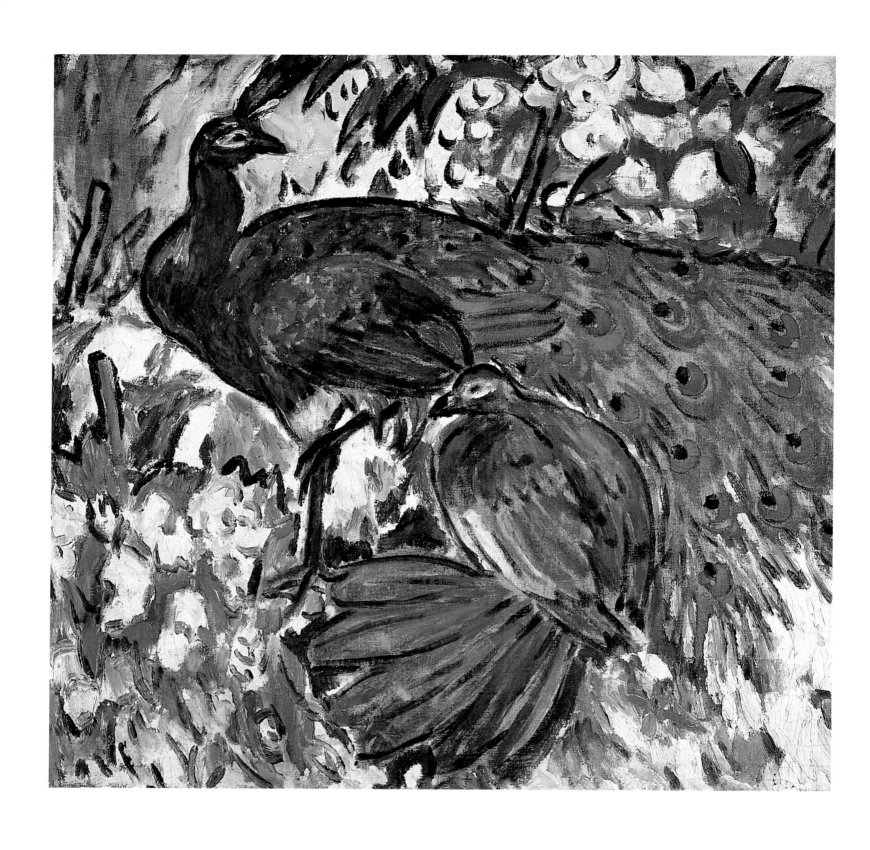

Peacocks. 1910
Oil on canvas. 94.5 x 995 cm
Tretyakov Gallery, Moscow

Peacock. Ca. 1910
Oil on canvas. 104.5 x 100 cm
Art Museum, Ulyanovsk

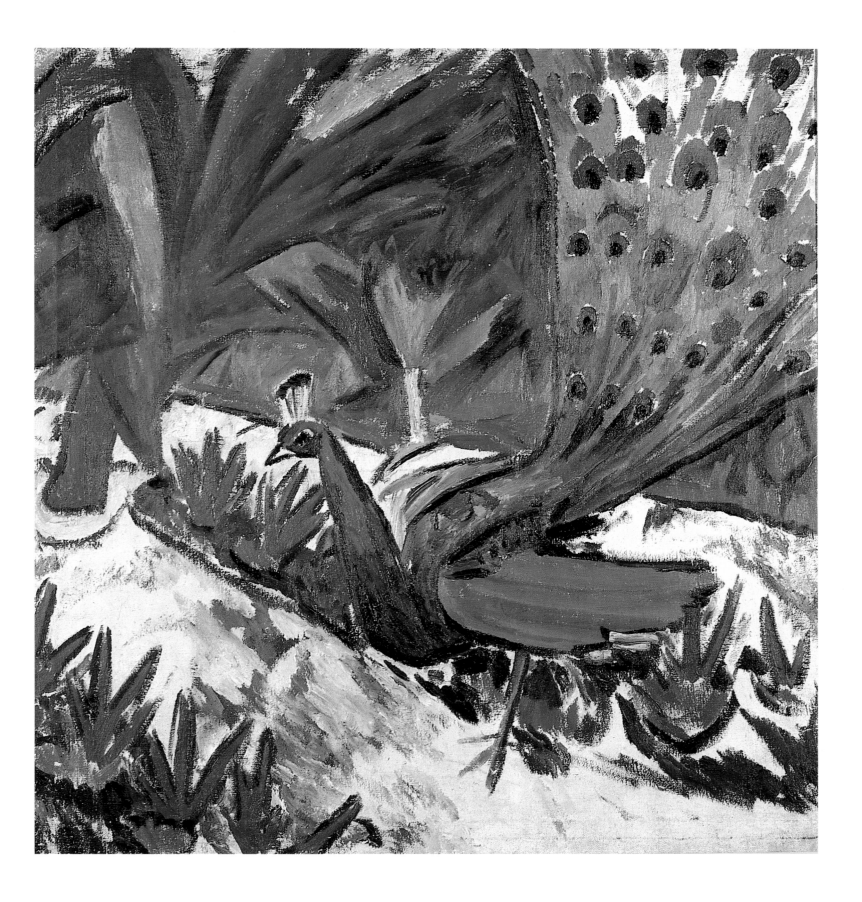

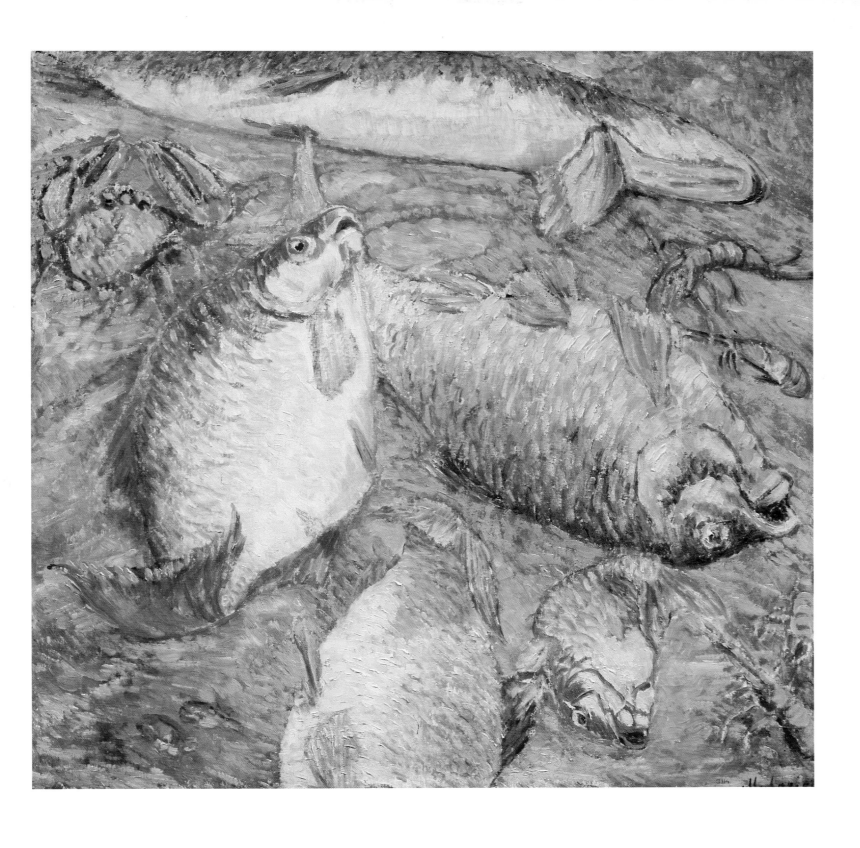

A Turkey-Hen. 1905
Oil on canvas. 61 x 71 cm
Russian Museum, St Petersburg

Geese. 1906
Oil on canvas. 68 x 84 cm
Tretyakov Gallery, Moscow

*Fish in the Setting Sun
(Fish at Dusk).* 1904.
Oil on canvas. 100 x 95 cm
Russian Museum, St Petersburg

33

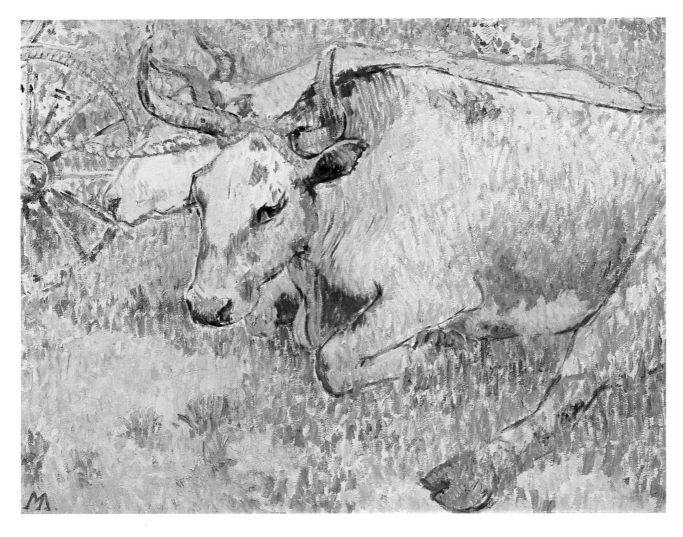

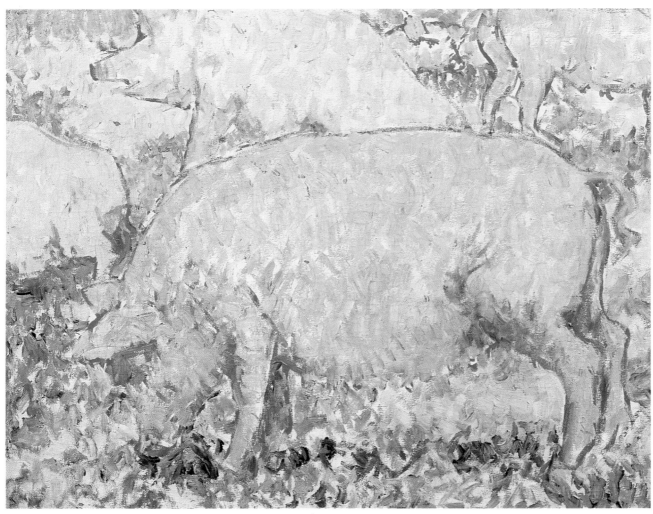

Oxen at Rest. 1906
Oil on canvas. 89 x 116.5 cm
Tretyakov Gallery, Moscow

Pigs. 1906
Oil on canvas. 68.5 x 85.5 cm
Musée national d'art moderne,
Centre Georges Pompidou, Paris

A Gypsy Woman in Tiraspol
Oil on canvas. 95 x 81 cm
Private collection, Paris

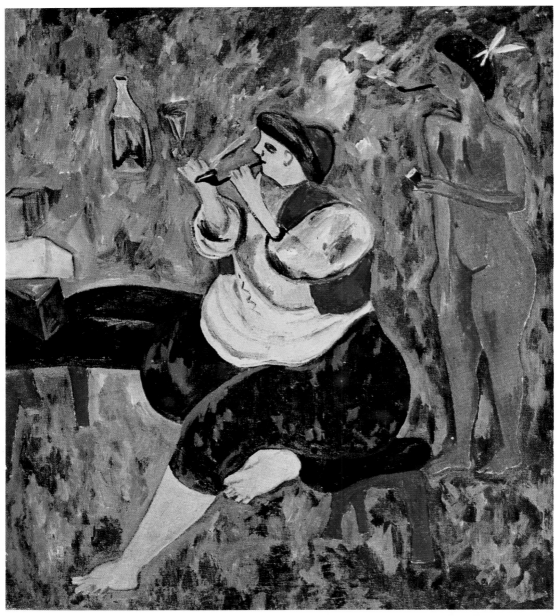

The Beginnings of Primitivism.
The Painted Shop-Sign

[1] Varsonofy Parkin, "'Osliny khvost' i 'Mishen'" ["The 'Donkey's Tail' and the 'Target'"], in Osliny khvost i Mishen': Sbornik, Moscow, 1913, p. 75

A Turkish Scene.
A Woman Smoking. 1910
Oil on canvas. 115 x 103 cm
Private collection, Paris

Unknown artist
Sign for a grocer's and baker's.
First half of the 20th century

In the years 1904–05 the character of form changed in Larionov's works. Symptoms of primitivization can be observed in the 1905 canvas *Restaurant on the Seashore*, but it came about fully in 1907 when the artist discovered new values for himself — the astonishing, colourful world of the Russian icon, the lubok popular print, and the painted shop-sign that even the boldest critics and artists did not venture to count as art. The years 1907 to 1912 saw a new, Primitivist period in Larionov's career and were the time when he was most active as an artist.

Larionov spent his youth in provincial Tiraspol. The artist was fascinated by the unique atmosphere of the southern town with its noisy, multilingual bazaars and green boulevards along which the local dandies strolled. Here he came across painted signs in large numbers adorning the fronts of little shops. Larionov was the first Russian artist to detect the artistic virtues of the shop-sign and was ahead of all others in drawing lessons from this form of creativity. A few years later a critic would remark: "And didn't the notorious shop-sign style that everyone is now fed up with come from Larionov? Suffice it to recall his provincial dandies and belles, the celebrated *Barber*, all painted back in 1907 when there was not even talk about shop-signs among artists."[1]

Larionov first "noticed" the shop-sign in his early, Impressionist period. In *A Fruit Shop* (1904–05), the background, treated according to Impressionist principles, is formed by signs framing the door of the shop.

In 1907 Larionov painted *A Provincial Dandy*: a young man strolling down a street where a hatter's sign hangs on the wall of a building. Here the sign is more than just noted — its primitive treatment of form breaks into the painterly structure of the work. The dandy is painted in the same style as the lady depicted on the sign. This canvas marks the beginning of the Primitivist period in the artist's creative biography. Other young painters followed Larionov down this path.

In late 1910 a group of Moscow-based artists organized the Jack of Diamonds exhibition. The initiators were Larionov, Goncharova and David Burliuk. The exhibitors included future participants in the Jack of Diamonds association — Vladimir and David Burliuk, Piotr Konchalovsky, Alexander Kuprin, Aristarkh Lentulov, Ilya Mashkov and Robert Falk, and future members of the Donkey's Tail — Goncharova, Larionov, Kasimir Malevich, Nikolai Rogovin and I. Skuye. The display also featured works by artists from Munich, headed by Wassily Kandinsky: Vladimir Bekhteyev, Marianna Verevkina, Gabriel Münter and Alexei Yavlensky, as well as some by two French Cubists — Albert Gleizes and Henri Le Fauconnier.

Among the works in which the influence of shop-signs made itself felt the visitors' attention was taken by Larionov's *Bread*, a canvas treated in a monumental manner in which long and round loaves form a pyramid occupying the whole surface of the painting. They "display" themselves, even "preen" themselves. When shown at the Jack of Diamonds exhibition the work evoked the following highly perceptive observation from Maximilian Voloshin: "Larionov is the most naive and

the most direct of the 'Jacks'. His *Bread* really is just bread: large, whole, well-baked bread, that would be the delight of any baker's if it were painted on a tin-plate sign."[1]

While "flirting" with shop-signs (in terms of subject and even composition), Larionov never stylized his own works in direct imitation of them. This can be sensed in the difference in attitude between the sign-painter and Larionov to what was depicted: the former would be genuine and serious, while the latter was playing a sort of game, both admiring and ironic at the same time.

A fascination with the shop-sign infected many young artists. Its enthusiastic advocate was David Burliuk, who wrote: "The Russian shop-sign — in it the Russian genius's capacity for painting found its sole outlet... It is still not too late — much can be saved in museums for posterity, for those in whose time there will no longer be the epic of Russian folk art. Civilization, literacy, the printing press and the factory machine will have done their work. 'Cottage' art will die out, disappear from the face of the Russian land and there will only be one place — museums — in which the flavour and delight of the national (and not international) folk spirit will live on."[2]

In November 1912 Burliuk gave a lecture on shop-signs in St Petersburg in which he set them alongside the works of acknowledged masters of painting. Alexander Benois, who was present, exploded with the article "Cubism or Cocking-a-snookism?": "Burliuk fulminated against authorities with great valour and advanced propositions each 'stranger' than the last, striving with all his might to be bold, original, heedless of prejudice. He sang the praises of the Russian shop-sign, comparing it with folk poetry, and began to ardently defend the idea of a 'national museum of shop-signs'."[3]

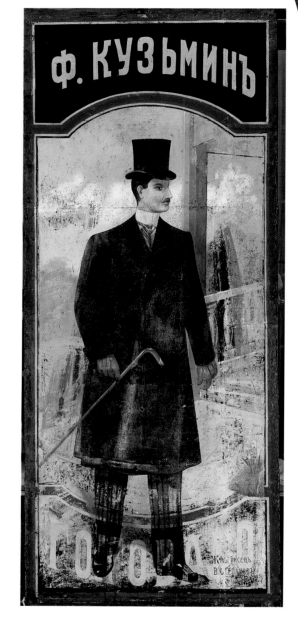

Burliuk's "blasphemous" comparisons also roused the indignation of the critic Ieronim Yasinsky: "The world is not yet turned upside down; the museums are still unplundered and the signs still hang quietly above the entrances to laundries, barbers', hay and food shops, butchers', greengrocers' and bakers', and no-one is yet collecting them and using them to adorn their walls in the place of paintings."[4]

The critic was wrong, however. Signs were already being collected by Larionov, the Zdanevich brothers, Marc Chagall and David Burliuk who "sought them out in obscure southern towns and put together a fascinating collection."[5]

The years approaching 1910 saw Larionov produce a celebrated series of "shop-sign" *Barbers*, the best of which are now in foreign collections.

Vasily Stepanov
Sign for F. Kuzmin's ready-made dress shop. First quarter of the 20th century

[1] M. Voloshin, "Bubnovy valet" ["The Jack of Diamonds"], *Apollon*, No 1, 1911, Artistic Chronicle, p. 12
[2] D. Burliuk, "Kustarnoye iskusstvo" ["Cottage Art"], *Moskovskaya Gazeta*, 25 February 1913
[3] A. Benois, "Kubizm ili kukishizm?" ["Cubism or Cocking-a-snookism?"], *Rech'*, 23 November 1912
[4] I. Yasinsky, "Vyvesochny renessans" ["The Shop-Sign Renaissance"], *Birzhevye vedomosti*, morning edition, 28 November 1912
[5] A. Koonen, "Stranitsy iz zhizny" ["Pages from a Life"], *Teatr*, No 1, 1968, p. 86. The fate of this collection remains unknown.
In *The Marksman with One and a Half Eyes* [*Polutoraglazy strelets*] Benedict Livshitz suggested that it perished at Pushkino outside Moscow where the Burliuk family moved in 1914.

[1] D. Burliuk, "Tri glavy iz knigi: *Mayakovsky i yego sovremenniki*" ["Three chapters from the book *Mayakovsky and His Contemporaries*"], *Krasnaya strela: Sbornik–antologiya*, New York, 1932, p. 11

[2] Quoted from: N. Khardzhiyev, V. Trenin, *Poeticheskaya kultura Mayakovskogo* [*Mayakovsky's Poetic Culture*], Moscow, 1970, p. 48

In *The Officers' Barber*, Larionov simplified the design in pursuit, like the sign-painters, of an image that had a distinctive representativeness and could be easily "read". To this end the barber is deliberately turned to face the viewer, while the customer is presented in profile — no "half-way" positions that might obscure what is taking place. There is the same exaggeration in the movement of the barber's scissors and in the blind submission of the customer who is being brought to sacrifice, as it were.

Larionov's Primitivist canvases had an influence on the literary world, in particular on Mayakovsky who became fascinated with motifs similar to Larionov's at this time. "He was interested in urban still-lifes," David Burliuk wrote. "Metal signs for smoked fish, pipes down which moisture cascades in a waterfall. The whole of his first period of poetic creativity took place on the boulevards and the streets."[1] Here is a poetic sketch by Mayakovsky on the *Barber* theme:

> I went into a barber's and said quite calm,
> "Be so good as to trim my ear."
> The smooth barber lost all his charm
> His face twisted in a leer.
> "Madman!
> Redhead!"
> The words simply sped,
> Abusive, hissing, caddish
> And laughter rang out lo-o-ong
> From someone's head
> Bobbing from the crowd, like an old radish.
>
> (*They Don't Understand Anything*, 1913)

The Barber. 1907. Detail

As Alexei Kruchenykh observed: "It is not poetry but a journeyman-like caption to Larionov's painting *The Barber*.[2]

With his venture into the world of anti-poetic themes, banal subjects and marketplace tastes, Larionov anticipated many phenomena in the fine arts and literature. After his barbers, soldiers and Venuses it became possible for Piotr Sokolov to produce his genre portraits, Yury Vasnetsov his "market" still lifes, Nikolai Zabolotsky his urban sketches, and Daniil Kharms his verse "lubok". The loftily ironical tone of Kharms's *Temptations* has clear echoes of Larionov's *Officer's Barber*, painted twenty years earlier:

> The colonel in front of the mirror:
> Moustache wind up, at the double!
> Sabre, leap to my side.
> You, comb, comb my hair,
> And I, a Russian cavalier,
> Will not move. Forelock curl;
> Beard fall into the plate.
> I am off to ring my spurs
> And take foreign towns.
>
> (*Temptations*, 1927)

Larionov's Primitivist paintings, created within the mainstream of the folk art tradition, became a creative stimulus for many of his associates. They revealed to all those active in the arts, the possibility of drawing on the extremely rich national traditions of the past while at the same time being a highly modern artist.

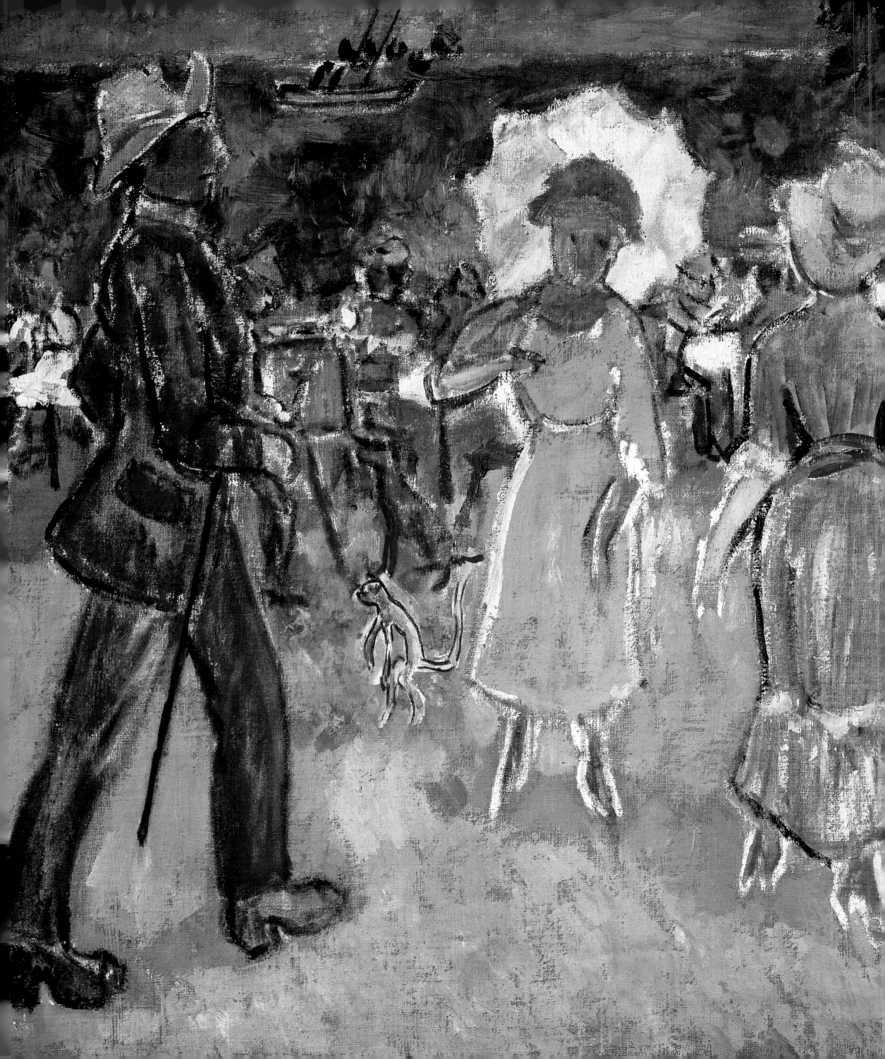

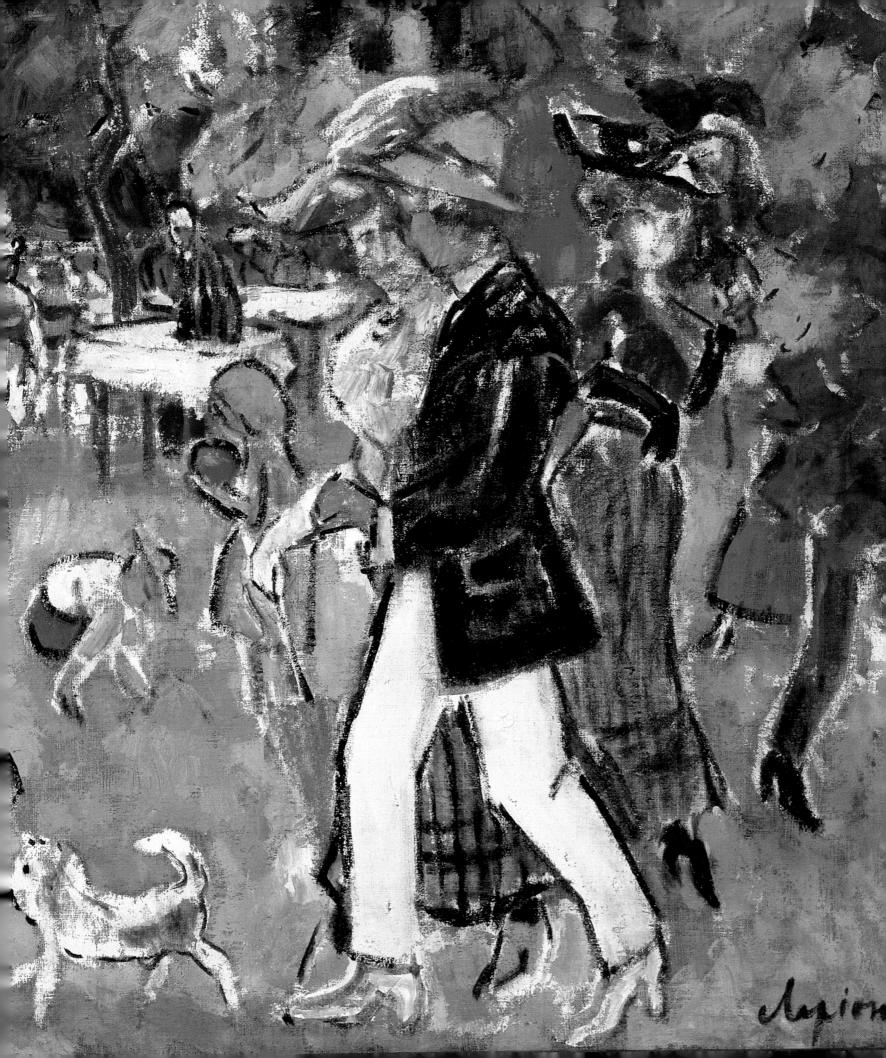

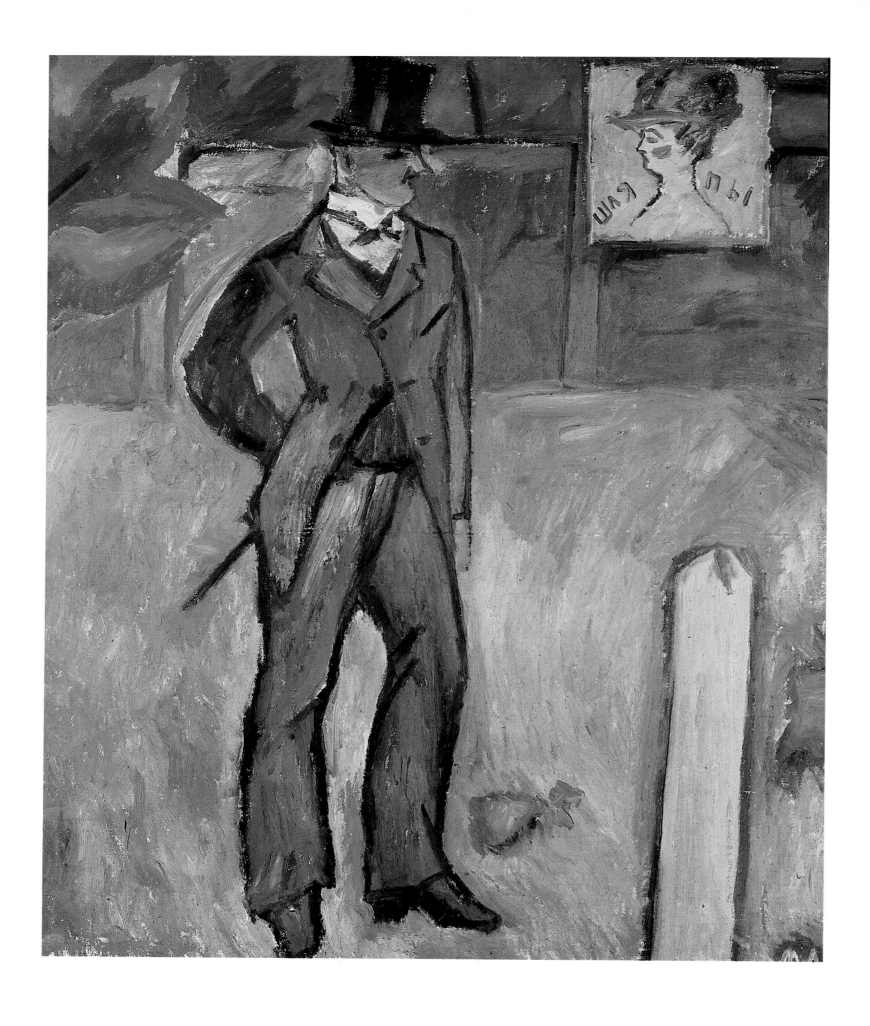

Restaurant on the Seashore. 1904–05
Oil on canvas. 73 x 123 cm
B. A. Denisov collection, Moscow

A Provincial Dandy. 1907
Oil on canvas. 100 x 89 cm
Tretyakov Gallery, Moscow

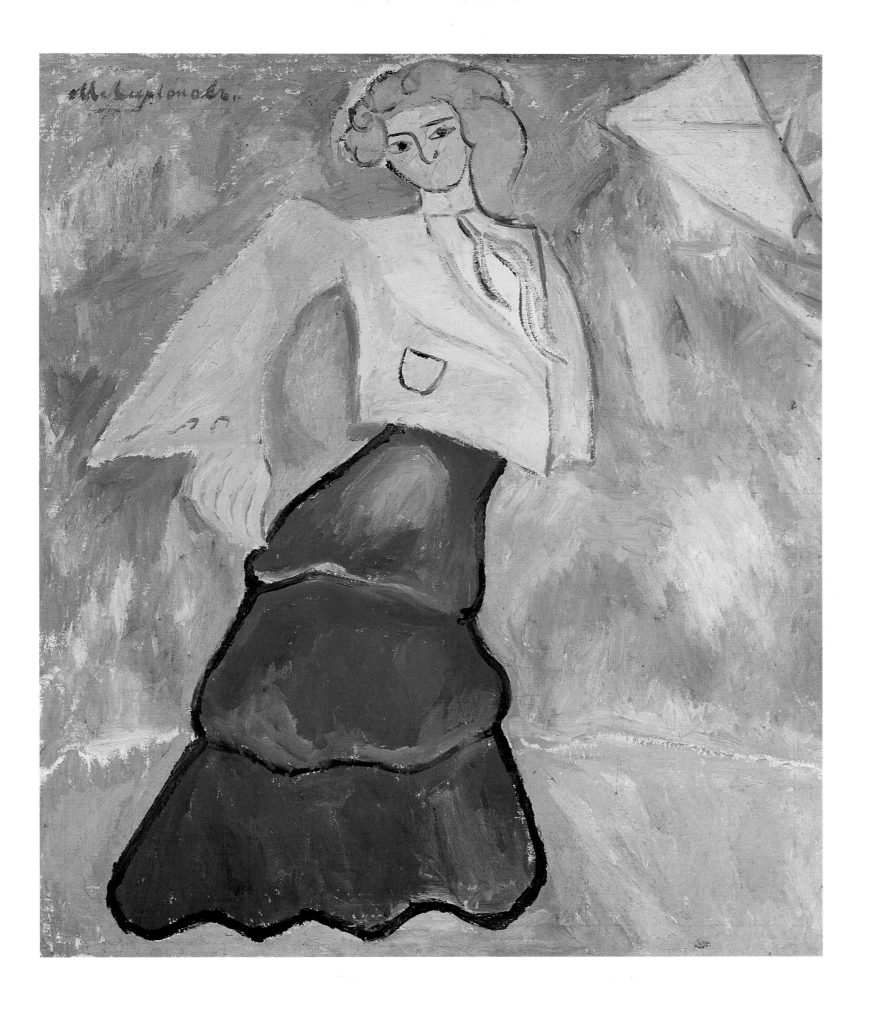

A Provincial Belle. 1907
Oil on canvas. 109 x 95 cm
Museum of Fine Arts, Kazan

43

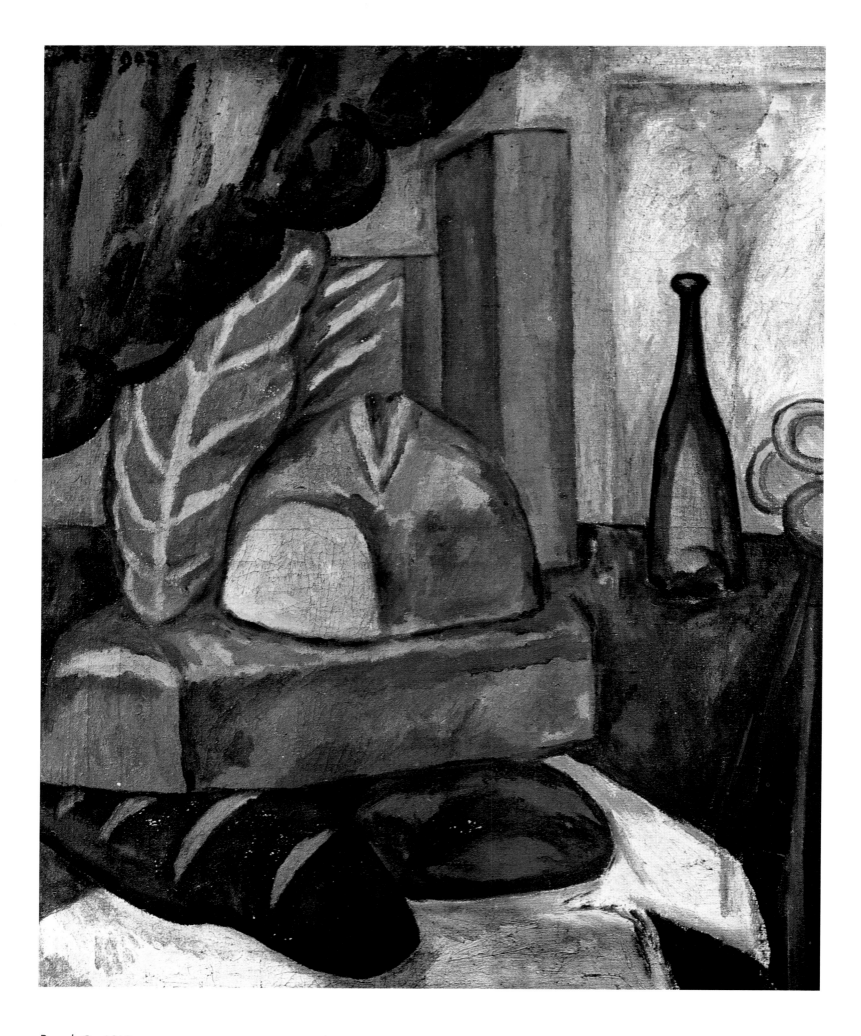

Bread. Ca. 1910
Oil on canvas. 102 x 84 cm
Private collection, Paris

44

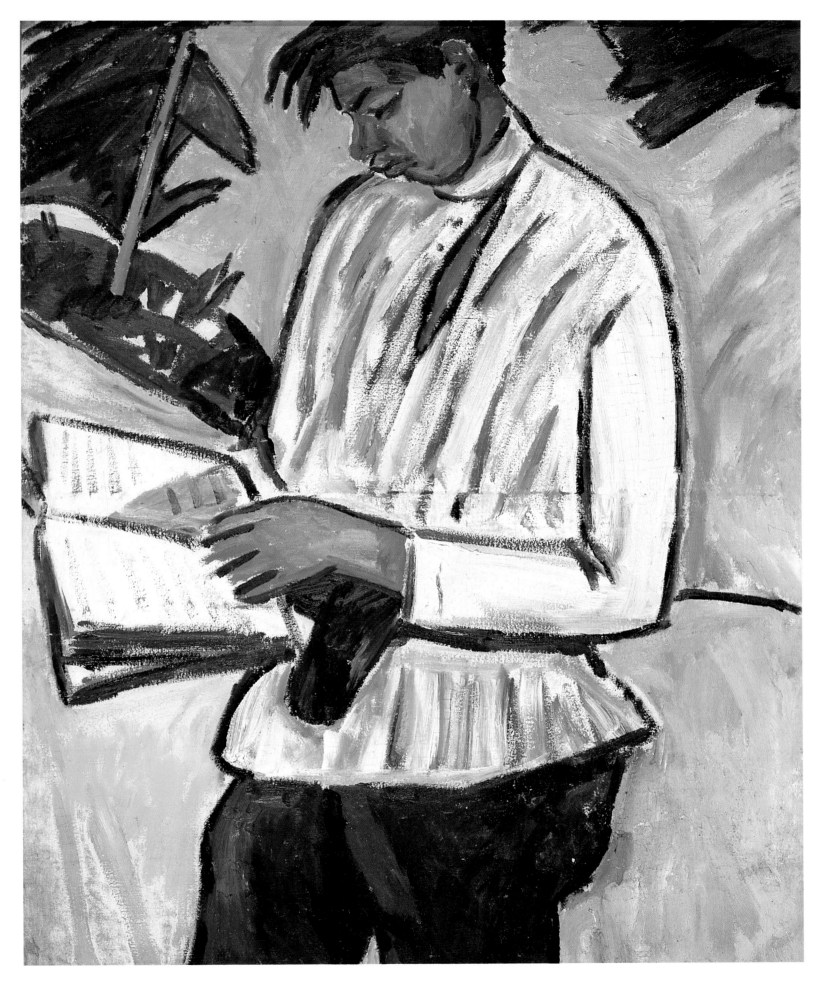

Portrait of the Poet Velimir Khlebnikov. Ca. 1910
Oil on canvas. 136 x 106 cm
From the former collection of A. K. Tomilina-Larionova,
Paris

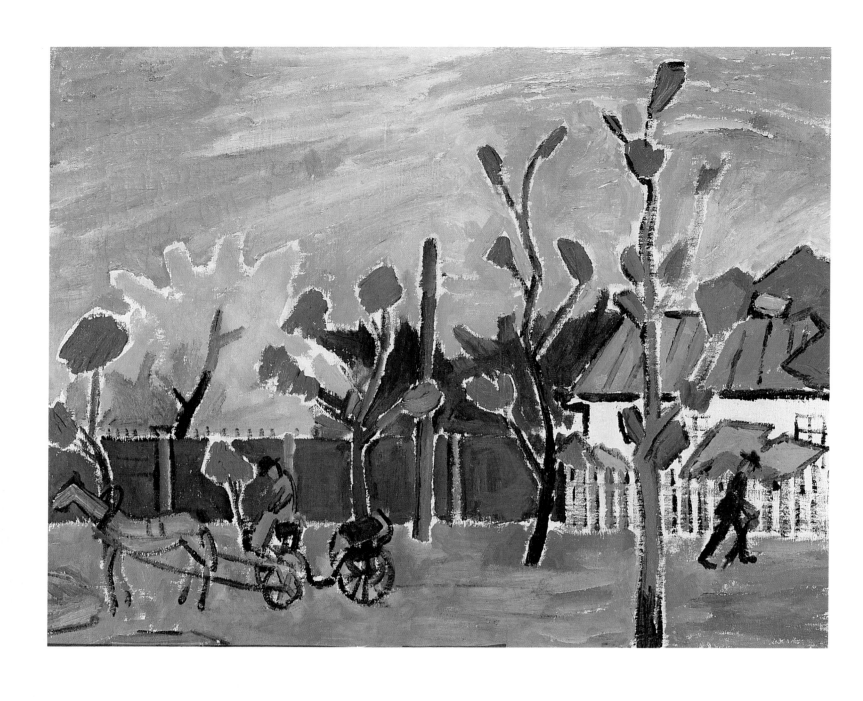

Horses. 1908
Oil on canvas. 71 x 97 cm
Russian Museum, St Petersburg

Sunset after Rain. 1908
Oil on canvas. 68.5 x 85.5 cm
Tretyakov Gallery, Moscow

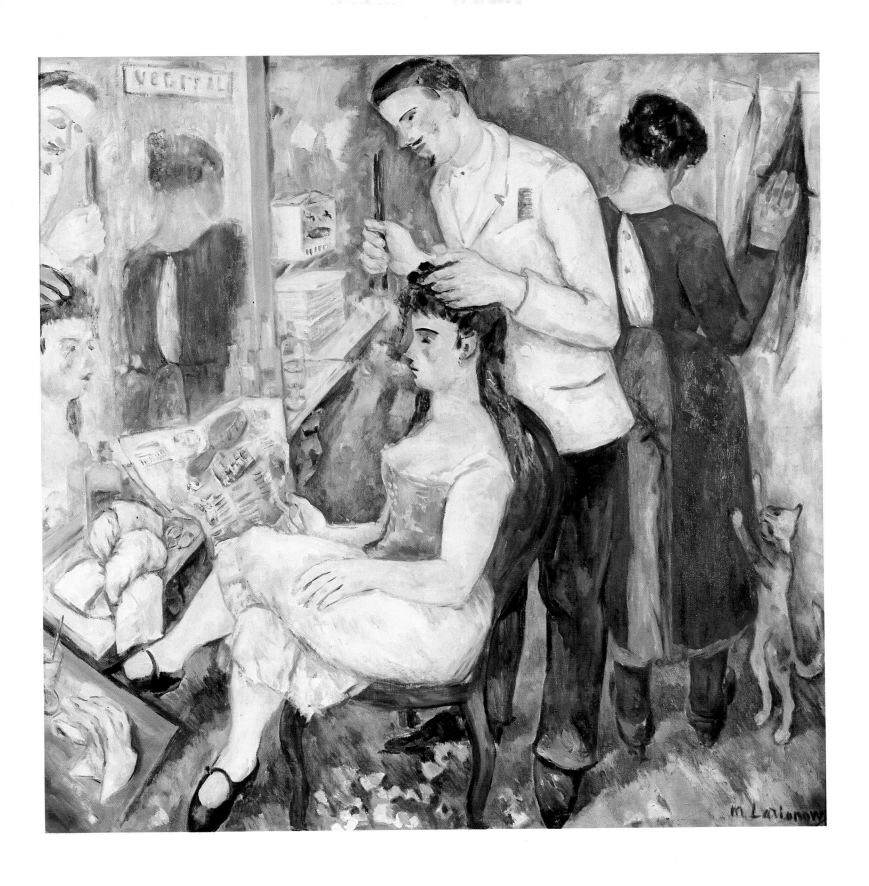

Girl at the Hairdresser's. 1920s
Oil on canvas. 159 x 152 cm
From the former collection
of A. K. Tomilina-Larionova, Paris

→
The Barber. 1907
Oil on canvas. 77.5 x 59.5 cm
Russian Museum, St Petersburg

→
The Officers' Barber. Ca. 1910
Oil on canvas. 117 x 89 cm
From the former collection
of A. K. Tomilina-Larionova, Paris

→
A Waitress. 1911
Oil on canvas. 102 x 70 cm
Tretyakov Gallery, Moscow

→
Circus Dancer. 1911
Oil and tempera on canvas. 107 x 77 cm
Museum of Fine Arts, Omsk

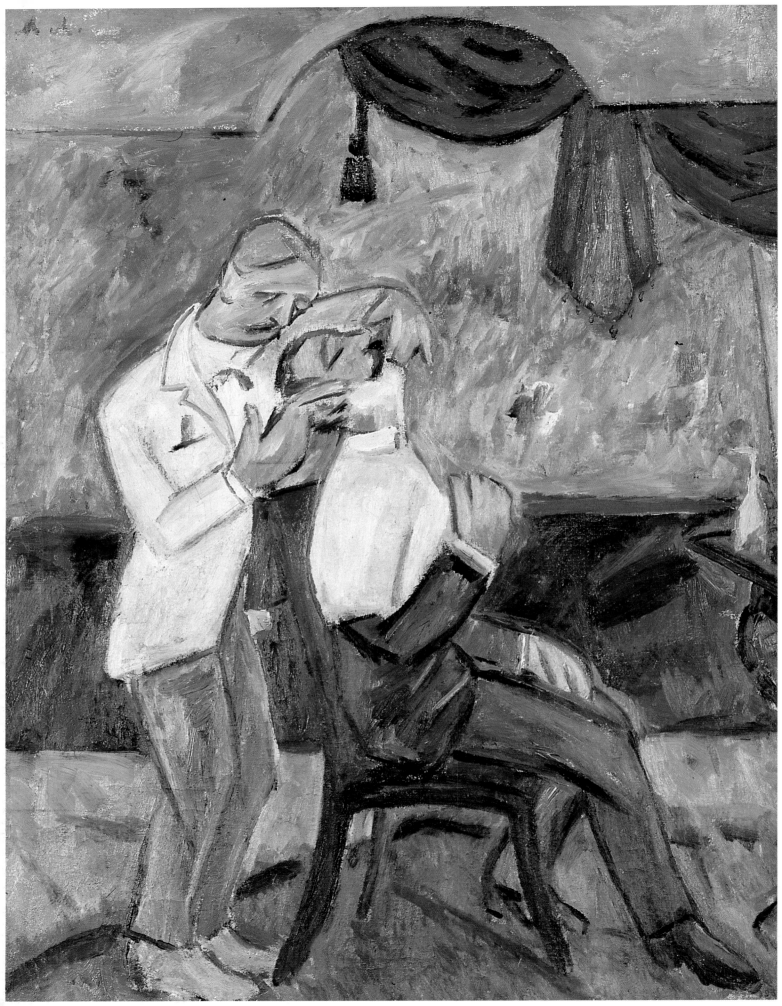

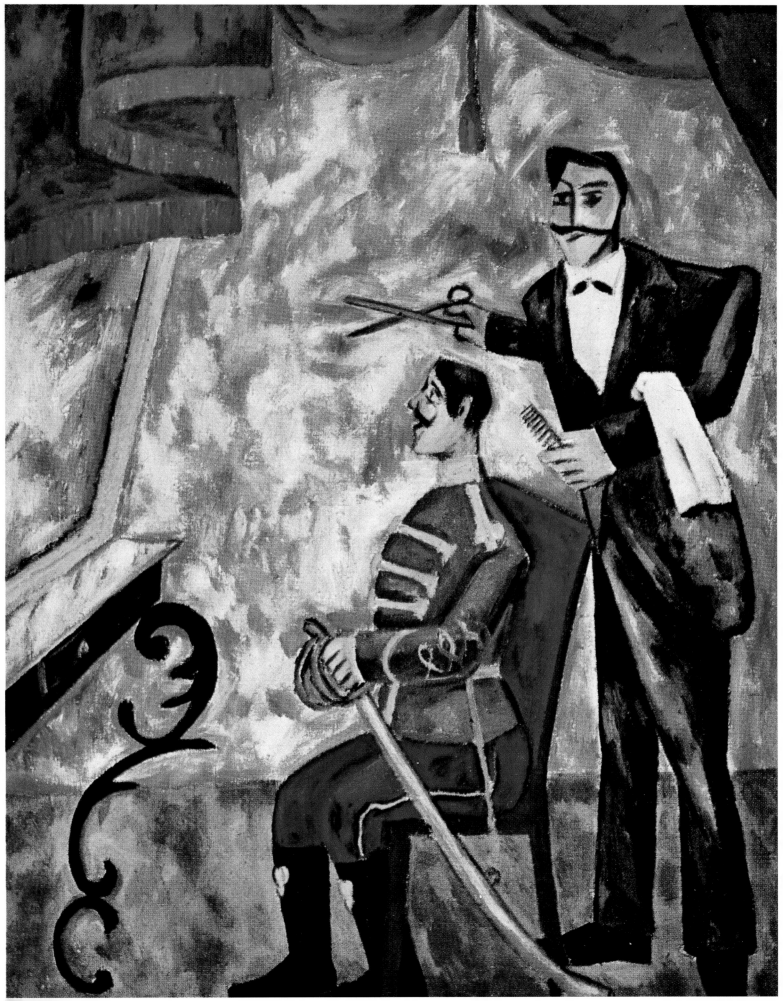

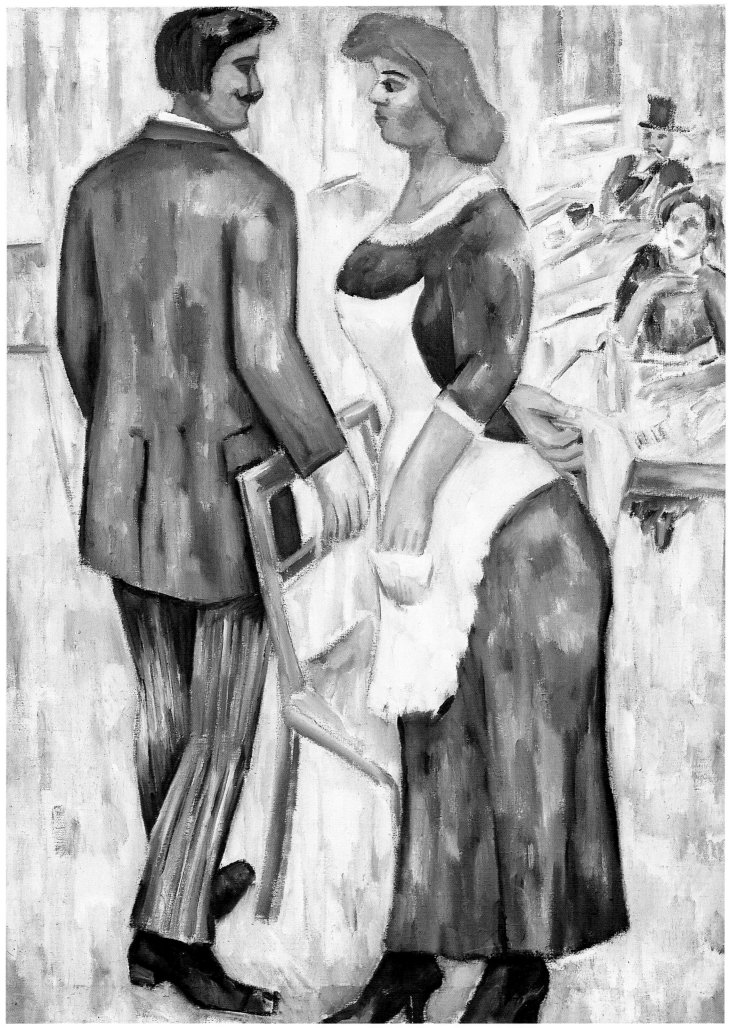

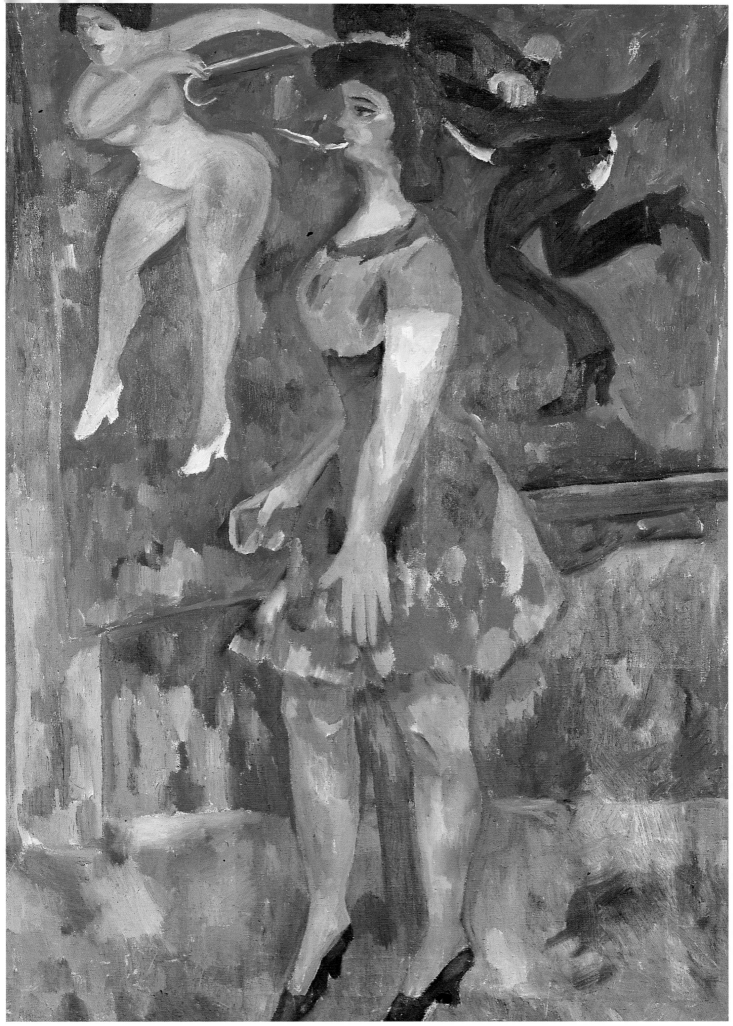

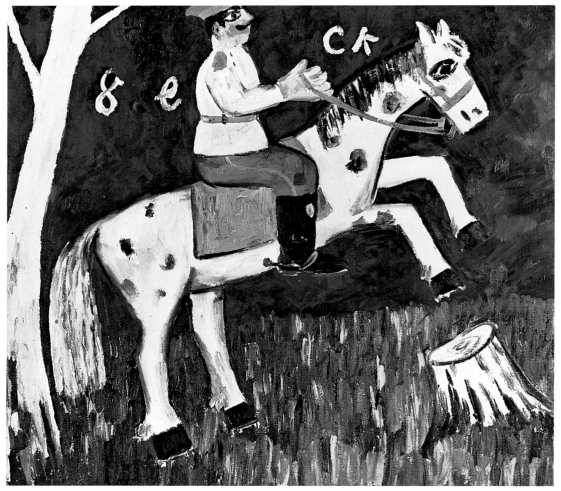

The Donkey's Tail

[1] F. M., "Osliny khvost" ["The Donkey's Tail"], *Moskovskaya gazeta*, 12 March 1912

The exhibition entitled The Donkey's Tail (*Osliny Khvost*) was held at the College of Painting, Sculpture and Architecture between 11 March and 8 April 1912.

The contributors included Mikhail Larionov, Ivan Larionov, Natalia Goncharova, Kasimir Malevich, Vladimir Tatlin, Mikhail Le Dantu, Victor Bart, Alexander Shevchenko and Marc Chagall.

The "Donkey's Tail" displayed jointly with the St Petersburg artists belonging to the Union of Youth: Pavel Filonov, Olga Rozanova, Iosif Shkolnik and Voldemar Matvei (Vladimir Markov).

The exhibition was a great success with the Moscow public, attracting some 10,000 visitors. A newspaper wrote: "Larionov, Goncharova, Malevich and Bart literally gripped the public with the power of their paints and manner of painting. They dominate [the exhibition]."[1]

Such reviews were, however, the exception. Most newspaper reporters attacked the exhibition from vulgar standpoints, making all possible plays on its title. Take the satirical section of *Golos Moskvy* [*The Voice of Moscow*]:

Donkey's Tailery
As we entered
The first week of Lent
The Donkey's Tail
Pitched its tent.

With theatres closed,
And nowhere to go,
By pure default
Its a popular show.

*Soldier Riding a Horse
(A Galloping Hussar).* 1910–11
Oil on canvas. 87 x 99 cm
Tate Gallery, London

Mikhail Larionov and Natalia Goncharova
(seated on the right). Photograph. 1910. Riga

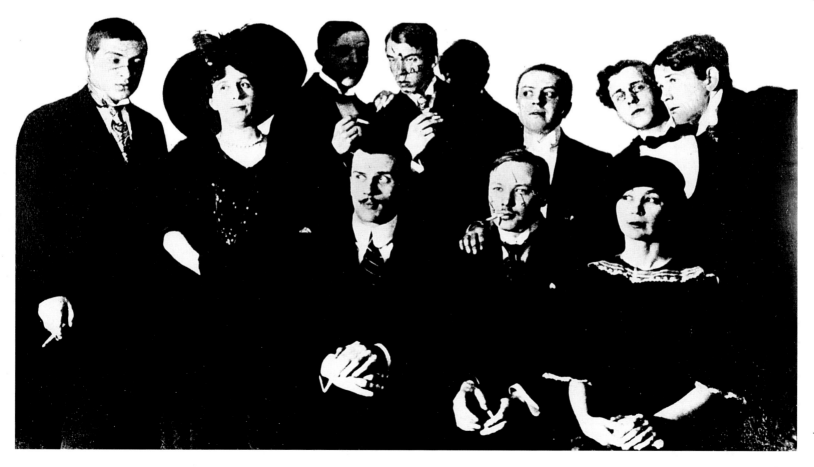

They've crawled out of the woodwork,
A sight to make you pale,
The Jack of Diamonds
And the Donkey's Tail.

The bored in their hundreds
Flock to view,
To yawn and gape,
And pay, of course, too.

A beat of hooves upon the desk
Followed by a wail —
Some popinjay's making
a speech
About the Donkey's Tail.

The "Burlies" are out en masse
Calling tune and time.
Raphael the incomparable
Is dubbed a philistine!

A mass quite unproductive,
A most disgraceful show.
Howling, baying, clapping —
That's no way to go.

In art now too
Rasputin hail —
He's the Jack of Diamonds;
He's the Donkey's Tail.[1]

Larionov displayed thirty-seven works at the exhibition. Thirty of them were devoted to soldierly life: *Target Practice*; *Mounting the Guard*; *Morning in the Barracks*; *Soldiers Dancing*; *A Soldier Resting* and so on.

Like many art students Larionov delayed graduating from college so as to avoid being drafted into the army. After he did graduate in 1910 he was obliged to go through a period of training in annual camp, not just once, but several times.[2] In the spring of 1913, for example, he was in camp at Khodynka outside Moscow.[3]

Larionov did his military service in several places — outside Moscow and in the environs of St Petersburg. The artist's widow, Alexandra Tomilina-Larionova, wrote that she would like to clear up the question of where he served: "Somebody assured me it was near Moscow. Mikhail Fiodorovich told me many times that it was in St Petersburg, that is to say thereabouts; that he was not often in the barracks, but spent his time in the museums. His comrades covered for him and the senior officers took a tolerant attitude thanks to the special pleading of Serov, who even disposed Nicholas II in his favour."[4] After serving a total of eighteen months, Larionov was discharged with the rank of ensign in the reserve.

As his military service was not particularly burdensome, Larionov was able to produce about forty canvases on themes from soldierly life. His first biographer Ilya Zdanevich (who wrote under the pseudonym Eli Eganbiuri)

[1] Aga, "Oslinokhvostiye", *Golos Moskvy*, 15 February 1912
[2] G. G. Pospelov noted that the artist's military training was divided into several periods. See his article: "M. F. Larionov", *Sovetskoye iskusstvoznaniye '79*, No 2, Moscow, 1980, p. 265
[3] In a letter to Mikhail Le Dantu and Ilya Zdanevich, Larionov informed them that he would be in camps until 20 July (MSS Dept., Russian Museum, fund 135, item 7, folios 3f)
[4] *Letter to Yevgeny Kovtun*, 18 February 1973. In the recepient's archive

noted: "There he became acquainted with a new way of life and he was delighted by the merits of the soldiers' barrack-room painting, to which no-one had ever paid attention before him. Their primitive wall-paintings and the cavalry badges that the soldiers paint on sheet-metal with depictions of people and horses and hang up to indicate the quarters of a certain part of the regiment were new stimulations. He managed to introduce something of his own into this current and to create some splendid art."[1] In Larionov's *Soldier Cycle*, it was no longer the shop-sign that inspired the artist, but an even "lower" source. Take his *Soldier Riding a Horse*

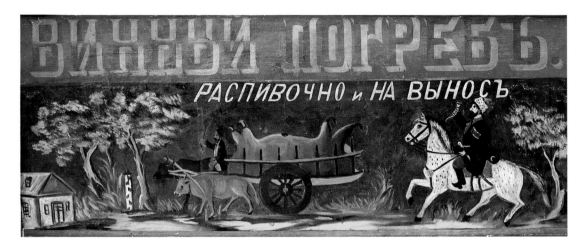

Niko Pirosmani
"Drink Here or Take Away"
Shopsign: *Wine-Cellar*

(Tate Gallery, London) on a dummy-like horse. He is galloping and at the same time stays on the spot in the sort of photographic stiffness one finds in popular lubok prints and the painting on distaffs. The crudely, tastelessly painted rearing horse is exactly the kind found on screens in provincial photographers' studios. You could "mount" it by sticking you head through an opening and have your picture taken as a dashing hussar. This was the source and an occasion for the observant and ironic artist to extract minor pearls where others saw only bad taste. Such primitive, "marketplace" depictions were only a starting-point for Larionov; his own Primitivism was of a high professional class. Dmitry Sarabyanov made a very accurate observation: "Larionov's joke is like that of a folk artist. His Primitivism is indeed remarkable for the fact that it encompasses the likeness of an attitude to an object, the likeness of a view of the world, but rejects stylization. Larionov possessed the rare talent of absorbing the popular conception, while retaining the awareness of the professional who understands the delight of folk primitiveness."[2]

Contemporaries noted Larionov's bold advance into various spheres of urban existence. The critic Varsonofy Parkin wrote: "In some of Larionov's pieces attention is attracted by his desire to interpret those very things that evoke the greatest number of attacks at present: photography, cinematography,[3] newspaper advertisements. Flying in the face of everything, he paints in the style of those things, confirming in the best possible way the idea that anything whatsoever can serve as an object for a talented artist."[4] Neither did Larionov overlook the soldiers drawings on the barracks walls of horses, women and other subjects that were often accompanied by risqué inscriptions. It had never even occurred to artists to seek inspiration there.

[1] Eli Eganbiuri (Ilya Zdanevich), *Natalia Goncharova, Mikhail Larionov*, Moscow, 1913, pp. 32f
[2] D. Sarabyanov, *Russkaya zhivopis' kontsa 1900-kh – nachala 1910-kh godov*, p. 115
[3] Cinematography, then in its early days, was not in the least perceived as an art-form in its own right and of equal value. It was regarded as "only eccentric nonsense, only a visual accumulation of banalities and idiotisms" (N. Chukovsky, *Literaturnye vospominaniya* [*Literary Memoirs*], Moscow, 1989, p. 67).
[4] V. Parkin, "Osliny khvost" i "Mishen'" [*The "Donkey's Tail" and "The Target"*], in *Osliny khvost i Mishen'. Sbornik*, Moscow, 1913, pp. 63f

Larionov's "aesthetic daring" quite often led him into the lowest "depths", but he always climbed out with an artistic "catch", discovering a pure source of creative inspiration everywhere. There were occasional accusations of "cynicism" and "vulgarity" with regard to some of Larionov's paintings and drawings. The booklet *Le futur*[1] which featured a drawing of a prostitute was even impounded by the censor's office. But the "guardians of morality" and "purists" were foisting their own banality and dubious taste on Larionov. We find a worthy rebuttal in the writings of Sergei Romanovich, a younger associate of Larionov: "What is the nature of Larionov's 'cynicism' of which quite a lot was said in its time? There is no cynicism, in the usual sense of the word, in his art at all. There are people who, when walking through the halls of a museum, turn away from Classical statues with their nudity. ... When Larionov took delight in soldiers' depictions of women on fences, when in some paintings he repeated the inscriptions on those fences or put into the mouths of his characters expressions he had come across (also, presumably, through inscriptions), he was caught up in that spontaneous manner of life in which all that existed. It was only possible to express that life in the way he wanted by conveying its powerful animal basis. ... People inclined to vulgarity of course found what they wanted in these works, and what was really in them was beyond their grasp."[2]

Even one of the finest paintings of the soldier cycle, the celebrated *A Soldier Resting*, was beyond the grasp of the newspaper critics:

[1] *Le futur*, poems by K. Bolshakov; illustrations by Goncharova and Larionov, Moscow, 1913
[2] S. M. Romanovich, O "tsinizme" Larionova [*Regarding Larionov's "Cynicism"*], 1957. The manuscript was kindly given to the author by M. A. Spendiarova, Romanovich's widow, from her personal archives.

A Soldier Resting. 1911. Detail

A *Soldier Resting*
Based on the 1911 painting of the same name, now in the Tretyakov Gallery, Moscow
Print from a series of lithographed postcards published by Alexei Kruchenykh (Moscow, 1912)
Lithograph. Tinted print. 9.2 x 14 cm
State Library of Russia, Moscow

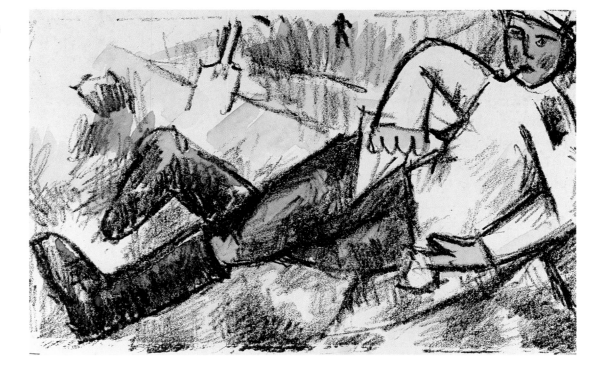

"Here we have espied
A soldierly type. Phew!
His belly on one side
Legs all askew...
No eyes at all, if you please
Where'd they go?
To such men as these
The army must say no!"[1]

A *Soldier Resting* is an example of plastic freedom of expression, improvised painting that nonetheless gives rise to a visually precise image. The principle of unconstraint, of a harmony achieved seemingly without labour and effort permeates the artist's creation. His painting is constructed on three relationships — the ochry-red earth, the silvery-blue fence and the yellow-green soldier's greatcoat, but in each of them there is an infinite variety of gradations and vibrations of colour that makes the painting resemble some precious natural material.

Malevich, researching into the essence of painting, defined three types of approach. The first is graphic colour painting or tinted drawing, as, for example, the work of Holbein. The second is colour painting proper, founded on pure, local relationships of colour. This embraces the canvases of Matisse and Malevich himself in his peasant cycle. The third type is live painting. Here we might name Rembrandt or Surikov. Such a painter, in Malevich's words, "will always soil his paint, mixing it, turning it into a tone... The genuine painterly nature (Konchalovsky) cannot bear colour and in this process the more he fears colour, the better the painting becomes (colour-phobia)."[2] Larionov too was "afflicted" by that kind of "colour-phobia" that produces painterly values. He belongs to that same series of painterly magic as Vrubel and Borisov-Musatov.

Among the exhibitors at the Donkey's Tail was Larionov's younger brother Ivan (1884–1920), a talented, yet almost unknown artist. A few lines are devoted to him in Parkin's book: "Ivan Larionov, a profound and powerful

[1] "A modest reviewer", "Osliny Khvost" ["The Donkey's Tail"], *Golos Moskvy*, 15 March 1912
[2] Malevich's rounds of the studios at GINKhUK. Round No 3 (Kudrov), 12 October 1926: Ye. F. Kovtun, *Russky avangard 1920–1930-kh godov* [*The Russian Avant-Garde 1920s–1930s*], St Petersburg, 1996, p. 86

artist, but sadly so little exhibited that of his pieces one can mention only a portrait painted with chrome and madder (red). For force of expression this is an entirely exceptional piece."[1]

In the 1950s Larionov reminisced about his brother: "From 1899–1900, when he was 16 or 17, Vanya made himself a sailor and lived in Archangel (our father's home city) on the White Sea, or more properly on the Northern Dvina River. At that time and slightly earlier he began to take an interest in art and to work. He stayed in Archangel, with breaks, until 1905. He lived sometimes in his native Tiraspol, sometimes in Moscow. The rest of the time he was at sea. In the pauses between his seafaring, usually in winter and early spring, he practised painting in Moscow."[2]

Ivan Larionov took part in the first exhibition of the Union of Youth (1910) and the International Exhibition held in Vladimir Izdebsky's salon. As well as the Donkey's Tail, his works were presented at the *Target*. Ivan shared his brother's artistic position and signed the 1913 *Rayonists and Futurists* manifesto together with other members of the group. The Russian Museum possesses several canvases by Ivan Larionov, acquired from Alexandra Tomilina-Larionova, including the portrait displayed at the Donkey's Tail. His painting is distinguished by strained, intense colour and a purity of laconic forms. While he worked alongside his elder brother, Ivan Larionov retained his painterly originality, keenly expressing his own view of the world.

During the war against Germany, Ivan Larionov served in the field. He was taken prisoner and spent the rest of the war in an officer's camp outside Heidelberg. A number of postcards that he sent to Mikhail from the camp have survived: "You know, of course, from the newspapers what it's like to be a prisoner of the Germans. ... From the disconnected nature of this letter you may conclude that I have not only forgotten how to write, but even how to think. That is due to the cultured and humane Germans (in inverted commas)."[3] When he found himself abroad with Diaghilev, Larionov sent a parcel to the camp for his brother. "Dear Misha," Ivan wrote, "I got your parcel with warm clothes, sausage, cheese and tobacco. Many thanks for the parcel. Why don't you write anything to me? People tell me that Diaghilev and his troupe have left for America. Are you going too? There is lots I would like to ask and write about, but due to certain considerations I can't. My best regards to Natalia Sergeyevna. I kiss you strongly. Yours Ivan."[4]

Ivan Larionov returned from captivity in 1918, but died in Moscow in 1920.

[1] V. Parkin, "Osliny khvost" i "Mishen'", p. 66
[2] M. F. Larionov. *Biographical Information about I. F. Larionov*, after 1952. Archive of Alexandra Tomilina-Larionova, Paris
[3] I. F. Larionov, *Letter to M. F. Larionov*, 27 November 1918, Archive of Alexandra Tomilina-Larionova, Paris
[4] I. F. Larionov, *Letter to M. F. Larionov*, 16 January 1916, Archive of Alexandra Tomilina-Larionova, Paris

Ivan Larionov
Portrait of an Unknown Man in a Blue Blouse. Ca. 1913

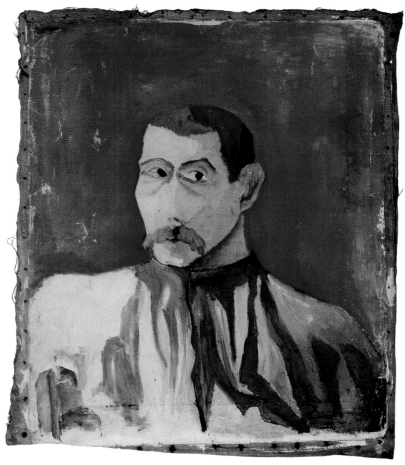

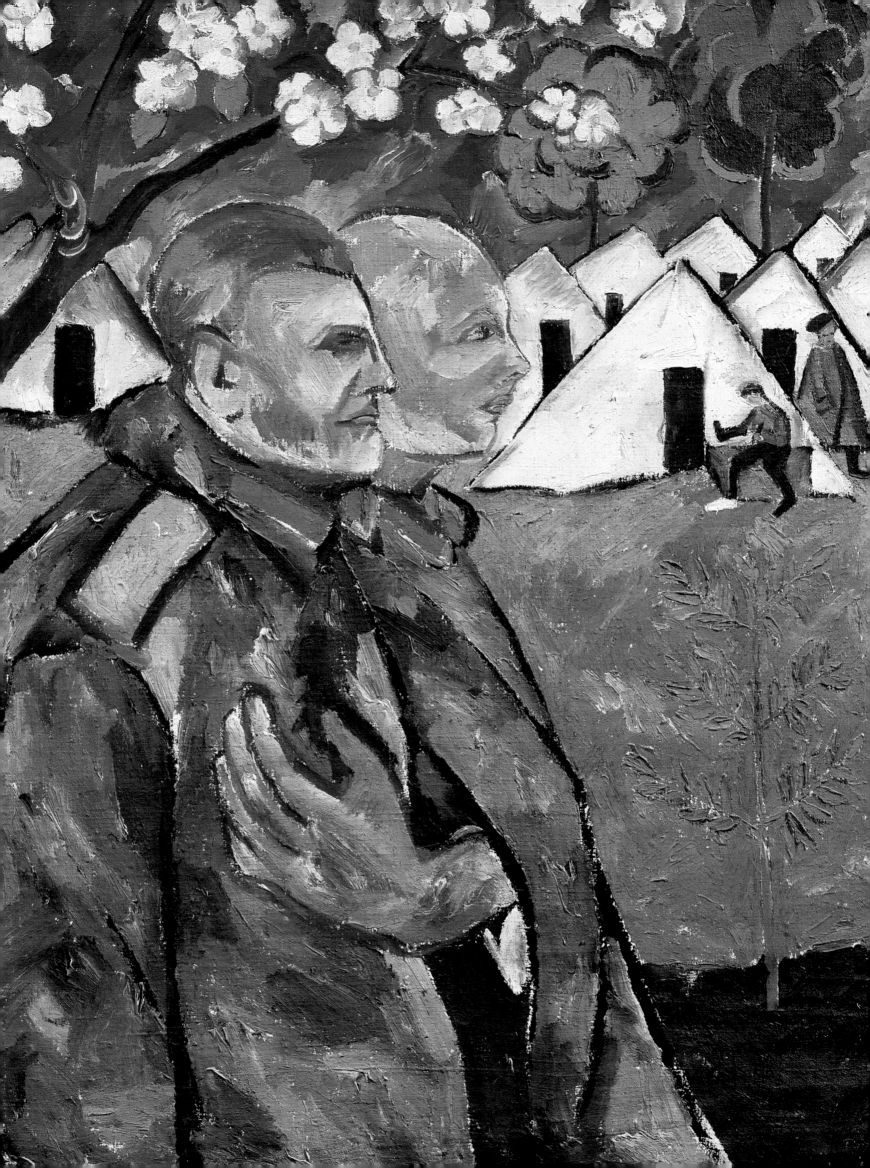

←
Natalia Goncharova
**Portrait of Mikhail Goncharov
and His Platoon Commander.** 1911
Russian Museum, St Petersburg

Near a Camp. 1910–11
Oil on canvas. 72 x 89.5 cm
Russian Museum, St Petersburg

A Soldier Smoking. 1910–11
Oil on canvas. 119 x 122 cm
Tretyakov Gallery, Moscow

62

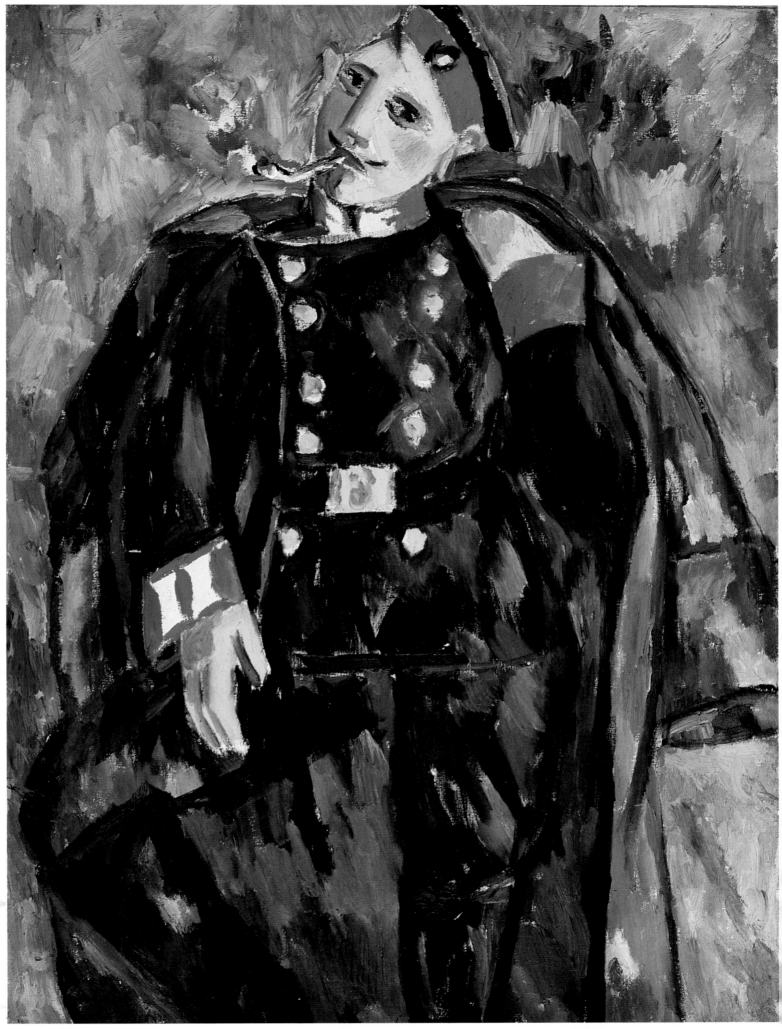

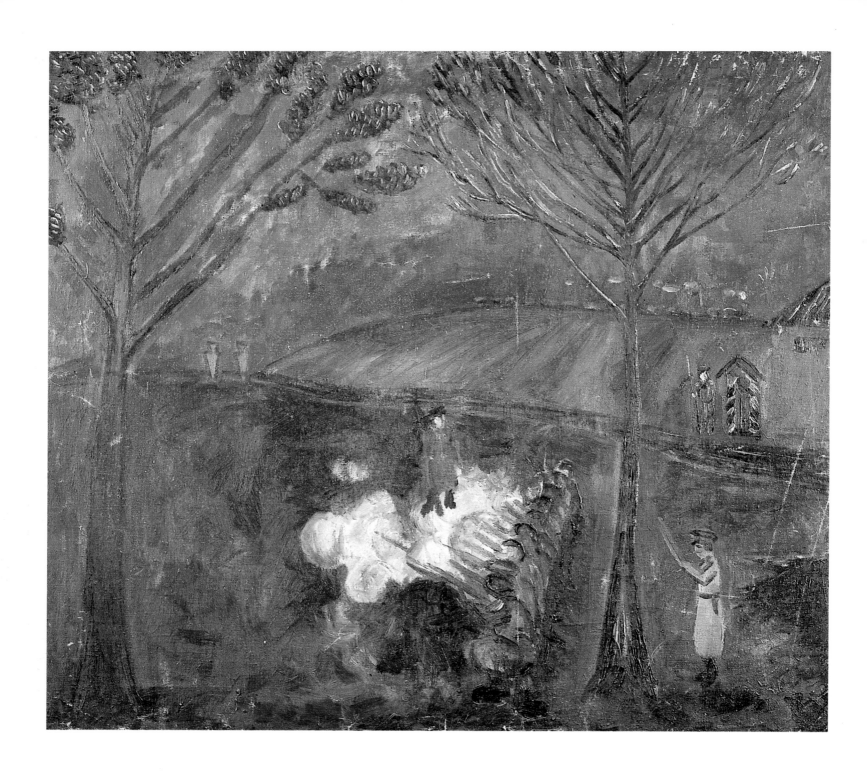

Salvo. 1910–12
Oil on canvas. 88.5 x 89 cm
Musée national d'art moderne,
Centre Georges Pompidou, Paris

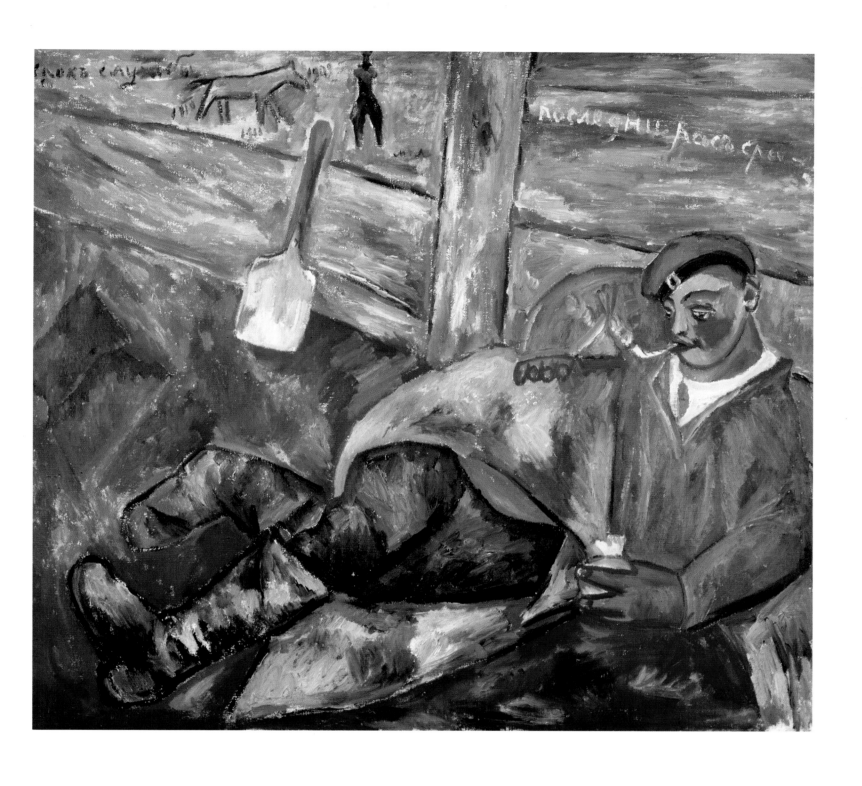

A Soldier Resting. 1911
Oil on canvas. 119 x 122 cm
Tretyakov Gallery, Moscow

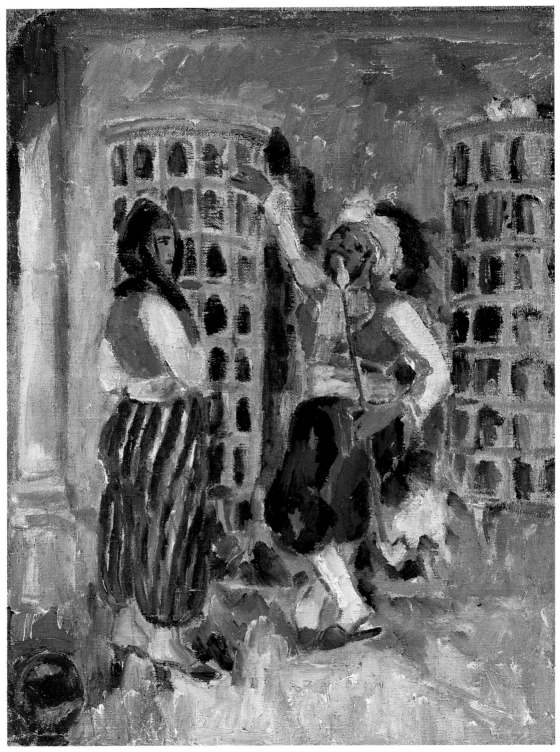

The East and Nationality

[1] "Mneniya o syezde khudozhnikov" ["Opinions on the Congress of Artists"], *Protiv techeniya*, 24 December 1911, No 15
[2] For more about Matvei see Ye. F. Kovtun, "Vladimir Markov i otkrytiye afrikanskogo iskusstva" ["Vladimir Markov and the Discovery of African Art"], in *Pamyatniki kultury. Noviye Otkrytiya. Yezhegodnik za 1980 g. [Monuments of Culture: New Discoveries. Annual for 1980]*, Leningrad, 1981
[3] *Soyuz molodiozhi: sbornik [The Union of Youth: an anthology]*, St Petersburg, 1912, No 1, p. 11
[4] *Ibid.*, p. 7

Turkish Man and Woman. 1910
From the series *An Imaginary Journey to Turkey*
Oil on canvas. 72 x 51.5 cm
Russian Museum, St Petersburg

Voldemar Matvei. Photograph.1910

The artists of Larionov's group believed that the original, deep-running roots of Russian art were bound up with the Byzantine tradition. In 1911 Larionov pointed out to the All-Russian Congress of Artists the need for a protective, caring attitude towards the early Russian artistic legacy that had carried down to the present day vital traces of the Byzantine tradition that were valuable for contemporaries.

"The Congress is utterly vital. There and only there is it possible to work out the conditions required for the preservation of the Russian past and its monuments, the protection of church frescoes and so on. ... Byzantine art, of which Russia is full, needs protecting."[1]

Larionov and those who shared his views found themselves faced with the age-old question of East and West, Russia's place and role in the interaction of the two. Russian artists were experiencing the profound influence of new Western art: Impressionism, Gauguin, Matisse, Cubism. It opened their eyes to their own values. Western art was a sort of catalyst in the process of Russian artists communing with their own national artistic sources and roots. They saw that in the West too the most modern and vital manifestations of creative endeavour drew on the experience of Eastern art. They understood that their own interaction with the East could be direct, without the West as intermediate. Voldemar Matvei (Vladimir Markov) was one of the first theoreticians in Russia who spoke out against the narrowness of the Euro-centric conception of art, which considered the yardstick by which to measure was the Ancient Greek canon.[2] Contemporary Europe, he observed, while having achieved so much in the field of science, was "very poor in regard to the development of the plastic principles bequeathed to us by the past." Matvei spoke of the unproductiveness for art of such dogma of European aesthetics as maximum adherence to life, geometric perspective, "anatomical" realism and the imitation of colour. "The scientific apparatus of Europe sets up hurdles to the development of such principles as the principle of gravity, flatness, dissonance, economy, symbols, dynamism, the *leitmotif*, the limited spectrum and so on and so forth."[3]

Matvei's first article — "The Principles of a New Art" (1912) — appeared in the same year as the book on Cubism by Gleizes and Metzinger was published in Paris. At different ends of Europe thoughts were moving in the same direction. For Matvei, as for the French writers, subjective arbitrariness was alien in the realm of visual creation. The idea of the existence in the plastic arts of principles and primary elements "that might be elevated to the status of indisputable truths, fundamental principles" runs through the whole article. "Many peoples have left the stage of history, have become lost in the obscurity and remoteness of the past," Matvei wrote, "but their creative principles have been preserved in a pure or reworked form."[4]

Artists' interest shifted in the direction of the "untutored children" in whose art "previously unremarked values" were revealed. "The ancient peoples and the East," according to Matvei, "did not know our scientific rationality. They were children with whom feeling and imagination dominated over logic. They were irrepressible, unspoilt children who penetrated intuitively into the world of beauty, who could not be won over either by realism or by scientific researches into nature."[1]

On the eve of the *Target* debate, Larionov informed Le Dantu: "We are to have a debate on 23 March. The theme is this — the East and nationality against Western epigonism, and in separate items — traditions in art, the russification of Western forms. The East inspires the West (Japan and Impressionism, China and Mongolia, Negroes and Cubism). We can commune directly with the East, and not through the mediation of the West. Our ideas influence the West, but we do not sense them and so on. And that applies to everything, music, poetry, the theatre and painting."[2] A leaflet was produced for the debate, which took place on 23 March 1913, entitled "The East, Nationality and the West". In the preface to the *Target* exhibition catalogue which Larionov wrote, two points were devoted to this theme: "We strive towards the East and turn our attention to national art. We protest against slavish subservience to the West that returns us our own Eastern forms in trivialized form and levels everything."[3]

The "russification of Western forms" was the goal of Larionov and his group. They sought to enable Russian painting to speak at the top of its voice in a distinctive, authentic national idiom.

In 1913 Alexander Shevchenko published a brochure entitled *Neo-Primitivism. Theory. Possibilities. Achievements*. This was one more manifesto from Larionov's group, asserting the primacy of Eastern impulses in the development of modern Russian art. "We are seeking to discover new paths for our art," the artist wrote, "but we do not wholly reject the old either and among its previous forms we acknowledge above all the primitive, the magical fairy-tale of the old East."[4] He was seconded by Ilya Zdanevich: "The history of modern art, beginning with the Impressionists' fascination with the Japanese, the Cubists' with negroes and Aztecs, the Orphists' with the Chinese, and so on, takes the form of an undeviating procession to the East and to non-European countries, an ever increasing esteem for non-European art over European, ending with the Futurists' proclamation of the East as the sole value."[5]

Goncharova took the same position, declaring that she would "draw artistic inspiration in [her] homeland and in the East that is close to us."[6] Diaghilev's production of *The Golden Cockerel* with sets by Goncharova astonished Parisians and the French art world with its colourful magic. "Delirious singing in peacock colours," as Nikolai Gumilev described the paintings of the Russian female artist.

This success was bolstered by an exhibition of the work of Larionov and Goncharova held in Paris on the eve of the Great War. Apollinaire, who had a high estimation of Russian artists, particularly noted the Eastern emanations coming from Goncharova's painting: "Her work is also a discovery of that astonishing decorative freedom that never ceased to lead Eastern artist among the luxurious treasures of form and colour."[7]

When in 1915 Larionov and Goncharova went abroad at Diaghilev's invitation, Ilya Zdanevich sent a farewell letter to her as the "conqueress" of the West: "I have learnt that you are going abroad and will work there. I congratulate you

Mikhail le Dantu. Photograph. 1914

[1] *Soyuz molodiozhi: sbornik* [The Union of Youth: an anthology], St Petersburg, 1912, No 1, p. 10
[2] M. F. Larionov, *Letter to M. V. Le Dantu*, 1914, MSS Dept., Russian Museum, fund 177, item 54, folio 7
[3] *Mishen'* [The Target], Moscow, 1913, p. 6
[4] A. Shevchenko, *Neoprimitivizm*, Moscow, 1913, p. 9
[5] I. Zdanevich, *Futurizm i vsechestvo* [Futurism and Universality], 1914, MSS Dept., Russian Museum, fund 177, item 21, folio 7
[6] *Vystavka kartin Natalii Sergeyevny Goncharovoi. 1900–1913:Katalog* [An Exhibition of Paintings by Natalia Sergeyevna Goncharova. 1900–13: a Catalogue], Moscow, 1913, p. 3
[7] G. Apollinaire, "The exhibition of Natalia Goncharova and Mikhail Larionov", *Les soirées de Paris*, 1914, No 26–27, p. 370

[1] I. Zdanevich, *Letter to N. S. Goncharova*, 6 December 1914, MSS Dept., Russian Museum, fund 177, item 54, folio 7
[2] *"Osliny khvost" i "Mishen'": Sbornik*, Moscow, 1913, p. 12
[3] M. F. Larionov, *Letter to I. S. Shkolnik*, June 1913, MSS Dept., Russian Museum, fund 121, item 39, folio 1
[4] M. Fabbri, *Letter to M. V. Le Dantu*, 1913(?), MSS Dept., Russian Museum, fund 135, item 12, folio 15r and v
[5] M. V. Le Dantu, *Letter to Z. S. Le Dantu*, 14 April 1912, Central State Archive of Literature and Art, fund 792, list 1, item 4, folio 49v

Akhmet
Illustration from Alexei Kruchenykh's and Velimir Khlebnikov's lithographed book: *Mirskontsa* [*Worldbackwards*], Moscow, [1912]
Lithograph. Tinted print. 17.8 x 13.6 cm
National Library of Russia, Moscow

from the bottom of my heart. The great current of art is now rushing from East to West and the barbarians are again setting out to conquer. How good it is that instead of Léon Bakst you, who are loyal to the East, will be Russia's envoy. The flutes cry out at dawn together with the peacocks and the warriors embarking on campaign. I, who remain at home, hail them and, standing on the roof, watch how people hide. Do not forget to come back. May the enemy camp not entice you. Do not stay in the camp of the defeated and the people of the West. Or the East will stop sending rays. Our time has come. The day known as tomorrow has dawned. Board your aeroplanes, set your weapons. I hail you and your art, rising from the East. But may they not forget the East."[1]

Zdanevich's sentiments touched prophetically on the fate of Russian artists who found themselves abroad. Sadly, his metaphorical suggestion that the East would stop sending "rays" proved accurate. The year 1913 saw Larionov attempting to collaborate with Eastern artists. The manifesto *Rayonists and Futurists* states directly: "We are coming together with contemporary Eastern artists for joint work."[2] In a letter to Iosif Shkolnik, Larionov wrote of a joint exhibition with Eastern artists that was supposed to take place in Moscow and St Petersburg in 1914.

We do not know what channels linked Larionov's group with Eastern artists. There is, however, one suggestion. In letters from this period Larionov mentions a mysterious Persian priest called Mejid Saltane. In the same letter he informed Shkolnik: "'Our entrepreneur' is not financially interested and looks only to the realization of the principles we propound. We repudiate the West and only create and affirm our ideas together with contemporary Eastern artists. Our entrepreneur is a Persian prince educated in Paris — Mejid Saltane."[3] Some researchers have suggested that the "Persian prince" was nothing more than a "leg-pull" by Larionov who was fond of hoaxes. He did, however, have an existence outside Larionov's imagination and was indeed connected with the artists of the group. In one letter Maurice Fabbri complained: "I recently received from Monsieur Sal[tane] a letter and a copy of a telegram in which he inquires after my health. ... I do not understand the man. He leaves me in such a position without aid and then wires that he is concerned about me."[4] There is uncorroborated evidence that at the time of the revolution Saltane left for Turkey together with Fabbri and his tracks were lost in emigration. Another witness, Mikhail Le Dantu, seems to have met the Persian prince in Tiflis in 1912. "This prince, Mejid Saltane (a collector — his full name would stretch to a whole page), has picked up in the bazaar here an awful lot of valuable things from [for?] his collection. It is now valued at about a million roubles. (I shall have to court his daughter, the more so as she is very pretty!) I shall abduct a Persian princess like Stenka Razin did, then demand his collection as a ransom. A good plan, isn't it?"[5] It is probable that this Persian prince was the connecting link between Larionov's group and the Oriental artists of the Persian-Turkish region. The war prevented Larionov from realizing his "Eastern" plans.

The first Eastern motifs appeared in Larionov's work as early as 1898 in the form of illustrations to Arab fairy-tales. They were displayed at the exhibition of works by students of the College of Painting, Sculpture and Architecture in 1904, and then at Larionov's one-day exhibition in the "Society of Free Aesthetics" in 1911. We do not know how many there were; two are now in the Russian Museum. One

of them, *Eastern Motif*, was executed in a decorative manner: a golden back-ground, a red couch, a woman in a white dress and brightly-coloured parrots. The artist recreates the heady atmosphere of the Eastern fairy-tale. He exploits the chromatic effects achieved by combining bronze and aluminium paints. The second work — *A Woman and a Flamingo* — was done in pastel, and in the female image one can divine the characteristic types found in Larionov's later "Turkish" paintings. The pastel reveals the artist's faultless painterly sense. Captivated by the East and its artistic culture, in the early 1910s Larionov intend-ed to make a journey to Turkey. For some reason the trip never took place, but the artist did paint a number of works on Turkish themes. He was aided, of course, by the impressions of Tiraspol with its colourful bazaar and strong Eastern atmosphere. Turks and Greeks made up a significant proportion of the population in Tiraspol. This is the background to the cycle of paintings known as *An Imag-inary Journey to Turkey* that appeared in 1910–12. It comprised *A Mistress and Her Maid*, *Pastorale*, *Turkish Man and Woman* and other canvases.

Since early times Russian art had been creating its own "Eastern myth". It is present in the colourful tiles on the domes of St Basil's, in the mysterious Sirin and Alkonost birds and in the decorative patterns painted on wooden articles. Pushkin worked on the myth in *Ruslan and Liudmila* and his tales of Tsar Saltan and the Golden Cockerel. Khlebnikov and Yesenin paid tribute to it in poetry, Glinka and Rimsky-Korsakov in music. This was the East refracted through the prism of Russian culture and Russian perceptions.

Larionov's "Turkish" paintings fit into this same tradition. Lively impressions giving an impression of verisimilitude are fused in this precious, jewel-like paint-ing with expressive "folklore", with the shop-sign "myth". The image of the smoking woman in *A Mistress and Her Maid* is clearly related to tobacco-nists' signs which always depicted smoking Turks. This is one of Larionov's painted masterpieces, executed in colour that is simple in the manner of shop-signs, yet subtle: the separate areas of colour are filled with barely detectable chromatic tinges, a com-plex painterly vibration which gives the decorative relationships an uncharacteristic figurative expressiveness and power. In a few combinations — turquoise-blue, lilac, golden yellow — every colour, particularly the blue background, possesses painterly depth, glittering with a precious range of tints and hues. Larionov returned many times to this subject. In his Parisian period he created the serigraphic album *A Journey to Turkey* that features images of Turkish women smoking. The State Library of Russia has a lithographic variant of this composition dating from 1913. In the flowing lines of the two figures, mistress and maid, the eye detects rhythmical repetitions and hidden contrasts that evoke a sense of elevated harmonization of form and a delicate balance of all its elements. These aspects of the drawing are brought out even more powerfully by the watercolour tinting, the tender translucent interactions of green and pink, crimson and yellow. The white areas too, left untouched by the brush, fit organically into the general spectrum.

A Turk. 1910–12
From the ceries *An Imaginary Journey to Turkey*
Oil on canvas. 88.5 x 44.5 cm
From the former collection
of A. K. Tomilina-Larionova, Paris

Smoking Woman. A Turkish Scene
Based on motifs from Larionov's painting *A Mistress and Her Maid*.
A Turkish Scene. 1911 (?)
From the series of lithographed post-cards published by Alexei Kruchenykh (Moscow, 1912)
Lithograph. Tinted print. 12.5 x 9 cm
State Library of Russia, Moscow

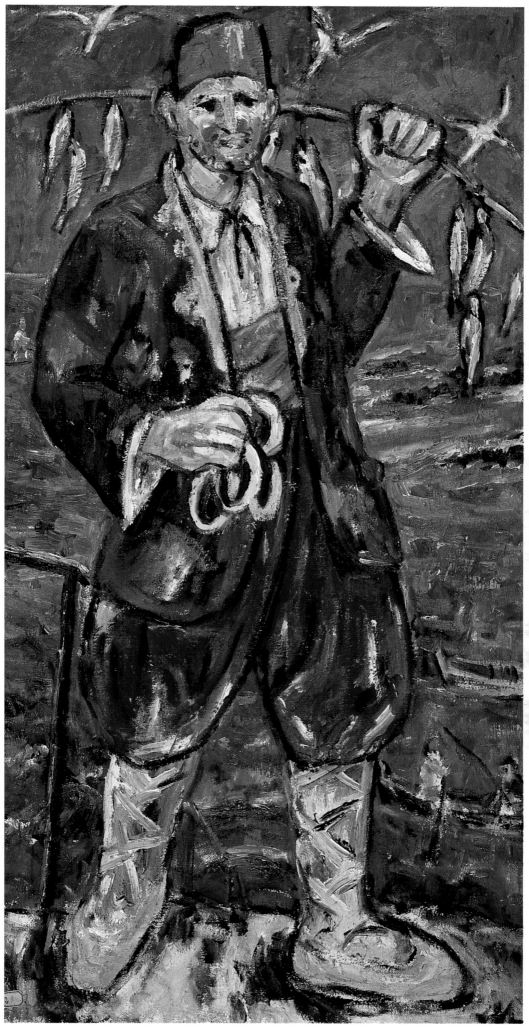

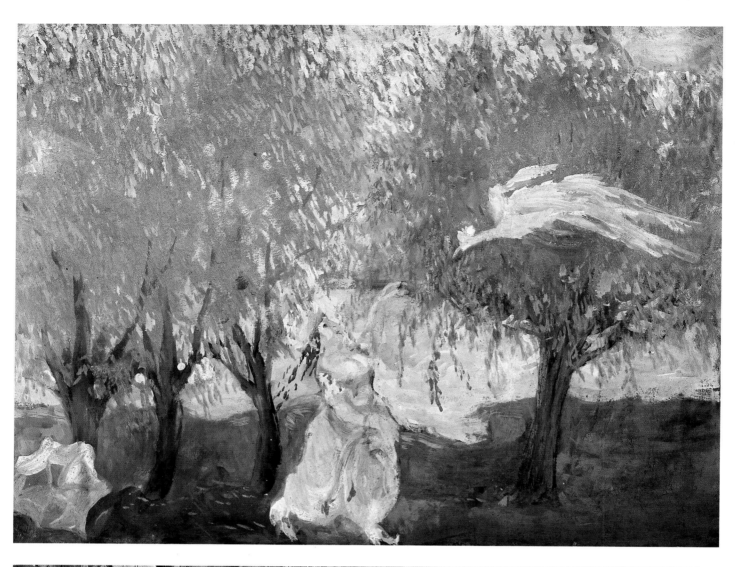

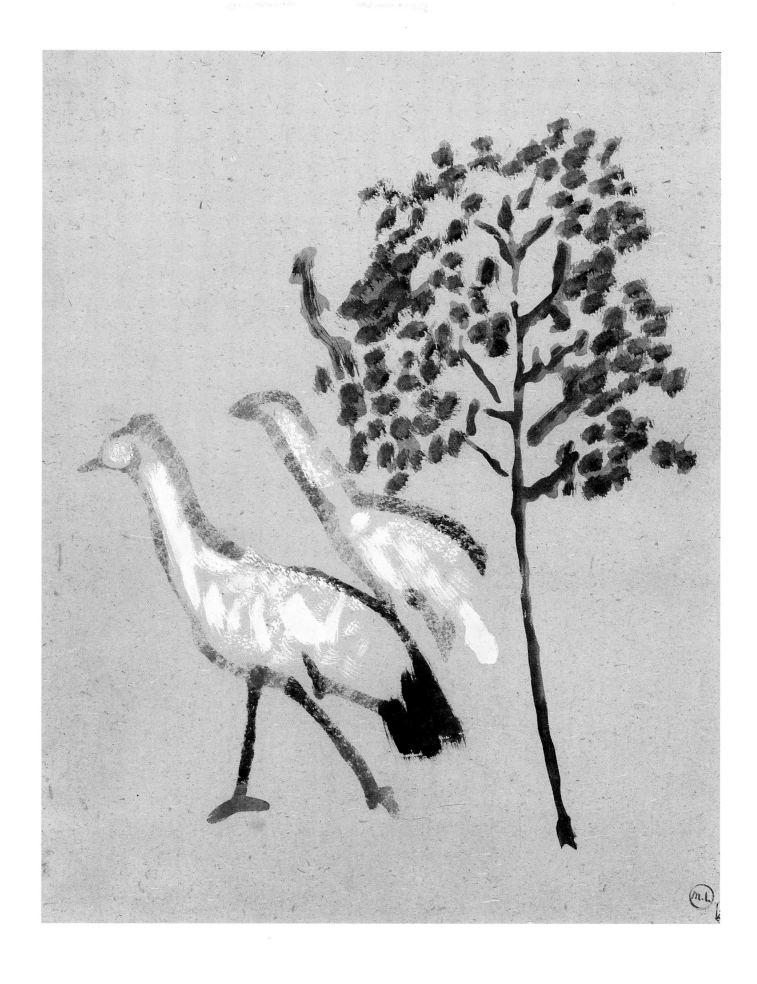

A Woman and a Flamingo. 1898
Illustration for Arabian fairy-tales
Pastel on paper. 13.5 x 21.5 cm
Ya. E. Rubinstein collection, Moscow

Pastoral. A Turkish Idyll. 1911–12
From the series *An Imaginary Journey to Turkey*
Oil and gouache on paper. 67.5 x 98.5 cm
Musée national d'art moderne,
Centre Georges Pompidou, Paris

Peacocks under a Tree. Ca. 1928
Gouache, silk-screen and stencil
on paper. 32.6 x 25 cm
Russian Museum, St Petersburg

73

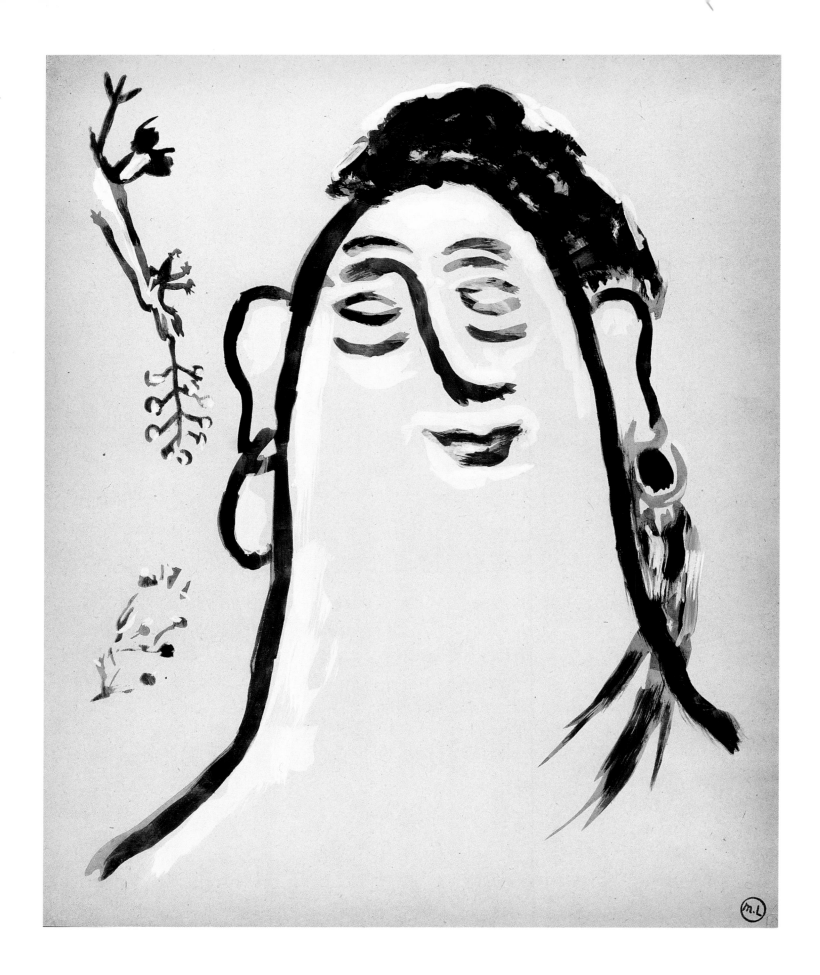

**Female Head and a Bird with a Twig
in ts Beak.** Ca. 1928
From the album *A Journey to Turkey*
Gouache, silk-screen and stencil on paper.
33.1 x 27 cm
Russian Museum, St Petersburg

74

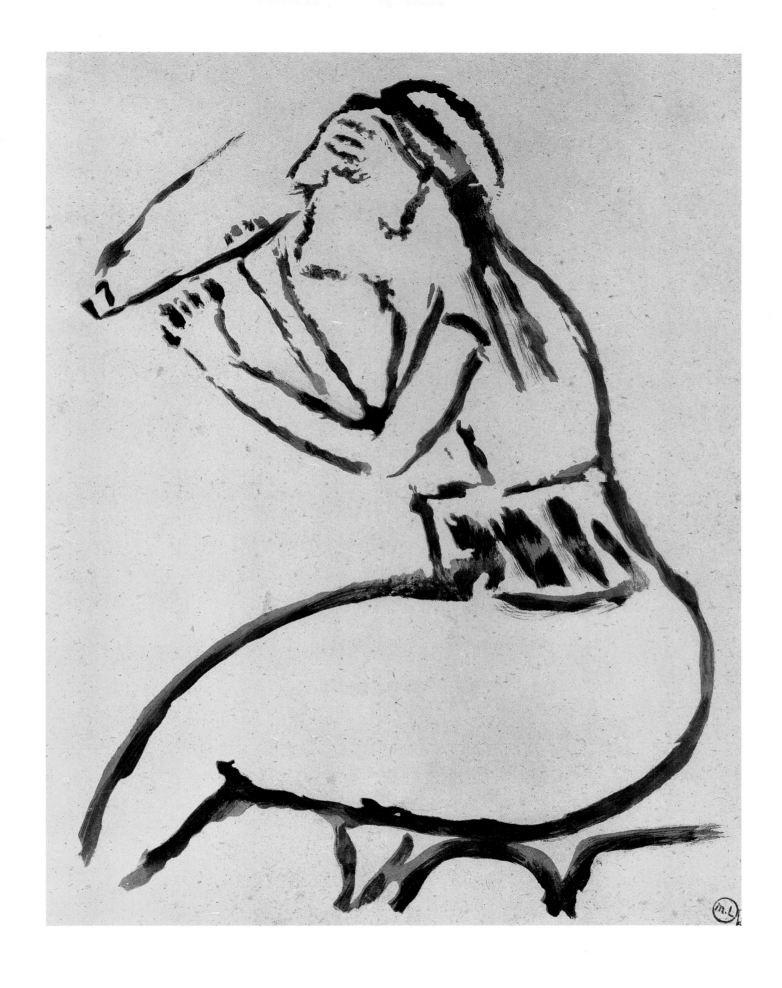

A Turkish Woman with a Pipe. Ca. 1928
Gouache, silk-screen and stencil on paper.
32.5 x 25.3 cm
Russian Museum, St Petersburg

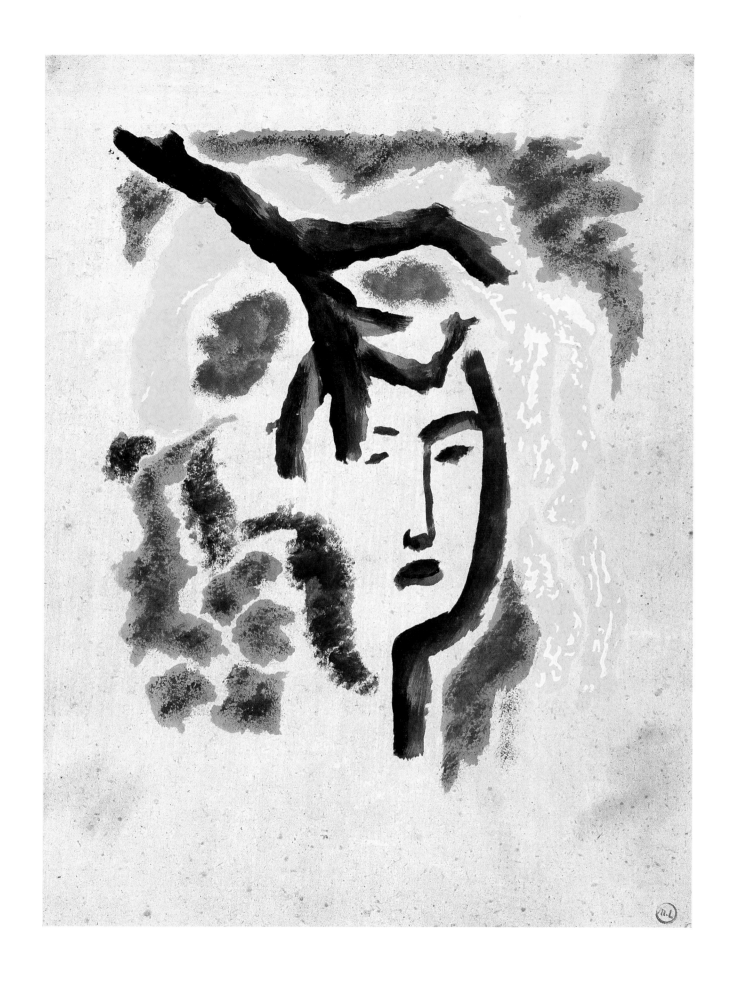

A Female Head and a Branch. Ca. 1928
From the album *A Journey to Turkey*
Gouache, silk-screen and stencil on paper.
41.5 x 29.5 cm
Russian Museum, St Petersburg

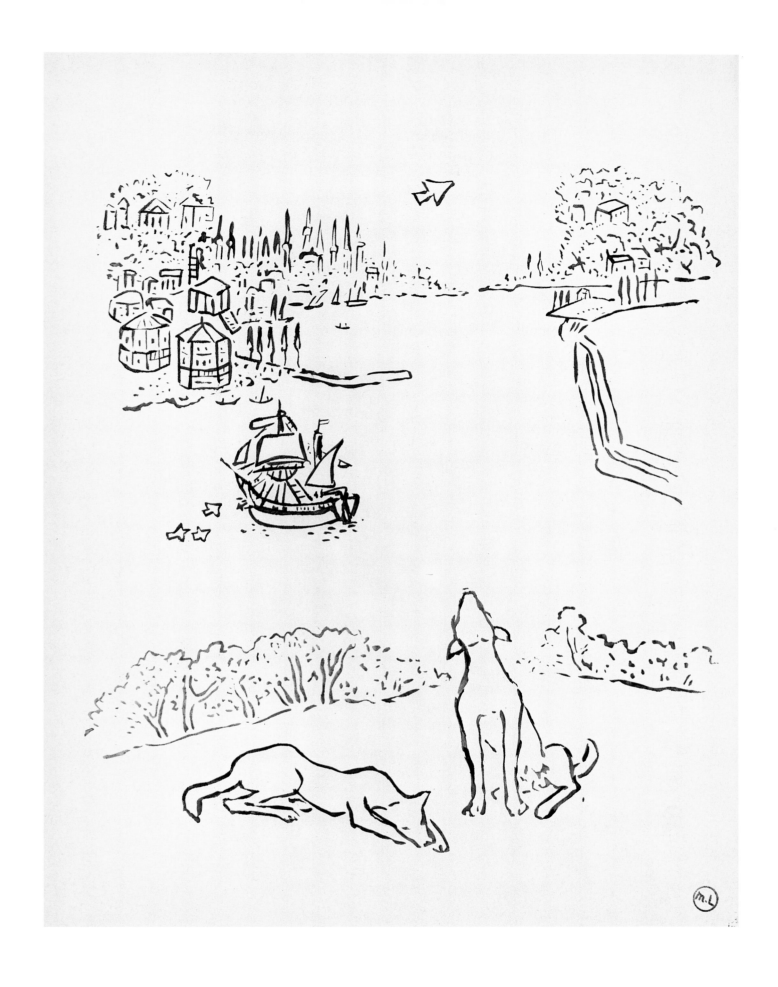

Dogs on the Shore of a Harbour. Ca. 1928
Sheet from the album *A Journey to Turkey*
Gouache, silk-screen and stencil on paper.
32.5 x 25.3 cm
Russian Museum, St Petersburg

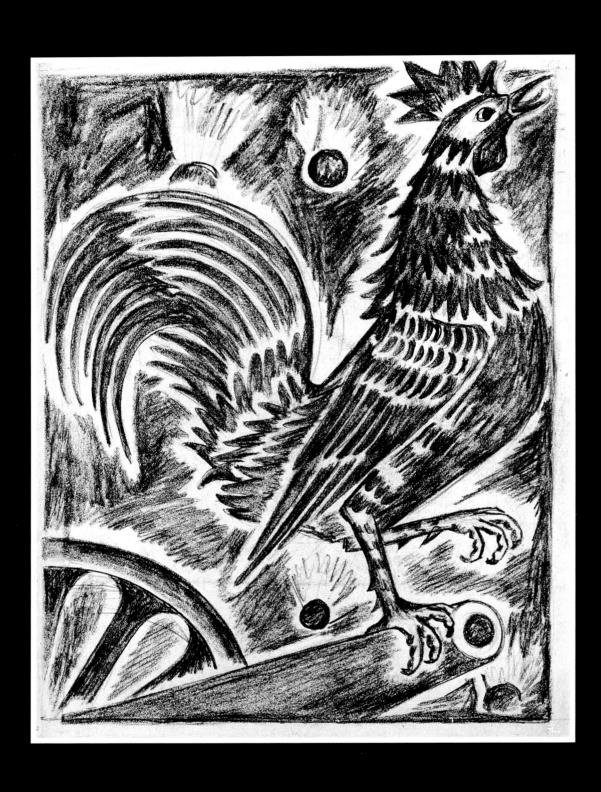

The Lubok Exhibitions

The influence of folk art on the Russian avant-garde manifested itself in various ways: sometimes it can be detected "with the naked eye" as in a number of paintings by Natalia Goncharova, Alexander Shevchenko, Ilya Mashkov or Piotr Konchalovsky; often the effect is less direct as in the work of Mikhail Larionov, or almost totally concealed as in the canvases of Kasimir Malevich, Pavel Filonov or Vladimir Tatlin. In this context it makes sense to stress that the work of these innovators cannot, as is often done, be explained entirely in terms of Cubism or other "isms". It was as traditional as it was innovative, only the set of traditions from which they proceeded was different from that drawn on by their predecessors. It is difficult to imagine Larionov without the urban shop-sign, David Burliuk without the stone images left behind by the Scythians, Goncharova and Malevich without the lubok and icons, while the influence of early Russian frescoes can be felt in Tatlin's creations.

The lubok (popular print) and folk art in general were "discovered" by the artists of the early twentieth century who were the first to find high art in them.

In the nineteenth century the folk picture became familiar to the cultured section of society through

Natalia Goncharova
*A French Cockerel
(A Gallic Cockerel).* 1914. Lithograph

*Alkonost, a Bird of Paradise.
Sirin, a Bird of Paradise.*
Late 18th – early 19th century

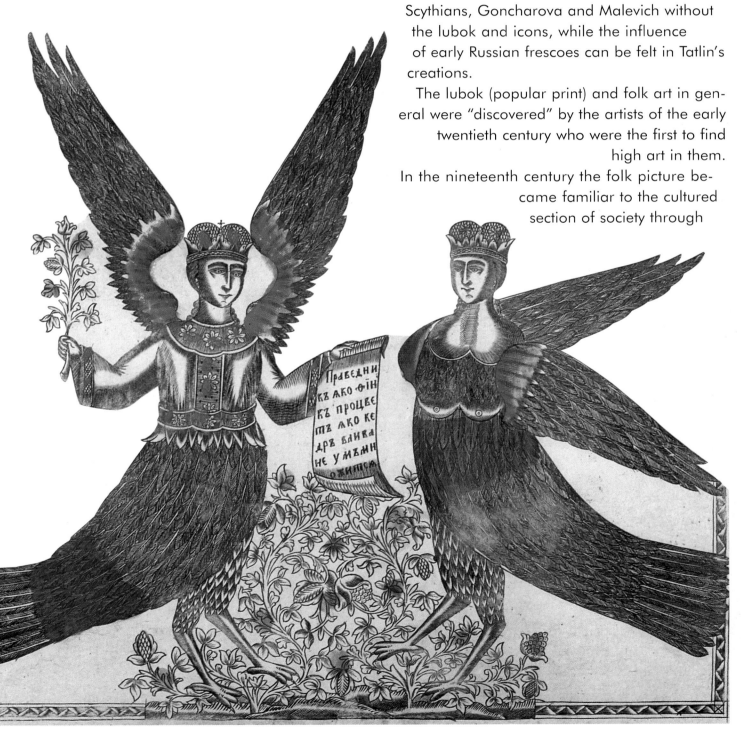

the efforts of such figures as Ivan Snegirev and Dmitry Rovinsky, but it was perceived as a phenomenon belonging to the realm of ethnography, cultural history or folklore studies. It did not occur to anyone to place the lubok on a par with "high art". We find the same blindness towards the lubok and other forms of folk art among artists themselves: neither in academic painting, not in the work of the Itinerants can one find points of contact with the colourful world of the lubok. The painters of the second half of the nineteenth century with their love of the countryside must have seen such images thousands of times in peasant dwellings, but they did not take notice of them: for them the lubok was artistically not on the agenda and, evidently, uninteresting from a painterly viewpoint. There may, of course, have been instances of meetings and coincidences between the lubok and the work of the Itinerants, but they belong only to the sphere of subject matter, ethnography, or the realm of typology. They speak different languages. The nature of the Itinerants' painting and the colourful firework display of the lubok produce an impression of aesthetic incompatibility.

How could that be? Why did Russian professional painting and equally Russian folk art end up in "opposing camps"? It was a long process, considerably accelerated by the reforms of Peter the Great. It comes down to this — on Russian soil there was a clash between two artistic conceptions: the Eastern or Byzantine (in the bosom of which early Russian art developed) and the Western or Renaissance. Without going into details over the differences between them, we note only that in fundamental points these conceptions were poles apart: in their understanding of artistic space and flatness, perspective and the depiction of shape, their sense of colour and its organization within a work.

The art that bore the reflected gleam of the Russo-Byzantine tradition was driven from the cities but lived on in the countryside, in the lubok and the painting of houses and distaffs, in woodcarving, printed cloth and many other forms. It continued to exist openly, but unremarked. By the end of the nineteenth century it seemed that the victorious "scholarly" art had parted from popular creativity completely and irreversibly. But then something unexpected happened to place folk art at the centre of artists' attention. Young painters again acquired an interest in heightened colour, in an intensified expressivity of form and in an understanding of artistic space that was different from the accepted one.

The practical rehabilitation of the lubok and other kinds of folk art is connected, above all, with the activities of Larionov and the artists of his circle. The "overthrowers of tradition" took a concerned, protective attitude towards traditional forms of art. On the eve of the All-Russian Congress of Artists (that took place between 27 December 1911 and 5 January 1912) Goncharova published an announcement in the newspaper Protiv techeniya [Against the Tide]

ВЫСТАВКА
ИКОНОПИСНЫХЪ
ПОДЛИННИКОВЪ
и
ЛУБКОВЪ

Организованная М. Ф. Ларіоновымъ

МОСКВА
Большая Дмитровка, Художественный
Салонъ 11
1913.

Cover of the catalogue
of the exhibition of prototypical icons
and lubok prints (Moscow, 1913)

demanding a ban on the export of icons, lubok prints and other examples of national creativity because "the significance of these works for the future of Russian art is infinitely great. Major, serious art," she stressed, "cannot help but be national. By depriving itself of the achievements of the past, Russian art is cutting away at its own roots."[1]

The artists themselves began to collect pieces of folk art, including lubok prints. Pavel Mansurov recounted Larionov's tale of the "hunt" for popular prints that he and Kandinsky engaged in around the flea-markets of Moscow.

Natalia Goncharova
St Barbara the Martyr. Ca. 1913.
Lithograph

"More than anything he and Kandinsky wandered around the markets and looked for peasant lubok prints. Bova Korolevich and Tsar Saltan, and with them angels and archangels, 'whacked' all over with aniline — it was that, and not Cézanne, that was the source of all beginnings."[2]

This testimony is supplemented by a letter Kandinsky wrote from Munich to Nikolai Kulbin which is now in the archives of the Russian Museum.[3] On 12 December 1911 Kandinsky wrote: "Can I make a personal request to you? I have long dreamt of having a lubok of the Last Judgement, as old and primitive as possible (with a Serpent, devils, high priests and so on). If you come across one like that [in the markets] would you buy it and send it to me?"[4] When he learnt that the lubok would soon reach him, Kandinsky hurriedly put pen to paper: "Dear Nikolai Ivanovich, You delighted me terribly with the news of the lubok prints. My most heartfelt thanks! In this regard I am endlessly greedy: I would be pleased to receive even a bad *Last Judgement*, that is to say the one you already have and which you call bad. And if I get a good one, and a few more from the provinces through the efforts of N. Ye. Dobychina, then my delight will know no bounds. It's true, my heart even starts pounding when I think about it."[5]

In 1912, Kandinsky placed seven reproductions of popular prints in the *Blauer Reiter* almanac devoted to questions of the latest art, thus proclaiming the link between his painterly experiments and Russian folk art. In the same year he opened an exhibition of Russian lubok prints in the Galerie Hans Goltz in Munich, the first exhibition to present the popular print as a true work of art. In Russia the first exhibition of lubok prints (called simply that) was held between 19 and 24 February 1913 in the halls of Moscow's College of Painting, Sculpture and Architecture. It was organized by Mikhail Larionov and Nikolai Vinogradov (1885–1980), then a young architect who collected lubok prints and spicebread moulds. Later Vinogradov was involved in the monumental propaganda campaign. He worked as a stenciller on the ROSTA windows and as a restorer, and organized the Moscow Museum of Architecture. Apart from the Russian section, the exhibition included Oriental prints (from China, Japan, Korea, Buryatia, Persia and Turkey) and also Western European ones. In all 551 items were listed in the catalogue. Larionov included shop-signs and

[1] *Protiv techeniya*, St Petersburg, 1911, No 24
[2] P. A. Mansurov, *Letter to Ye. F. Kovtun*, 28 May 1971. In the recipient's archive
[3] Yevgeny Kovtun published this letter in *Pamyatniki kultury: Novye otkrytiya. Yezhegodnik 1980* [Cultural Monuments: New Discoveries. An Annual for 1980], Leningrad, 1981. Referred to below as *Pamiatniki*
[4] *Pamyatniki*, p. 407
[5] *Pamyatniki*, p. 408

painted trays, bronze castings and wooden sculpture, spicebread boards and even baked dough. In an article accompanying the catalogue he wrote: "This is all the lubok in the broad sense of the word and this is all great art."[1] The greater part of the exhibits belonged to Larionov.
The fate of his collection, numbering several hundred works, remains obscure.

Exactly a month later, on 24 March 1913, Larionov opened an Exhibition of Prototypical Icons and Lubok Prints in premises on Bolshaya Dmitrovka in Moscow. The 596 exhibits included 129 icons and 170 lubok prints from the artist's collection.

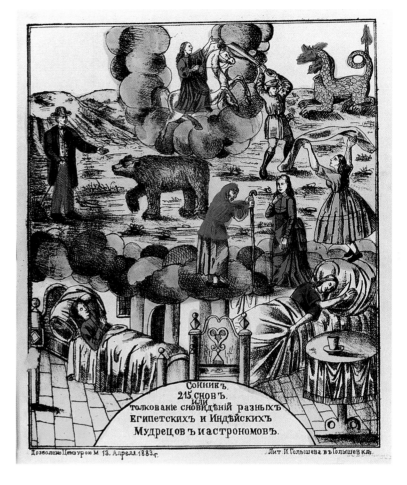

The catalogue again included Larionov's article that had appeared in the catalogue of the First Exhibition of Lubok Prints. Let us examine some of the ideas expressed there. It is preceded by three spoof epigrams, of which Larionov was a great master. Two are from "an unpublished history of art"; the third is attributed to "Razdabai, Chapter 7" (a play on the pseudonym Radda-Bai used by the noted theosophist Helena Blavatsky in her publications). All three imply that the lubok is a timeless form of art. Here is one of them: "In the reign of the Assyrian king Hammurabi an exhibition of nineteenth- and twentieth-century lubok prints was organized. ... They evoked such an uplift in feelings of the order of the arts that time was killed by the timeless and extraspatial."[2] In fact, of course, the lubok is a historical phenomenon, tightly bound up socially and ethnically with time and place. Yet Larionov was correct in his own way, polemically sharpening the idea that art, despite all the chronological changes, remains a single whole due to the timeless visual elements that constitute its foundation. Vladimir Markov termed these elements a "plastic symbol". We cannot penetrate to the ultimate meaning of an Egyptian fresco, yet it remains something aesthetically precious to us. When Yakov Tugendhold saw the "black idols of the Congo" in Picasso's studio, he "asked the artist whether he was interested in the mystical side of those sculptures. 'Not in the least,' he replied. 'I am fascinated by their geometrical simplicity.'"[3]

The popular lubok prints from the second half of the nineteenth century that were displayed at Larionov's exhibitions were tinted in haste, with two or three strokes of the brush, on a production line, as we would say now. The aniline wash spread over the boundaries of the drawing, creating decorative patches.

Researchers regarded this as "carelessness" and "crudity", the inevitable consequence of haste. Larionov was the first to see it as something else — a distinct artistic device.[4] This method was extensively employed by the early-twentieth-century artists in the creation of unique lithographic books.

At Larionov's exhibition Goncharova displayed her attempts to revive the lubok — six watercolour pieces: *The Green Serpent* (a Russian metaphor for alcohol, for the Teetotal Society's tea-shop), *Florus and Laurus*, *St George the Victorious*, two lubok prints on poems by Nekrasov — *Pedlars* and *Market-*

Cover of a book of dream interpretations. 1883. Lubok print

[1] *Vystavka ikonopisnykh podlinnikov i lubkov, organizovannaya M. F. Larionovym* [*The Exhibition of Prototypical Icons and Lubok Prints Organized by M. F. Larionov*], Moscow, 1913, p. 9
[2] *Ibid.*, p. 5
[3] Ya. Tugendhold, "Frantsuzskoye sobraniye S. I. Shchukina" ["The French Collection of S. I. Shchukin"], *Apollon*, No 1, 1914, p. 33
[4] *Vystavka ikonopisnykh podlinnikov i lubkov*, p. 3

Natalia Goncharova
Angels and Aeroplanes. 1914

Gardener, and *St Barbara the Martyr*. Of these only the last is now known and in the Tretyakov Gallery collection. It is a composition in patches (a centre and four "scenes from the life"), original in painterly terms and free of stylization in imitation of the lubok.

Following the lubok, Goncharova did not reject the narrative, which the artists of her circle avoided by all possible means. "Not to fear in painting either literature, or illustration, or any of the other bugbears of the present day, by dint of the rejection of which certain contemporary artists wish to raise the missing painterly interest in their works," Goncharova wrote. "Try, on the contrary, to have all this expressed vividly and definitely by painterly means."[1] The lubok, and folk art generally, helped the artists of the early twentieth century to find themselves and to overcome the barrier separating "scholarly" and popular art.

[1] Introduction to the catalogue of the exhibition of paintings by Natalia Sergeyevna Goncharova. 1900–13, Moscow, 1913, p. 3

ГЛАВАРЬ ОСЛИНАГО ХВОСТА и ОРГАНИЗАТОР "МИШЕНИ", УБІЙ ПРОТИВНИК "БУБНОВАГО ВАЛЕТА".

Artistic Debates

Rech', 26 February 1912

In early 1912 a wholly new form of interaction between artists and public appeared — artistic debates, usually timed to coincide with the opening of an exhibition. The nineteenth century never saw such debates; nor did France in the heat of the argument over Cubism. The Italian Futurists organized public street demonstrations that developed into real battles. However, debates in the manner they took place in Moscow and St Petersburg in the pre-war years were a product of Russian artistic life. Larionov and his group played the most active part in them.

The new Russian art overturned established conceptions about visual creativity. The nineteenth century taught the viewer that the artist would convey on canvas directly and immediately what he saw with his eyes, reproduce life in the forms of life itself. In the paintings of the early twentieth century, the proportion of what one might call the invisible grew; artists painted works from imagination, from intuition. They gave a visible image to things not present in the real-life original, in the visible phenomenon.

The broader public was lost, proving unprepared to take in the new kind of art. To the majority it was incomprehensible. At the Jack of Diamonds debate, one of the opponents, a certain Shatilov, "offered the artist Lentulov the following curious deal: if Lentulov could explain the meaning of his painting *The Patriotic War*, he, Shatilov, was prepared to spend six months in the lock-up."[1]

Caricature on Mikhail Larionov (*Stolichnaya molva* [*Rumours* Going *Around the Capital*], 3 December 1912)

Mikhail Larionov, Natalia Goncharova, Ilya Zdanevich. Photograph (*Argus*, No 12, 1913)

The critics found themselves in the same position, not to mention the newspaper reporters who accompanied the first steps of the Russian avant-garde with constant ridicule. Alexander Benois, the leading authority of the World of Art society and the most influential art critic of the period, took a rigidly negative stance regarding the innovators. Neither did he approve of their interest in folk art: "children's drawings, lubok prints, trays are 'very fine and touching'," he wrote in 1915, "but when such 'wild game' is

stacked up in excessive quantities, and at the same time anything refined, thought out, any 'artifice' is banished, then one begins to feel queasy."[1] Benois gradually abandoned this attitude, but there was in his efforts to acknowledge the new art a sense of compulsion and haughty condescension.

As the new movement grew stronger and began to stand on its own two feet, the tone the young artists employed towards Benois also changed. In 1909 three of them requested Benois: "Dear Alexander Nikolayevich, We have delivered our canvases to the premises of the Union[2] exhibition. We would ask you to do every-thing possible to have the members of the Union association view them and if something proves acceptable to have it displayed at the exhibition. D. D. Burliuk, A. V. Lentulov, V. D. Burliuk."[3] A year later David Burliuk was already writing to Benois in a different manner: "What colossal and barely repairable damage you are doing when you discredit in the eyes of the gullible and trusting public Russian youthful art (calling Yakulov, Larionov and Pavel Kuznetsov 'madmen' and so on). ... At least refrain from pressing matters! Be attentive, be circumspect. ... You will be joining the majority, even among the public! You have the contentment of prosperity. I, perhaps, have the bared teeth of a cornered beast."[4] By 1913 Burliuk was no longer attempting to remonstrate with Benois; their rela-tionship was openly hostile: "A wolf in sheep's clothing, in the clothing of a friend of the New Art. Nobody believes in your sincerity — it's playing to the gallery, it's politics!"[5] ,

When art outstrips the critics, the artists themselves take up the pen. It happened in France at the birth of a new movement in art (Gleizes and Metzinger publishing their manifesto of Cubism in 1912) and the same thing took place in Russia.
Between 1912 and 1915 virtually all the leading exponents of the new art — Kandinsky, Larionov, Shevchenko, Alexander Grishchenko — produced theoretical treatises and manifestos. The artists' public statements explaining their positions were intended to aid the change of criteria in art.
The first such public statements devoted to the new art were two papers presented on 8 December 1911 at the Society of Free Aesthetics where a one-day Larionov exhibition was being held. At the All-Russian Congress of Artists at the very end of December Nikolai Kulbin made a speech justifying the principles of the new art; he also read Kandinsky's paper "On the Spiritual in Art (Painting)". From the members of Larionov's group Sergei Bobrov presented a paper entitled "The Foundations of New Russian Painting". A poet and artist who displayed his canvases at Larionov's exhibitions, Bobrov to a cer-tain extent played the role of theoretician for the group at this time. He noted the decisive significance of popular creativity and the values of early Russian art for the young painters. These first public statements, as one of the critics wrote, "laid the basis for all the debates and lectures on the theme of new art."[6]

The two Jack of Diamonds debates took place one after the other in February 1912 in the hall of Moscow's Polytechnical Museum. The first was held on 12 February. The hall could ac-commodate 1,000 people, but there were more who wanted to get in. Benedict Livshitz recalled: "Long before the start of the debate the 'sold out' sign was hanging in the ticket office, but those, mainly students, who had not managed to get hold of tickets

[1] Alexander Benois, "Trudno li?" ["Is It Difficult?"], Rech', 12 April 1915
[2] The Union of Russian Artists
[3] Letter of 18 February 1909, MSS Dept., Russian Museum, fund 137, item 767
[4] D. D. Burliuk, Letter to A. N. Benois, 3 March 1910, MSS Dept., Russian Museum, fund 137, item 766, folio 2
[5] D. D. Burliuk, Galdyashchiye "Benois" i novoye russkoye natsional'noye iskusstvo (Razgovor g. Burliuka, g. Benois i g. Repina ob iskusstve) [The Benois Hullabaloo and the New Russian National Art (A Conversation on Art Between Messrs. Burliuk, Benois and Repin)], St Petersburg, 1913, p. 12
[6] Osliny khvost i Mishen': Sbornik, p. 33

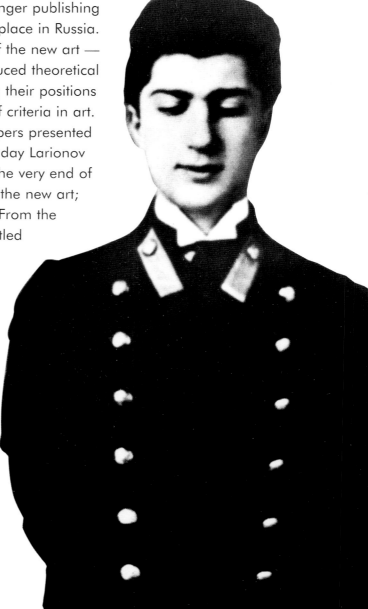

Ilya Zdanevich. Photograph. 1911

were determined not to disperse, so that a special police detachment had to be called in to establish order."[1]

Piotr Konchalovsky chaired the debate and the official opponent to the motion was Maximilian Voloshin. Kulbin presented a paper entitled "The New Art as the Basis of Life"; David Burliuk spoke on Cubism. The debate took place at a moment when a tense, almost hostile relationship had developed between two Moscow-based groupings — the Jack of Diamonds and Larionov's Donkey's Tail. While speaking of new Russian art Burliuk showed slides of two paintings by

Ilya Zdanevich and Mikhail Larionov. Photograph (*Argus*, No 12, 1913)

Goncharova. After his speech, Goncharova herself took the floor. "A slender woman in black appeared [at the lectern]. Hair combed smoothly back, a burning look and sharp, angular movements made her resemble the ecstatic female Social Revolutionaries who in 1905 exhorted us from university auditoria to hurl ourselves beneath the hooves of the Cossacks' horses".[2] She declared that the speaker should not have shown her paintings since she belonged to another group, the Donkey's Tail. "This name provoked Homeric laughter, almost hooting, among the audience. Goncharova responded in a restrained, reproachful manner: 'Don't laugh at the name. When there's an exhibition you can laugh, but it's not right to laugh at the title.' And there was something in her tone that made the public serious."[3] After Goncharova, Larionov spoke, expressing criticism of the Jack of Diamonds, contrasting it with the Donkey's Tail. The hall grew noisy. Konchalovsky tried to stop the speaker: "Larionov, all pale, pounded the rostrum, breaking something in it and shouted: 'Damn it, let me speak!' The volume of noise doubled and as a result Larionov, who had long resisted, exclaimed: 'The French are great. The Jacks of Diamonds are imitators of them and me!' and quit the cracked rostrum."[4]

The debate marked the total breach between the Jack of Diamonds and the Donkey's Tail, the two most important groupings in the Russian avant-garde. Now, looking back over the intervening decades, it is hard to understand the ardour and furious intolerance of the speakers. After all, two years before this same Larionov had been one of the organizers of the first Jack of Diamonds exhibition.

[1] Benedict Livshitz, *Polutoraglazy strelets* [*The Marksman with One and a Half Eyes*], Leningrad, 1933, p. 74
[2] *Ibid.*
[3] B. Sh. [B. Shuisky] "The Artistic Debate", *Protiv techeniya*, 18 February 1912
[4] *Ibid.*

Both camps were linked by a lively interest in Russian folk art as the foundation of their own work. But this was the "incubation period" of the Russian avant-garde which was developing at a rapid pace and choosing points of orientation for its advance. Divergence and demarcation were inevitable and it was the more vehement, the smaller the original differences. The same hindsight makes it understandable why Larionov, Malevich and Tatlin ended up in the Donkey's Tail camp. The Jack of Diamonds, time would show, stopped at the stage of initial Cubism and Cézannism. Larionov's group strove to overcome the French influence and it is above all in the work of its members that Russian art began to go beyond the bounds of Cubism. As early as 1912 Larionov created his first Rayonist works; in his wake Malevich and Tatlin embarked on the course of Suprematism and Constructivism. Behind Larionov's furious polemics there was an early hint of a different line of development for Russian painting, distinct from the Jack of Diamonds. The hidden build-up of new tendencies on the very point of bursting to the surface explains the savagery of the clashes in these debates.

Mikhail le Dantu. Photograph
(*Argus*, No 12, 1913)

Natalia Goncharova. Photograph
(*Argus*, No 12, 1913)

Following Moscow, a series of debates was also held in St Petersburg. Two evenings, of 23 and 24 March 1913, were devoted to issues of the latest painting and literature. The debates were organized by the Union of Youth and took place in the Trinity Theatre. Mayakovsky, Kruchenykh and the Burliuks took part in the literary debate.

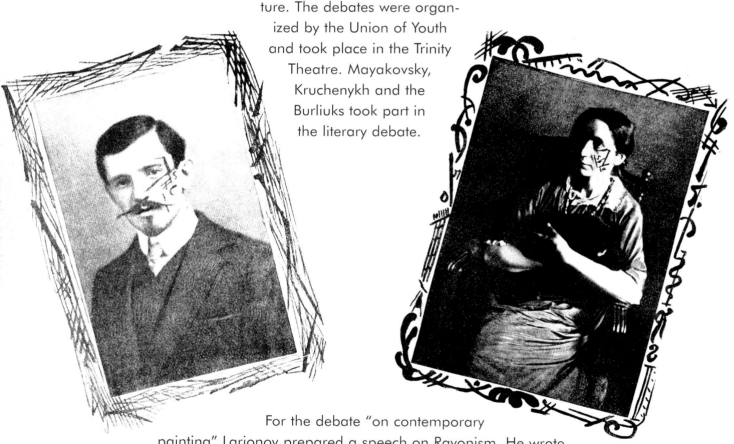

For the debate "on contemporary painting" Larionov prepared a speech on Rayonism. He wrote to Mikhail Matiushin: "I shall read the lecture myself or someone will read it for me. I shall write it out in full and bring it. There are no points in common with D. D. Burliuk, because what David Davidovich said is not included and Rayonism is a wholly new phenomenon that as yet belongs exclusively to me."[1] Larionov's speech was not, however, given.

Matiushin chaired the debate. David Burliuk presented a paper on "The Art of the Innovators and Academic Art in the Nineteenth and Twentieth Centuries". Malevich's speech, devoted to the Jack of Diamonds irritated the audience. Demonstrating portraits in the Itinerant manner, the artist sought to prove that Realism and

[1] M. F. Larionov, "Letter of 8 February 1913 to M. V. Matiushin", *Yezhegodnik rukopisnogo otdela Pushkinskogo doma na 1974 god* [*Annual of the Manuscript Department of the Pushkin House for 1974*], Leningrad, 1976, p. 15

photography were one and the same thing. "With the words 'This is what Serov does', Malevich projects on the screen an ordinary picture from the fashion magazine *Woman in Hat and Coat*. A row broke out and an interval had to be announced. But even then they didn't let Malevich have his say."[1]

One and the same motif repeated itself at the debates: someone in the audience said of the Cubo-Futurists' paintings "My little Petya can draw better!"

Olga Matiushina, who sold Futurist literature at the debate in the Trinity Theatre, related a typical episode:

"Malevich came up to the table.

When he saw me, he said

hello and

**The Futurists' Manifesto
"Why We Paint Ourselves"**
(*Argus*, No 12, 1913)

Почему мы раскрашива=емся

МАНИФЕСТЪ ФУТУРИСТОВЪ.

Очеркъ для «Аргуса» Михаила Ларіонова и Ильи Зданевича.

Чрезвычайности, которыми столь богаты наши дни, заслуживаютъ на нашъ взглядъ не только отрицательнаго отношенія, но и вниманія. Дѣвая богатый психологическій матеріалъ, онѣ не всегда бываютъ только чрезвычайностями, но содержатъ подчасъ цѣнныя положенія и мысли. Помѣщая статью г.г. Зданевича и Ларіонова, проповѣдниковъ новой раскраски лица, причемъ второй является ея творцомъ, редакція «Аргуса» руководилась только желаніемъ дать возможность широкой публикѣ познакомиться съ ихъ идеологіей и убѣжденіями.

asked me something. The public recognized him.

"'Are these your drawings?' a long-haired, bad-tempered man asked provocatively, stabbing his finger at a book of Malevich's drawings.

"'They're mine.'

"'Can you draw anything else, apart from these daubs?'

"'I can,' Malevich replied laughing.

"'Will you draw a real landscape?'

"'Come with me and we'll paint together. On one condition though — if my landscape is better, you paint this way for me.' Malevich pointed to his drawing.

"'I don't bother with nonsense.'

"'This nonsense requires a high standard of ability as a painter...' Malevich began, but his opponent had already got up from the table and gone off into the crowd.

[1] M. V. Matiushin, "Russkiye kubofuturisty" ["The Russian Cubo-Futurists"], *K istorii russkogo avangarda* [*On the History of the Russian Avant-Garde*], Stockholm, 1976, p. 148

"'Well, are we going to paint that landscape?' Malevich called after him, but the long-haired man was already a good way off. The crowd burst out laughing and whistled after him."[1]

The culmination of the public declarations by Larionov's group was the Target debate that took place on 23 March 1913, the eve of the opening of the exhibition of the same name, in the Polytechnical Museum. The debate had as its theme "The East, Nationality and the West". A leaflet-*cum*-programme was produced indicating who would speak and on what subject: "1. Futurism. 2. Rayonism. 3. Nationalism against Westernism. 4. Against the European theatre. 5. The music and rhythm of the theatre of the future. 6. Futurism and Rayonism in the dynamic theatre. The theses will be presented by Arkhangelsky, N. Goncharova, Ilya Zdanevich, Mikhail Larionov, Mikhail Tomashevsky and Alexander Shevchenko. Tickets from 5 roubles 10 kopecks."[2]

The hero of the debate turned out to be the young poet and critic Ilya Zdanevich, a new, vivid personality in Larionov's milieu. Let us briefly examine Zdanevich's biography and his role in Larionov's circle.

In 1911 the Zdanevich brothers left Tiflis for St Petersburg — Kirill to enter the Academy of Arts, Ilya the university. While in Moscow on their way, they met

[1] O. Matiushina, "O Vladimire Mayakovskom" ["Regarding Vladimir Mayakovsky"], *Mayakovskomu: Sbornik vospominanii i statei*, Leningrad, 1940, p. 26
[2] I. M. Zdanevich, *Letter to his mother* V. K. Zdanevich, 20 March 1913, MSS Dept., Russian Museum, fund 177, item 50, folio 16

The Futurists' Manifesto "Why We Paint Ourselves". 1913

Изступленному городу дуговыхъ лампъ, обрызганнымъ тѣлами улицамъ, жмущимся домамъ — мы принесли раскрашенное лицо: стартъ данъ и дорожка ждетъ бѣгуновъ.

Созидатели, мы пришли не разрушить строительство, но прославить и утвердить. Наша раскраска ни вздорная выдумка, ни возвратъ—неразрывно связана она со складомъ нашей жизни и нашего ремесла.

Заревая пѣснь о человѣкѣ, какъ горнистъ передъ боемъ, призываетъ она къ побѣдамъ надъ зем-

лей, лицемѣрно притаившейся подъ колесами до часа отмщенія, и спавшія орудія проснулись и плюютъ на врага.

Обновленная жизнь требуетъ новой общественности и новаго проповѣдничества.

Наша раскраска—первая рѣчь, нашедшая невѣдомыя истины. И пожары, учиненные ею, говорятъ, что прислужники земли не теряютъ надежды спасти старыя гнѣзда, собрали всѣ силы на защиту воротъ, столпились, зная, что съ первымъ забитымъ мячомъ мы — побѣдители.

Лѣвая щека. Изображенъ знакъ, ставящійся на домахъ, для счета ихъ, — знакъ этотъ знаменуетъ связь человѣка съ городскима строительствомъ.

Правая щека. Слово „идеа" и цифра, означающая связь человѣка съ городскимъ строительствомъ.

Larionov and Goncharova. Through Kirill's being a student at the Academy of Arts, Ilya Zdanevich became acquainted with Le Dantu. Later he became friendly with Vera Yermolayeva and Nikolai Lapshin. Despite the fact that Ilya entered the law faculty of the university and even graduated from it (in 1917), all his thoughts were on poetry. His work on the word and speech-sounds led to the creation of a transrationality in comparison with which even Alexei Kruchenykh's texts seem comprehensible.

Larionov immediately appreciated Ilya Zdanevich's polemical talents. He became an irreplaceable member of Larionov's circle — a critic, polemicist and extremist who took any idea to the point of utmost expression and paradox. His contributions to the debates were always accompanied by noisy scandals, ending at times with the police being called in.

At the Target debate only Alexander Shevchenko was able to present his paper. The following speech, Ilya Zdanevich on Marinetti's Futurism, upset the apple-cart. Larionov, who was in the chair, lost control and the course of the debate became unpredictable, ending in a tremendous brawl. The electrified audience exploded when Zdanevich showed the Venus of Milo on the screen and, waving a factory-made boot above his head, declared that "The modern boot is more beautiful than the Venus of Milo." The public rushed at the stage and engaged the speakers in fisticuffs. An extract from Zdanevich's letter gives an idea of the raging elements: "A dark youth springs up on the stage and waving his hands about shouts 'Bash the Futurists!' He is pushed back and the public, imagining he is a Futurist, gives him a beating. ... I didn't have time to fling the lectern (later we had to pay about twenty-five roubles for it), before the arms of a police-officer grabbed me by the shoulders and pushed me off the stage. Because of that I didn't see Goncharova's performance. Larionov and the others had already been dragged over where I was. They began making out a report. ... We still don't know what the consequences will be. Larionov might go to prison."[1]

This outcome of the debate suited both Zdanevich and Larionov, however, as it attracted attention to the exhibition due to open the next day. "I am happy with the scandal," Ilya Zdanevich wrote, "because it is the necessary advertising."[2] Zdanevich's "boot" that inflamed the audience was more than just a means of shocking the public. In Zdanevich's Futurism one detects the strong accent of utilitarianism, but on a different ideological and aesthetic level. Adherents of this doctrine had contrasted beauty with utility, replaced beauty with utility. Zdanevich's incisive criticism was directed elsewhere: he did not reject beauty, nor replace it with utility. He wanted to show that any modern article, if it is constructive, if its structure corresponds to its purpose, in other words, if its shape is constructively justified, then it can be, even should be beautiful. Zdanevich's shocking slogans anticipated the development of the Constructivist aesthetics, the position of Vladimir Tatlin and the French Purists who held that functionality engenders beauty.

Zdanevich's boot was an argument against aesthetics passéism, against Graeco-Roman partialities that prevented people finding beauty in the modern world. Zdanevich's "boot" is a parallel to Larionov's canvases, his "low" genres inspired by soldiers' and other "visual graffiti". The same "degrading" aesthetics, right down to the "boot", can be found in the poetry of Kruchenykh and Khlebnikov who jointly declared: "Writing or reading must come hard, even more awkward than boots or a lorry in the drawing-room."[3]

[1] Ibid., folios 19v–20
[2] Ibid., folio 21v
[3] A. Kruchenykh, V. Khlebnikov, Slovo kak takovoye [The Word as Such], Moscow, 1913

In 1913 and 1914 the Russian Futurists, artists and poets, carried out their own kind of street demonstrations with the aim of enraging people and so attracting attention to their activities. Malevich and other artists appeared on Kuznetsky Most, one of the central streets of Moscow, with wooden spoons in the button-holes of their suits. A reporter wrote: "The Futurists created a tremendous scandal at a Jack of Diamonds lecture in Moscow. Two of them, Malevich and Morgunov, appeared in the doorway with wooden spoons on their lapels."[1]

Larionov and his group took a different course, stirring up the public by painting their faces. "The free-and-easy innovators in the realm of painting have again provided rich food for conversation in Moscow," the newspaper *Russkiye vedomosti* wrote. "For several days now people in Moscow have been commenting on the strange prank by Larionov and the handful of young individuals who have gathered about him: they appear on the streets with painted faced, with some sort of gaily coloured stars on their cheeks."[2]

The magazine *Argus* published a manifesto "Why We Paint Ourselves" by Zdanevich and Larionov together with photographs of Goncharova, Larionov, Zdanevich and Le Dantu with painted faces.

Larionov and his fellows were tapping into an old tradition. In *The History of Art* [*Istoriya iskusstva*] Piotr Gnedich wrote of seventeenth-century France: "The ladies painted their lips, cheeks, eyebrows, shoulders, ears and hands" and reproduced a 1658 drawing showing stars, a crescent moon and a carriage on someone's face.[3] But Zdanevich and Larionov cited other motives for painting faces, not restricted to beautification. "City-dwellers have long made their nails pink, outlined their eyes, painted their lips and cheeks, and dyed their hair — but they all imitate the earth. We creators are not concerned with the earth; our lines and colours appeared with us. ... To the frenzied city of arc lamps, streets spattered with bodies, and huddled houses we bring something that is not of the past: unexpected flowers have come up in the orangery and they tease."[4]

What was the difference between the Futurist's face-art and the tattoos of primitive peoples? The authors of the manifesto declared: "Tattooing is done once and for all. We on the other hand paint ourselves up for an hour and a change of emotions evokes a change of design. ... Tattooing is beautiful, but it speaks of a little — only of the tribe and great deeds. Our face-art though is a news-boy."[5]

Larionov and Zdanevich considered face-art a direct continuation of art in life: "After artists' long isolation we called out loudly to life and life came crashing into art. Now it is time for art to come crashing into life. The painting of faces is the beginning of the invasion. ... Art is not only a monarch, but also a news-boy and a decorator. We value both the typeface and the news. The synthesis of the decorative and the illustrative is the basis of our face-art. We colour life and preach — that is why we paint ourselves."[6]

Ilya Zdanevich
Painting a Face. Cover. 1913

Poster for the "Target" debate. 1913. Detail

Новая Большая Аудиторія Политехнич. Музея.

Суббота, 23 марта
ДИСПУТЪ „МИШЕНЬ"
НА ТЕМУ
„ВОСТОКЪ, НАЦІОНАЛЬНОСТЬ и ЗАПАДЪ".
Музыка. ❋ Театръ. ❋ Живопись.
ПРОГРАММА.
— I. —
1. „ФУТУРИЗМЪ МАРИНЕТТИ".
Докладчикъ И. М. Зданевичъ.
2. „ЛУЧИЗМЪ ЛАРІОНОВА".
Докладчикъ М. Ф. Ларіоновъ.

Вступленіе. Разница въ стиляхъ благодаря времени. Природа не существуетъ, есть только взгляды на нее художника и черезъ него эпохи. Копій въ искусствѣ нѣтъ. Перемѣщеніе плоскостей для большей конструкціи въ предѣлахъ картинной плоскости. Кубизмъ, какъ выявленіе третьяго измѣренія и какъ движеніе плоскости. Нанесеніе формъ въ моментъ ихъ созиданія. Параллельное кубизму движеніе-сферизмъ. Футуризмъ, какъ ученіе о движеніи (динамика). Картина съ разныхъ точекъ зрѣнія. Художникъ въ центрѣ картины. Просвѣчиваемость предметовъ. Писаніе того, что знаешь, но не видишь. Фактура не какъ манера или характеръ поверхности, а какъ способъ воспроизведенія извѣстнаго состоянія картинной плоскости т. е. тембръ живописи. Посткубизмъ. Неофутуризмъ Персидское искусство. Анри Руссо первый, не придавшій значенія фабулѣ введшій ее въ живописную форму. Лучизмъ. Ученіе о излучаемости. Излученіе отраженнаго свѣта (цвѣтная пыль). Рефлективность. Лучизмъ реалистическій, изображающій существующія формы. Отрицаніе формъ въ живописи, какъ существующихъ помимо изображенія въ глазу. Условное изображеніе луча линіей. Стираніе границъ между тѣмъ, что называется картинной плоскостью и натурой. Начатки лучизма въ предшествующихъ искусствахъ. Ученіе о творчествѣ новыхъ формъ. Форма пространственная, форма, возникающая отъ пересѣченія лучей различныхъ предметовъ, выдѣленная волею художника. Передача ощущеній безконечнаго и внѣвременнаго. Красочное построеніе по законамъ живописи (т. е. фактуры и цвѣта). Естественное паденіе всего предшествовавшаго искусства, какъ дѣлающагося благодаря лучистымъ формамъ, такъ же, какъ и жизнь, только объектомъ для наблюденія художника.

[1] "Dereviannye lozhki" ["Wooden Spoons"], *Siniy zhurnal*, 1914, No 10
[2] "Novoye chudachestvo" ["A New Form of Eccentricity"], *Russkiye vedomosti*, 18 September 1913
[3] P. Gnedich, *Istoriya iskusstva*, vol. 3, St Petersburg, 1897, p. 193
[4] "Pochemu my raskrashivayemsia", *Argus*, 1913, No 12, p. 116
[5] *Ibid.*, p. 118
[6] *Ibid.*, p. 115

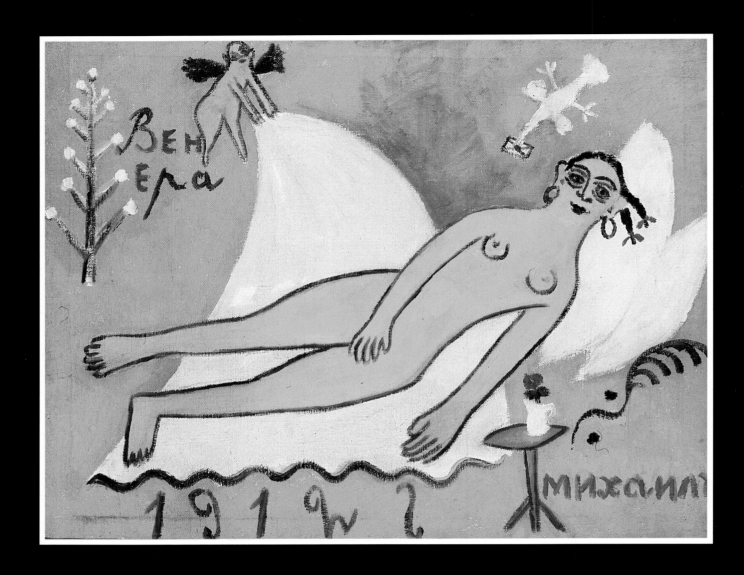

The Target Exhibition

[1] I. M. Zdanevich, *Round and about the Art of M. Le Dantu*, 1918, MSS Dept., Russian Museum, fund 177, item 37, folio 5
[2] M. V. Matiushin, "Russkiye kubofuturisty", p. 155
[3] A. Gleizes, J. Metzinger, *Du Cubisme*, Russian translation, St Petersburg, 1912, p. 14

The Target exhibition opened on 24 March 1913 in the exhibition halls of the Moscow College of Painting, Sculpture and Architecture. After the scandalous debate the public came in droves. Five years later Ilya Zdanevich said that this exhibition "decided the fate of Russian Futurism.[1] The Target proved the highpoint of the artistic movement that Larionov led. Matiushin observed: "The culminating period of Cubo-Futurism came in 1913, after that it was already losing its edge."[2] The more or less united movement soon began to flow into different channels.

Natalia Goncharova exhibited a number of Primitivist canvases, the Futurist *Factory*, and several Rayonist works, that included *A Cat (Rayonist), black with yellow and pink*. The Target, like Goncharova's one-woman exhibition that took place the next month, drew the balance of the artist's furiously tense work. She would continue to work for several decades, but all her substantial contribution to the Russian avant-garde had been made by 1913. Malevich, who displayed eight works at the Target, had by contrast everything before him. From the turn of the 1910s Malevich's work had been a sort of "experimental proving-ground" in which the art of painting tested and sharpened its new possibilities. *Woman with Buckets*, *Peasant Women in the Field (New Russian Style)* and *Portrait of Ivan Vasilyevich Kliunkov* were paintings that foreshadowed radical changes; they are "heavy with" Suprematism. The role of geometrization has grown and locally coloured surfaces have appeared. Non-objectivity is ripening in these works. Gleizes and Metzinger when affirming the principles of Cubism stopped short of that: "We acknowledge, however, that a certain reminder of actual forms should not be entirely eliminated, at least not at the present time."[3] The painting that Malevich exhibited at the Target was getting ready to overstep that mark.

Le Dantu made a brilliant display. Unjustly forgotten today, he was probably the most talented painter among Larionov's associates. His *Sazandar*, *In Happy Ossetia* and other works created under the impression of a trip to the Caucasus have a distinctive plasticity of forms that is far removed from Larionov's experiments. Some principle of crystallization determines the structure of his canvases. Le Dantu's painting is concentrated and restrained, constructive. Its forms tend towards monumentality.

Mikhail Vasilyevich Le Dantu (1891–1917) came from a family that had already made its mark in Russian history when the young French-born Camilla Le Dantu followed her Decembrist husband to Siberia in the 1820s. Expelled from the Academy of Arts at the same time as Kirill Zdanevich, Le Dantu studied in Mikhail Bernstein's private studio. There he met Vladimir Tatlin and made friends with Vera Yermolayeva and Nikolai Lapshin. In 1911 he displayed a few works for the first time at the Union of Youth exhibition and was involved as artist in a production of the folk drama *Tsar Maxemyan and his Unruly Son Adolf*, that revived the tradition of popular farce.

Venus (Venus and Mikhail). 1912
Oil on canvas. 68 x 85.5 cm
Russian Museum, St Petersburg

Cover of the catalogue of the Donkey's Tail and Target exhibition (Moscow, 1913).

ОСЛИНЫЙ ХВОСТЪ
И
МИШЕНЬ

МОСКВА
1913

It was, however, Larionov with his profound interest in painterly technique and questions of colour that became the chief centre of gravity for the young artist. Le Dantu, in turn, attracted the attention of Larionov's group as a first-rate artist. Larionov acquired his works, exchanging paintings with him, following his successes not only with interest, but even with a certain envy.

Ilya Zdanevich subtly defined the difference between the points of departure of Larionov and Le Dantu. He divided the innovative artists into two "races". One of them, the elder, such figures as Marinetti and Larionov, "ripened" on old soil and "having grown into it, first began the mutiny." The others were free from the old soil and roots, they "came from afar, from the side, when the mutiny had already broken out. ... But they came pure as a glacier lake, hard as the granite that surrounds it, and embarrassed the mutineers. ... Mikhail Le Dantu was an artist of the second race."[1] Zdanevich went on: "The antagonism between them is particularly important for an understanding of the course taken by art in recent years. Here is Mikhail Larionov, a major artist of the first race, whose roots are laid deep in the Itinerant movement. In revolt, he does not leave that soil, like a captain staying at the helm. 'We are Itinerants,' he admitted to the late Kulbin in response to reproaches."[2] In letters to friends Le Dantu expressed many profound thoughts about art and its future. He predicted radical shifts in the very concept of the nature of art that had particularly come to a head in Russian painting. Cubism and Picasso were for him not the beginning of something new, but the conclusion of the old Ingres tradition: "It is a profound error to consider Picasso a beginning — he is, rather, a culmination, and it is probably impossible to follow his path."[3] That is why in 1914 he resolved, together with a few companions, to form his own artistic association.[4] But the war put an end to everything. Le Dantu went off to the front as a volunteer and commanded an infantry regiment. On 25 July 1917 he was killed near the town of Proskurov in the western Ukraine.

Zdanevich gives us a glimpse of an unknown page in the history of Larionov's group, indicating the need for a deeper analysis of the processes taking place within the Russian avant-garde movement.

The Target exhibition was the first where the works of self-taught artists were displayed alongside those of professionals. The public was introduced to the art of Niko Pirosmani. Ilya Zdanevich sent three of his works: *Deer*, *Still Life* and the portrait of himself (Zdanevich); Le Dantu added the now celebrated *Girl with a Mug of Beer*. There were also paintings by two Muscovite non-professional artists.

[1] I. M. Zdanevich, *Round and about the Art of M. Le Dantu*, folio 2
[2] *Ibid.*, folio 4
[3] M. V. Le Dantu, *Letter to O. N. Liashkova*, 1917, MSS Dept., Russian Museum, fund 135, item 3, folio 2. (Le Dantu was not alone in such an assessment of Picasso's role)
[4] *Ibid.*, folio 6

Niko Pirosmani
A Beauty from Ortachaly. Diptych

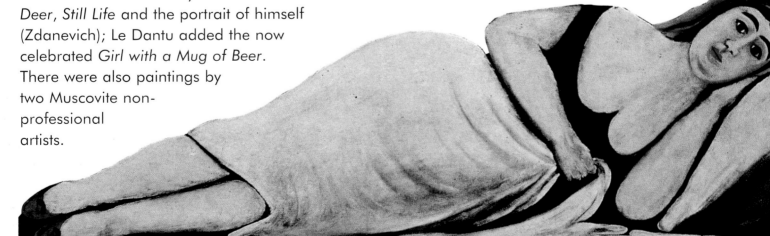

[1] Ya. Tugendhold, "Moskovskiye vystavki" ["Moscow Exhibitions"], *Apollon*, No 4, 1913, p. 58. Nikolai Kliuyev, a peasant by origin, was a well-known Russian poet

One of them, Timofei Bogomazov, was a sergeant major in the Moscow garrison; the other was G. Pavliuchenko, a former miner, latterly a shop-assistant in one of the places selling colonial goods. Sadly we can say nothing about their works: they have disappeared and we know only what is written in the catalogue. Larionov included in the display a few signs produced by the Moscow sign-painters' guild (*artel*). With this move he affirmed for the first time in practice the artistic value of the work of self-taught artists and its

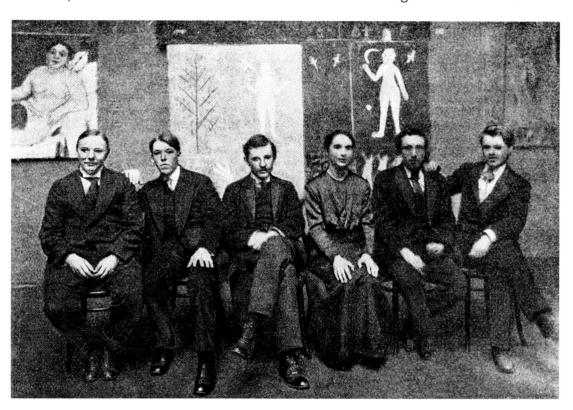

Mikhail Larionov, Maurice Fabbri, Mikhail Le Dantu, Natalia Goncharova, Vladimir Obolensky and Sergei Romanovich at the opening of the Target exhibition. Photograph. 1913

equal aesthetic rights with "scholarly" art. Larionov was very keen to discover his own, Russian Pirosmani. Yakov Tugendhold wrote: "It is very good that Larionov collects original icons and libok prints with such love and tries to 'bring out' house-painters as artists, a painter Kliuyev. (In the coming season he even proposes a special exhibition of house- and sign-painters.)"[1]

The newspaper critics met this new innovation with scorn and confusion. The artists of Larionov's circle were the first to pay close attention to children's creative work, finding in it immediacy and vivid imagery, qualities that they valued highly in art. In 1913 Alexei Kruchenykh published the book *Children's Own Stories and Drawings* in which the works of Nina Kulbina, the future artist, were reproduced in colour.

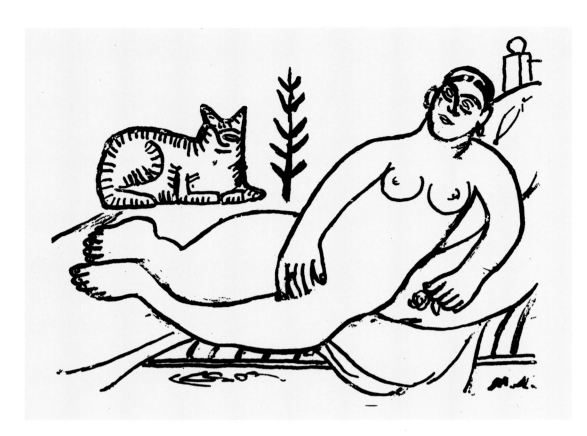

The "Katsap" Venus. 1913
Lithograph. 13.5 x 18.4 cm
Russian Museum, St Petersburg

This period also saw the appearance of the first collections of children's drawings. At the Target Larionov displayed children's' works from the collections of Alexander Shevchenko and the architect Nikolai Vinogradov. Larionov himself presented at the exhibition a cycle of four paintings *The Seasons* and two canvases from the uncompleted *Venuses* cycle: *Jewish Venus* and a sketch version of *Moldavian Venus*. The cycle also included *Soldiers'*, *Boulevard*, *"Katsap"* (a Ukrainian slang expression for Russians), *Turkish*, *Spanish* and *Negro Venuses*. The whereabouts of the majority are now unknown. Ilya Zdanevich remarked that in this series the artist wanted to give an idea of national types of beauty that are not limited to the Classical canons.

One of the most piquant in terms of plastic qualities is *Venus (Venus and Mikhail)*, now in the Russian Museum collection. The image amounts to an original visual formula presented in upbeat tones. Punin wrote with delight about the unexpected chromatic harmony that the artist achieved in this painting: "What subtle contrasts hold it together — yellow, brown, white. That is one of the strongest combinations in colour that an artist can ever allow. ... This artist is generally fond of such combinations... In this painting though he has greatly heightened them, taken them to a maximum of tension, a tension expressed in a childishly naive manner, but he has brought it to perfection."[1]

The entire *Venuses* cycle was polemically pointed against aesthetic passéism associated with *Apollon* and the World of Art grouping. Such "shocking" titles as *Boulevard Venuses* and *"Katsap" Venus* were also quite deliberate. But the provocative extremism was intended to underline the main thing — the protest against routine, "Graeco-Roman" predilections, the expansion of the sphere of the beautiful, a rejection of the constriction of a Eurocentric understanding of artistic values. It was no coincidence that the *Negro Venus* appeared at the very moment when the artist was discovering for himself the

[1] N. N. Punin, *An Excursion in the Russian Museum*, 10 December 1927, MSS Dept., Russian Museum, fund 6, item 539, folio 78

astonishing world of African sculpture. There can be no doubt that this cycle by Larionov was a challenge to the critics who disparaged the new art and was particularly directed against the "chief critic", Alexander Benois, who was irritated by the young artists' attempts to draw plastic conclusions for themselves from the experience of folk art. As late as 1910 Benois called on Larionov to abandon this course and return to the bosom of "the old art": "After all, instead of these affectations in the spirit of some new 'Primitivism' he could produce finished, perfect works in 'the former spirit'. But Larionov is depriving the sunset aureole of the old art of that flowery, festive ray that he could give it."[1] The *Venuses* cycle was the "unrepentant" artist's rebuff to the critics, a polemic attack launched in the form of painted canvases. To move ahead of the times, defying established tastes is not an easy burden. It requires of the artist selfless devotion, obstinacy and firmness of character. Larionov never betrayed himself, never gave in to the temptation to ease his own way by yielding a little and so come closer to success.

In the four *Seasons*, which Ilya Zdanevich defined as "infantile primitive", Larionov's Primitivism revealed a new facet. The influence of the shop-sign was expanded by others, from children's drawings. But that was only the outward stimulus. In essence these paintings are rendered complex by a profound contact with ancient, archaic, predominantly Eastern cultures. Their naivety is not childish, but adult: it is a view of the world filled with poetic simplicity of spirit and poetic symbolism. Not only are the images of peasants profoundly symbolic, so too is the treatment of colour in the painting. A woman with a sickle, a golden sheaf, figures carrying baskets of fruit — a precisely found set of symbols, emblems even, for *Summer Heat*. Each canvas is a kind of poem in visual images, complemented by simple, moving verses that sound the same notes as the painting: "Happy autumn, gleaming like gold, with ripe grapes, and heady wine." These last pre-war cycles — the *Venuses* and *Seasons* created in 1912 — complete Larionov's Primitivism. Beginning with a fascination with the shop-sign, the artist exploited an ever greater range of phenomena in his art — soldiers' visual graffiti, archaic cultural objects, children's drawings.

[1] A. Benois, *"Itogi"* ["Conclusions"], *Rech'*, 26 March 1910

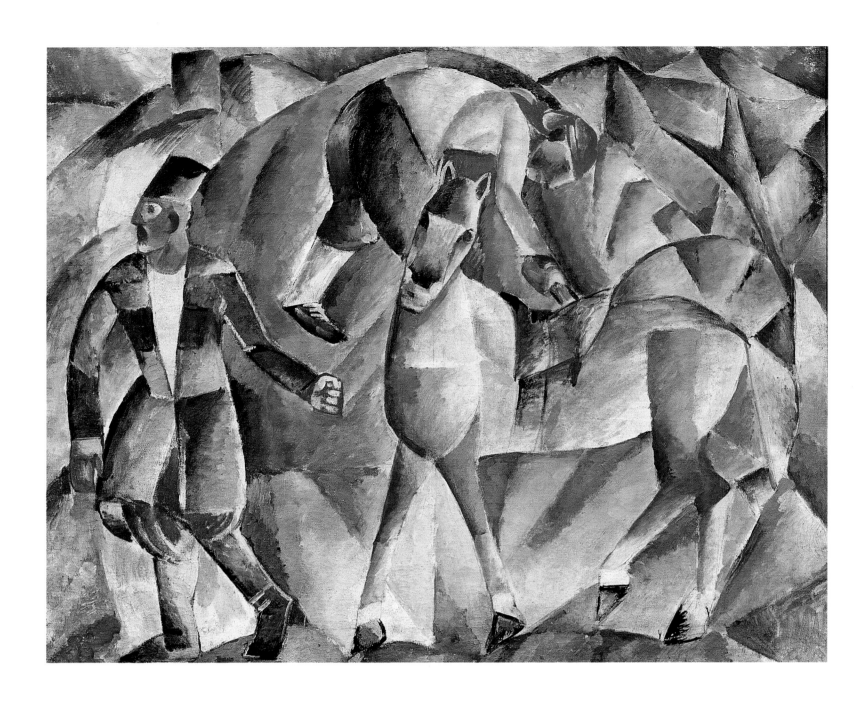

Mikhail Le Dantu
Man with a Horse

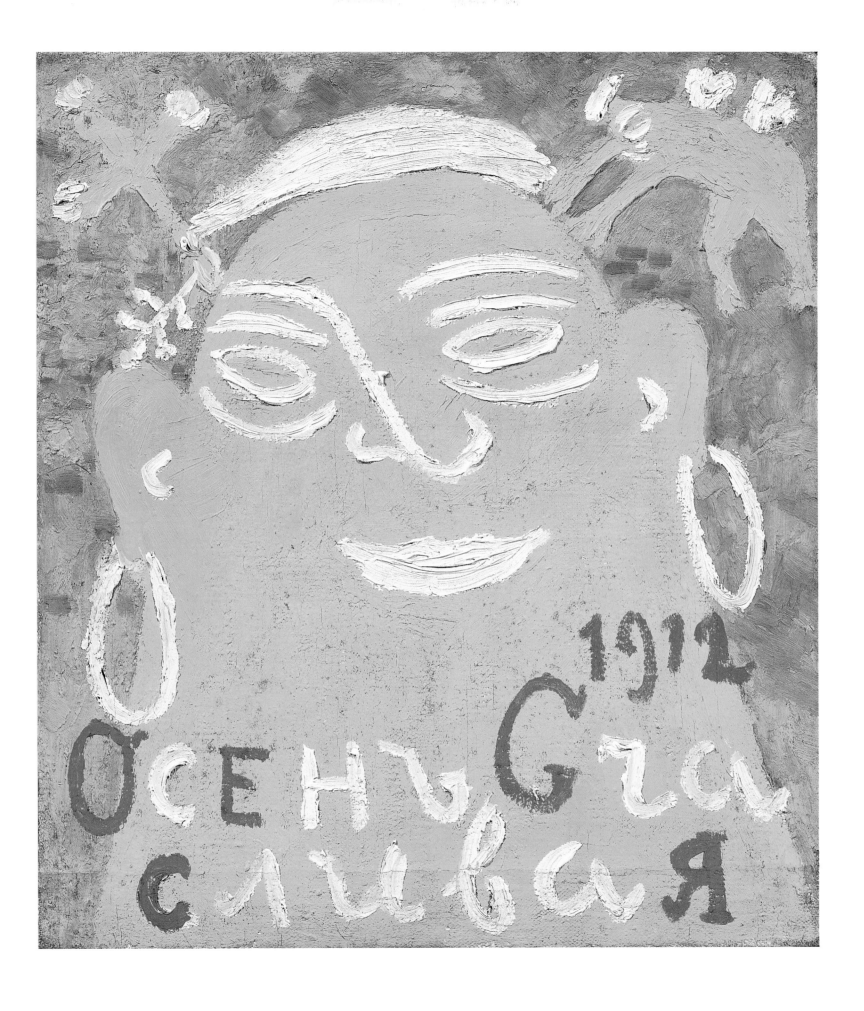

Yellow Autumn ("Happy Autumn"). 1912
Oil on canvas. 53.5 x 44.5 cm
Russian Museum, St Petersburg

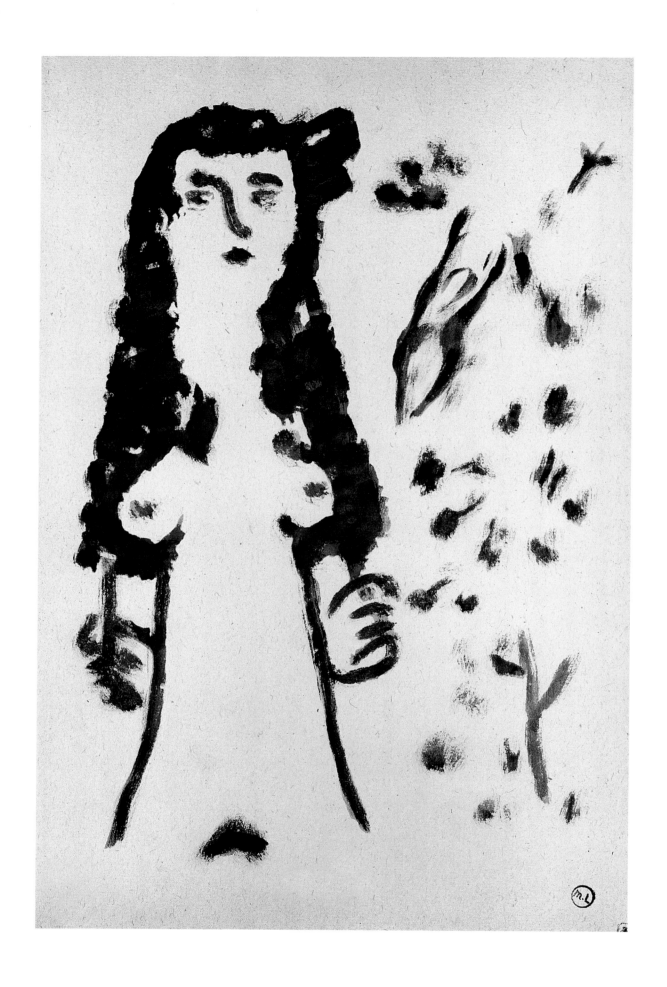

Female Figure. Ca. 1928
Sheet from the album *A Journey to Turkey*
Gouache, silk-screen and stencil on paper.
36.7 x 24.2 cm
Russian Museum, St Petersburg

"Manya the Bitch". Ca. 1928
From the album *A Journey to Turkey*
Gouache, silk-screen and stencil on paper.
32 x 24.2 cm
Russian Museum, St Petersburg

Spring. 1912
From the series *The Seasons*
Oil on canvas. 142 x 118 cm
Tretyakov Gallery, Moscow

Summer. 1912
From the series *The Seasons*
Oil on canvas. 100 x 122 cm
Private collection, Paris

→
Winter. 1912
From the series *The Seasons*
Oil on canvas. 100 x 122 cm
Tretyakov Gallery, Moscow

→
Autumn. 1912
From the series *The Seasons*
Oil on canvas. 136.5 x 115 cm
Musée national d'art moderne,
Centre Georges Pompidou, Paris

Зима хол-
одная снгровая
влтреная Вью
гийо кутан иза
кована льдомъ

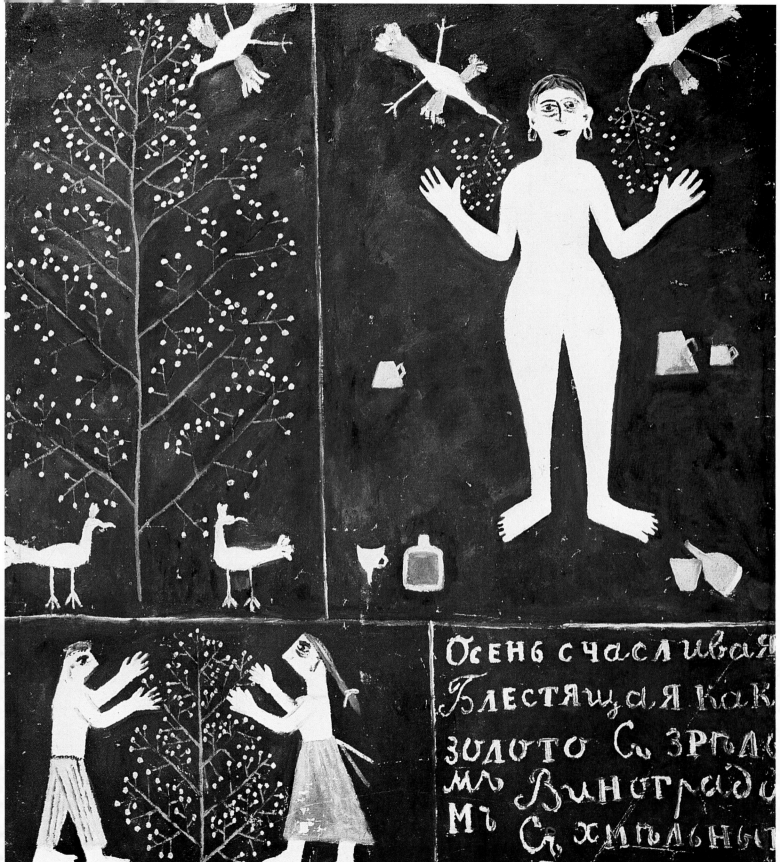

Осень счасливая
Блестящая как
золото Созрѣло
мъ Виноградо
мъ Съ хмѣльны
Виномъ

The Discovery of Pirosmani

[1] M. F. Larionov, *Letter to M. V. Le Dantu*, Late January 1913, MSS Dept., Russian Museum, fund 135, item 7, folios 8r–v, 9r–v
[2] F. M., "'Luchisty' (V masterskoi Larionova i Goncharovoi)" ["'Rayonism' (In the Studio of Larionov and Goncharova)"], *Moskovskaya gazeta*, 7 January 1913

It is a known fact that Pirosmani's painting was discovered by three people — the brothers Kirill and Ilya Zdanevich and Mikhail Le Dantu. It would not have happened though without Larionov, if all three had not been through Larionov's school of fascination with the shop-sign and with primitive folk art in general.

On 14 March 1912 Le Dantu went to Tiflis at the invitation of the Zdaneviches. The brothers were studying Georgian antiquities, ecclesiastical architecture, and Le Dantu's arrival, we can assume, turned their interests in a different direction. In the taverns of Tiflis they came across paintings by Pirosmani. Fascinated by his manner of painting, the Zdaneviches began collecting and registering his works, putting together a large collection. When he returned to St Petersburg at the end of August, Le Dantu took with him a Caucasian barber's shop sign and Pirosmani's *Woman with a Mug of Beer*. He showed the latter to Larionov who, as his letters show, developed a profound interest in the Georgian artist's work and decided to include his paintings in the forthcoming Target exhibition.[1] On 7 January 1913 Larionov gave a newspaper interview in which he mentioned Pirosmani's proposed involvement in the Target exhibition. He said: "A Georgian from Tiflis, very popular with people there as a skilful wall painter who mainly decorates taverns.... His distinctive manner, his Eastern motifs and the few means by which he achieves so much are magnificent."[2] Larionov was intending to travel to the Caucasus in the spring of 1913 to meet Pirosmani, but he was prevented by the call-up to military camp. Ilya Zdanevich spent the winter holidays of January 1913 in Tiflis, continuing to search out Pirosmani's work. This was when he had his first meeting with the artist, recorded in this extract from a letter to Le Dantu:

"Dear Mikhail Vasilyevich, I have not written to you for a long time. I have some news to report. Nikolai has been found. After long wanderings, I managed to find out that he spends his nights in a certain tavern at 23, Molokanskaya Street. I went there. The landlord told me that the information was correct, but he was not at home at the moment as he was working on Gogol Street, in an eating-house, and suggested I go there. Leaving my address, just in case, I went off to Gogol Street, spent a long time looking for any kind of eating-house, but could not find anything. All there was was some man in a brown suit and peaked-cap standing by one building and painting the letter S on the wall with red lead. I went up to him and asked whether he knew Nikolai. He replied that it was him.

"We introduced ourselves and got talking. I said I wanted him to paint my portrait. 'Why not,' he replied, 'if you like. What should I do it on — oil-cloth, a wall, canvas. Oil-cloth doesn't last long, but there are kinds that are like canvas.' He went on to say that he was busy for the next two days and asked me to call in the cellar in two days time (i.e. yesterday) and agree details. I went there yesterday, but did not catch him. I went today. The tavern was closed. He was standing by the tavern eating

Niko Pirosmani
Portrait of Ilya Zdanevich. 1913

Niko Pirosmani. Photograph. 1916

bread. We went to the cellar. He agreed to paint the portrait and we settled on a fee of eight roubles. Only he said that it was better to paint from a photograph and I should have one taken. I went on to say that the newspapers had written about him and that there were plans to show his work at an exhibition. At first he gave a puzzled look, then he was pleased and so on. Right then his landlord gave me a beautiful canvas with a depiction of the three kings. Then he began assuring me that he would work extremely hard, produce a lot of canvases, and so on and so forth. In short, we got on together very well. I will bring a few for the Target, six or seven canvases. Larionov should exhibit them, since he announced it in the press. In the meantime I shall try to get more of them and to give him work. Alexander Ivanovich Kancheli[1] has promised to let him paint the dining-room in his apartment. I shall describe further events. I shall be in St Petersburg about 2 or 3 February. Besides that, I have written a monograph on Larionov and Goncharova. The monograph is empty, an empty puff. It will be printed under a pseudonym."[2]

Zdanevich's letter explodes the myth that has migrated from book to book that the brothers met Niko Pirosmani together with Le Dantu in the summer of 1912. The source of this legend was a monograph by Kirill Zdanevich in which he recounted how they all three met the artist who was painting "Dairy" on a wall, then they went to an eating-house and "at the table Le Dantu asked Niko whether he knew that he was a great artist."[3]

Ilya Zdanevich's letter is undated. N. Elizbarashvili, who published a few lines from it, erroneously attributed it to the autumn of 1912.[4] We should note that Zdanevich mentions newspaper articles and intentions to exhibit Pirosmani's work. There can be no doubt that he had in mind Larionov's interview published on 7 January 1913 regarding the Target exhibition planned for that March. We know that Zdanevich had a subscription with the agency that provided newspaper cuttings related to the client's interests and was already aware of Larionov's interview when he met Pirosmani. Ilya Zdanevich's diary notes published in Paris indicate the precise dates when Pirosmani worked on his portrait: on 27 January 1913 Pirosmani was painting the portrait, on 31 January the portrait was almost finished, and on 2 February Zdanevich took it home. On 3 February he departed for St Petersburg.[5] It follows, therefore, that the letter was written no earlier than the second half of January 1913.

Since Le Dantu did not visit the Caucasus again after the summer of 1912 and Pirosmani never left Georgia, the two cannot have been personally acquainted. Kirill Zdanevich spent the spring and summer of 1912 in Tiflis, then left for Paris, returning only in 1914. Evidently his memory played tricks with him. The meetings and talks in taverns may have taken place, but only after Kirill's return from Paris and without Le Dantu who was by then fighting the Germans.

Mikhail Le Dantu
Sazandar. 1912

[1] A journalist
[2] I. M. Zdanevich, *Letter to M. V. Le Dantu*, late January 1913, MSS Dept., Russian Museum, fund 135, item 5, folios 1–2v
[3] K. M. Zdanevich, *Niko Pirosmanashvili*, Moscow, 1964, p. 13
[4] N. Elizbarashvili, "Zhiviye stranitsy letopisi" ["Living Pages of a Chronicle"], *Literaturnaya Gruziya*, 1981, No 8, p. 206
[5] See the catalogue: *Hiazd*, Paris, 1978, pp. 46f. On 29 January Zdanevich promised to show Pirosmani the newspaper article that mentioned him

Niko Pirosmani
Woman with a Mug of Beer

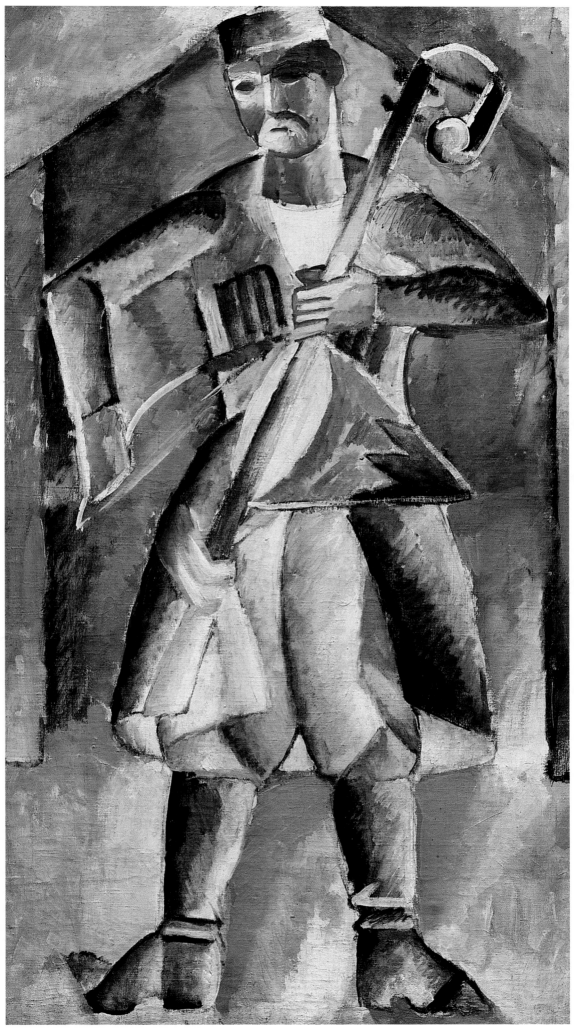

З стихотворенія
написаныя на
собственом языкѣ
От др. отличается:
слова его не имѣют
опредѣленаго значенія

✳

№1. Дыр бул щыл
убѣшщур
скум
вы со бу
р л эз

The Book Experiment

Page from Alexei Kruchenykh's book
Lipstick (Moscow, 1913)
Text and drawings by Mikhail Larionov
Lithograph. 15.2 x 10.9 cm

*Female Figure
with a Flying Bird.* 1913
Lithograph. 10.4 x 6.8 cm

In 1912 Larionov turned his hand to lithography and book illustration. His first experience in this field was lithographed postcards that appeared in the summer of 1912 in a series published by Alexei Kruchenykh. Apart from Mikhail Larionov, the nascent Futurist poet enlisted for this project Ivan Larionov, Natalia Goncharova, Vladimir Tatlin, Alexander Shevchenko and Nikolai Rogovin.

Larionov produced some two dozen lithographed postcards that have now become extreme rarities. They were all free replicas of his painted canvases. Among the series we find portraits of Kruchenykh, Goncharova and the artist himself. Stylistically they are executed in the same key, but psychologically they differ greatly. It is as if the artist reveals the image of the subjects through the prism of their own work: the intense concentration of the "transrational" Kruchenykh; the inner openness and directness of Goncharova; the mischievous irony of Larionov. The sparsely indicated background evokes the same associations — the stars around Kruchenykh are like a sign of the remote abstract spheres in which the poet soars; while in the rhythm of decisive, energetic lines and patches we can divine the monumentally simplified structure of Goncharova's canvases. "Larionov's Own Portrait" is a free repetition of the painted *Self-Portrait* first displayed at the Jack of Diamonds exhibition.

The State Library of Russia in Moscow possesses twelve lithographed postcards hand-tinted with watercolour.[1] A note appended to them states: "The aforesaid lithographs were printed in Richter's lithographic workshop on Tver Boulevard in Moscow. One copy was tinted personally by Goncharova for the Alcyone publishing-house (owned by Alexander Milentyevich Kozhebatkin) from whom it was acquired in 1932." The note is signed "A. M.", but it has not yet proved possible to find out who was behind those initials. One of the pieces — *Smoking Woman. A Turkish Scene* — has been tenderly and subtly touched by the watercolour. Green, crimson and pink tones glow nobly and shimmer, enhanced by the white patches of paper. The artistic manner and the colours suggest the hand of Larionov himself, rather than Goncharova.

On the basis of his painted soldier cycle, Larionov created the prints *A Soldier Resting, Sonya the Sutler, Dragoons, Changing the Guard*, and *Head of a Soldier*. Over the course of 1912–13 he produced three lithograph versions of the *Soldier Resting*, based on his own canvas of 1911. A comparison with the painting enables us to see the artist's method of working in lithography "after" his own canvases. Larionov treated the "original" with an ever greater degree of freedom. While the *Soldier Resting* in Shevchenko's booklet might still be called a lithographic replica of the painting, in Kruchenykh's publication it is a graphic "deduction" from the painting, a free variation on the same theme, independent in terms of composition and treatment of form. The third work with the same title was

113

executed in brush and lithographic ink and is no longer in any way connected with the painting or is at best a sort of "primitive formula" of it. This treatment of the original is evidence that Larionov was seeking to promote not his own paintings (for that purpose the colour lithographic reproductions published by the Society of St Eugene would have been better) but the new artistic principles that had formed in painterly practice. He wanted to create a graphic art analogous to that way of painting, mastering a new sphere of creativity. This can explain the active "campaign into lithography" waged by Larionov and his associates.

A sharply-drawn boundary separates their graphic art from that of the World of Art grouping. With those artists graphic art invaded painting, making even it graphic; with Larionov the painterly element penetrated into graphic art.

For him, as a born "colourist", black and white were sufficient to be painterly. Therein indeed lies the significance of his early-twentieth-century lithography: the artist revived the culture of "painterly graphic art". He was not alone in this, but it was in his works that these qualities revealed themselves most profoundly, vividly and consistently.

At the same time as the lithographs for postcards, Larionov produced his first illustrations, for collections of poetry by Vladimir Khlebnikov and Alexei Kruchenykh. The initiators of these publications were the poets themselves, but also Larionov and Goncharova. In the summer of 1912 Mayakovsky and Kruchenykh stayed at a dacha in Petrovsko-Razumovskoye. There they met the aviator G. Kuzmin[1] and the musician Sergei Dolinsky,

Rock drawing. The Lake Balkhash area. 4th–3rd millennium B.C.

[1] The aviator's younger brother, the sculptor Leonid Kuzmin, was a friend of Mayakovsky's youth

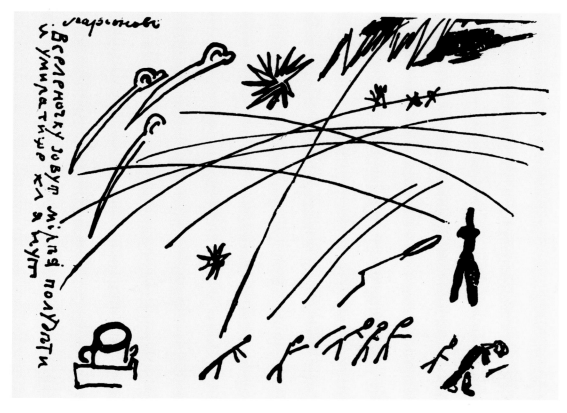

Universal Beauty. A Rayonist composition. 1912
Lithograph. 14 x 16.2 cm

114

[1] L. Zhegin, "Vospominaniya o Mayakovskom" ["Reminiscences of Mayakovsky"], *Literaturnaya gazeta*, 15 April 1935
[2] A. Benois, "Ikony i novoye russkoye iskusstvo" ["Icons and the New Russian Art"], *Rech'*, 5 April 1913

who between them agreed to assume the responsibilities of publishers of Futurist anthologies.

The Futurists' little books were produced in a light-hearted, easy-going atmosphere of collective creation. Lev Zhegin recalled how Mayakovsky's first collection, *Me!*, appeared.

"The HQ was my room. Mayakovsky brought lithographic paper and dictated poems to Chekrygin who set them down in his neat handwriting using special lithographic ink.

"The four drawings that Chekrygin produced by the same means (lithography), are remarkable in themselves, but have little connection, only outwardly, with Mayakovsky's text.

"'There you go again, Vasya,' Mayakovsky grumbled. 'You've drawn an angel. Why not do a fly. You haven't drawn a fly for ages.'

"Work on the outward design of the booklet lasted a week or a week and a half."[1]

Over three years (1912–14) the Futurists produced about a score different lithographed publications. They were printed in small lithographic establishments, chiefly in Moscow: Richter's, Titiayev's and Mukharsky's. With their semi-handicraft character, "hand-made" exterior, and illustrations that were strange to more than just the average man, these works differed tremendously from anything that had previously appeared on the book market. They staggered the connoisseurs and aesthetes of the World of Art who could find nothing in them beyond a jeer at common sense. "It is unthinkable that in ten years time the highly talented Larionov will still be acting the fool and publishing his jester's booklets," Alexander Benois fumed.[2]

The is no doubt that the intentions of those who published such collections included mockery of the accustomed tastes of the reader, a deliberate effort to shock, a breaking of aesthetic moulds and stereotypes of perception. Cheap grey

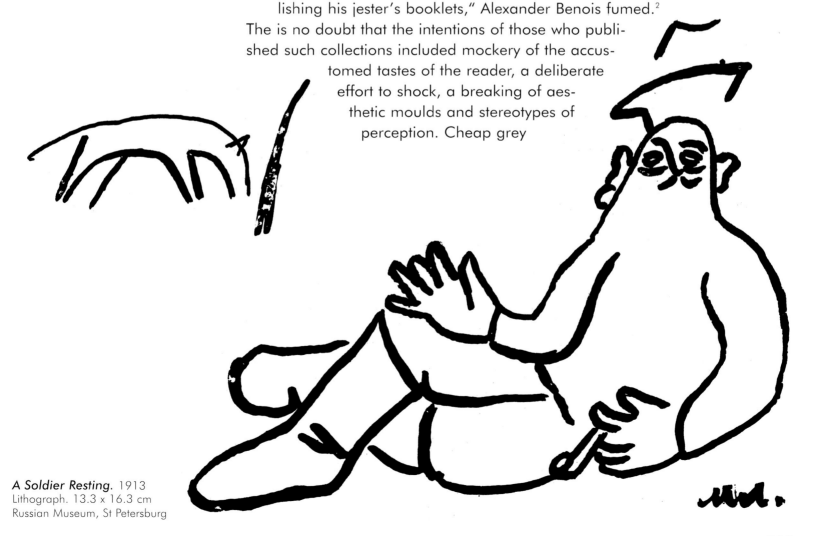

A Soldier Resting. 1913
Lithograph. 13.3 x 16.3 cm
Russian Museum, St Petersburg

paper, cardboard covers and careless binding were a challenge to the aesthetic preoccupations of the Symbolists. The result was a sort of "anti-book" when compared with the opulent publications of *Apollon* or *The World of Art*.

Kruchenykh wrote: "The publication of *Griffon*, *Scorpion*, *Musagetes* ... large white sheets ... grey printing ... there is a great temptation to wrap fish up in it.... And cold blood flows in those books."[1] *Sadok Sudei* [*A Trap for Judges*], the first anthology of young poets who had come together in the literary group Hylaea (Khlebnikov, Kruchenykh, Kamensky, David and Nikolai Burliuk, Yelena Guro, and others), was printed on the back side of cheap wallpaper.[2] David Burliuk gave this interpretation of the dissident symbolism contained in that aspect of the book: "... we shall pass through your whole life with fire and sword; bugs and cockroaches have been breeding behind your wallpaper, now let our young, youthful, cheerful verse live on it."[3]

The contents of these anthologies were just as much "a slap in the face of public taste". Kruchenykh's famous *Dyr bul shchyl*[4] – a poem written in his "own language" — evoked a genuine paroxysm of fury among newspaper critics. The aim of the verses printed using rubber stamps with movable letters on "onion-skin" paper was to irritate the reader:

"Eugene Onegin in two lines
eni voni
se i tsya"
"Sterilized. Howl
Body ferments."
"Reader, do not catch crows!"[5]

Kruchenykh finished one of the books with a monumental crude gesture towards the reader — a Shakespearian "fig" covering a whole page.[6] Yet all this evident desire to shock concealed something greater, criticism of outdated literary and artistic norms, a re-evaluation of values, the birth of new aesthetics that is always hostile to what goes before. The verbal creation of the Futurist poets and the visual creation of their artist colleagues expressed a yearning to return to the word and the image their original purity and immediacy, to make them accord with the changed spiritual and emotional experience of mankind. What was once a striking poetic image became with time a verbal cliché devoid of emotional impulses. It had to be smashed to clear the way for the new art. This is the meaning of Khlebnikov's poetic experiment and Mayakovsky's early work, their arguments with their precursors. New images, both verbal and visual, disrupt accustomed, automatic perceptions, demanding intellectual effort and emotional engagement from readers and viewers. The Futurists repeatedly stressed and even elevated to the status of a principle the difficulty of grasping their art. Such deliberately difficult poetry to a certain extent determined the character of the artists' work on books, the method of illustrating them and the design of the anthologies as a whole.

Why did the Futurists chose lithography as a technique for their publications? The reason lay in what Khlebnikov called "the silent voice of handwriting", something they greatly prized for its expressive possibilities.

[1] *Troye: Sbornik izd. "Zhuravl'"* [*Trio: an anthology of the Zhuravl publishing-house*], St Petersburg, 1913, pp. 40f
[2] It came off the press in May 1910. It was the first collective public action of Hylaea which united the nascent Futurists. Mikhail Matiushin recalled: "This booklet dropped like a bomb in the gathering of mystics around Viacheslav Ivanov. The Burliuks infiltrated them very piously and Viacheslav Ivanov received them with delight. Then as they left those 'scoundrels' popped a copy of *A Trap for Judges* into the coat pocket of everyone present. That is how I came by the book together with Remizov, Blok, Kuzmin, Gorodetsky and all the others who were with them." (M. V. Matiushin, "Nashi perviye disputy" ["Our First Debates"], *Literaturny Leningrad*, 20 October 1934)
[3] D. Burliuk, *Fragments from the Memoirs of a Futurist*, 1929–30, Russian National Library, fund 552, item 1, folio 29
[4] A. Kruchenykh, *Pomada* [*Lipstick*], Moscow, 1913, folio 51. David Burliuk deciphered the poem's title as the initial letters of "*Dyroi budet urodnoye litso schastlivykh olukhov*" – "The ugly face of happy blockheads will be a hole". (*Fragments from the Memoirs of a Futurist*)
[5] A. Ye. Kruchenykh, Aliagrov (R. O. Yakobson), *Zaumnaya kniga* [*Transrational Book*], Colour engravings by Olga Rozanova, Moscow, 1916
[6] A. Kruchenykh, *Vzorval'*, art-work by Kulbin, Goncharova, Rozanova and Malevich (lst edition). St Petersburg, 1913. Incidentally, by the admission of the artist himself, this page was created by Nathan Altman, the only instance of his involvement in the Futurists' lithographic publications.

[1] V. Khlebnikov, A. Kruchenykh, "Bukva kak takovaya. 1913" ["The Letter as Such. 1913"] in V. V. Khlebnikov, *Collected Works* (in Russian), vol. 5, Leningrad, 1933, p. 248. The text of this manifesto was written by Khlebnikov.
[2] N. Burliuk, "Poeticheskiye nachala" ["Poetic Beginnings"], *Futuristy*, No 1–2, 1914, p. 81

Cover for Valentin Parnakh's book *Slovodvig* (Moscow, 1913)
The cover and seven illustrations by Mikhail Larionov. Eight illustrations from drawings by Natalia Goncharova
Lithograph. 27.7 x 18.5 cm

Ordinary type-setting where the letters are "arranged in ranks, trimmed to size, and all equally colourless and grey", stripped the poetic word of graphic individuality. Exploring the nature of the handwritten book, Khlebnikov stressed two propositions: "1. That mood changes handwriting in the course of writing. 2. That handwriting, altered in a distinctive manner by mood, conveys that mood to the reader irrespective of the words." For that reason, Khlebnikov concluded, the author should write out his book himself or "entrust his child not to a compositor, but to an artist."[1] He even called for the foundation of a special profession — handwriting artists.

In their articles and manifestos Khlebnikov, Kruchenykh, Nikolai Burliuk and Kulbin touched on a number of important, unstudied questions: sound and its graphic representation, the graphic quality of the printed and hand-written word as an additional means of expression, the synchronic effect in poetry of the meaning, sound and shape of words. "The starting premise of our attitude to the word, like that to a living organism," Burliuk wrote, "is the idea that the poetic word is sensitive. It changes its qualities depending on whether it is written, printed, or pictured in the mind. It affects all our feelings."[2] The 1912 anthology *Mirskontsa* [*Worldbackwards*], drawn by various artists, is the most eloquent illustration of these propositions. The style of writing, its graphic and rhythmic qualities changes from page to pages: in one place it is calm and rounded, in another angular, fractured, nervous; in one place it scurries along as if weightless, in another the words are laid down heavily. The lines are sometimes cramped together, filling the whole page, sometimes arranged easily on the paper, forming a harmonious balance between black and white. Pages of text alternate with full-page illustrations; drawings are interwoven with the handwritten text, in some places interrupting it, in others occupying the margins. Each time there is a new harmony, a new plastic arrangement of the page. As a whole the anthology is constructed on a succession of contrasts that keep the reader's interest alive. The first lithographed (or "self-written" [*samopisnaya*], as the Futurists called them) book was the collection called *Old-Time Love* created in October 1912. *Old-Time Love* is striking for the harmonious integrity of writing and graphic work. Both the text and he drawings were executed in lithographic pencil. The unified "pencil" texture makes for organic transitions between one and the other. Larionov was able to achieve a special graphic subtlety in the script that is treated in the same stylistic key as the drawing. The title of the publication was written within a drawing on the cover. It is hard to say where the one ends and the other begins, since the lines of writing form part of the figurative structure of the drawing. In this regard the cover of *Old-Time Love* is reminiscent

above all of the painted shop-sign that Larionov valued so highly. This weaving of texts into designs, the transformation of inscriptions into elements of a depiction was traditional for folk art. We find this device not only in shop-signs, but also in lubok prints, painted wooden articles and needlework. Nikolai Khardzhiyev sets a high value on the artistic qualities of this first lithographed publication: "The lyrical tension of the images Larionov produced and the richness of his artistic language make it possible to number this first attempt at illustration among the more remarkably designed poetic anthologies of the beginning of the century. The book represents an integral artistic whole — from the front cover to the back."[1]

This unity was also shaped by the medium itself — the lithographic stone. Since Gutenberg invented movable type, illustrations and text had been printed by different means. Reproductive techniques gradually became more complex and closer to perfection; methods of printing in colour appeared, but the organic integrity between the written page and the illustration, that was characteristic of books printed from single blocks, disappeared. The Futurists' lithographed anthologies recovered that unity in a common method of printing.

As an artist, Larionov possessed a special gift for harmony of form. In his 1913 lithograph *Woman with a Little Bird* the light, seemingly floating drawing appears to take away the weight of the objects. The figure of the woman and the bird are inserted in a easy, unforced manner into the narrow margin of the page with faultless precision and a harmonious balance of all the depictive elements. It is hard to find a definition of Larionov's method of depiction but, it seems to me, the essence of it might be formulated as the principle of free plasticity. Strict harmony, precise form and logic that tolerates nothing random present themselves in Larionov's drawings in the guise of unlimited freedom of visual expression and seemingly arbitrary treatment of real life. Larionov probably greatly prized this appearance of arbitrariness and seeming chance as an expression of the immediacy of the creative process. David Burliuk drew attention to this peculiarity of Larionov's approach as early as 1912, comparing it to Khlebnikov's poetic principles: "M. Larionov's 'Soldier' paintings are the best examples of free drawing... The analogy in poetry is *vers libre*, the sole, most splendid exponent of which in contemporary poetry is Victor Khlebnikov."[2]

In many of his drawings and works for books Larionov made contact with ancient, archaic graphic tradition. This primitive foundation comes out particularly strongly in the illustrations to Kruchenykh's anthology *Half-Alive* (1913). Some of the drawings from this books "coincide" in terms of style and treatment of form with rock paintings of the neolithic era. It was not an imitation of the Stone Age, rather the very logic of the work of an artist, who always strove to seek out the fundamental plastic elements in an image, very likely led him to approaches close to the primitive depictive system. A direct connection with the folk tradition is displayed in those books where the illustrations were hand-tinted like book prints. There were not many such publications, but they opened up new possibilities for the artist working in this sphere. One of the most characteristic examples of such a book was Kruchenykh's *Pomada* [*Lipstick*] (1913) with illustrations by Larionov.

Nude
Illustration from Alexei Kruchenykh's lithographed book *Lipstick*
(Moscow, 1913)
Lithograph. 18.2 x 14.7 cm
Russian Museum, St Petersburg

[1] N. Khardzhiyev, "Pamiati Natalii Goncharovoi i Mikhaila Larionova" ["Memoirs of Natalia Goncharova and Mikhail Larionov"], in *Iskusstvo knigi: Sbornik* [*The Art of the Book: an Anthology*], No 5, Moscow, 1968, p. 316
[2] D. Burliuk, "Kubizm" ["Cubism"], *Poshchiochina obshchestvennomu vkusu: Sbornik* [*A Slap in the Face of Public Taste: an Anthology*], Moscow, 1912, p. 101. Nikolai Burliuk is erroneously credited as the author of the article.

Посвящается
Михаилу
Ларіонову

Я смѣло бросился на ножъ
Когда во тьмѣ богъ просіялъ...
И прозвенѣлъ какъ смѣхъ: хорошъ!
По стали вѣтренной зеркалъ

Я обагренный изойду?
Я умиральниць похоть?
Раздѣтый на виду
У всѣхъ паду на локоть?

О богъ войны! о чернь
Златаго пояса и кисти!
Я прокраснѣлъ на луг:быстрѣе серн
И тамъ мой праздникъ кисти!...

Из пѣсен гайдамаков

„С навѣсня пан летит бывало горинёж
„В заморских чоботах мелькают ноги
А пани под собой увидѣв нож
На землю падает уплует ноч
Из хлябей вынырнет усатый пан моржем
Чтоб простонать Santa Maria
Мы ж хлопцы весело заржем
И топим камнями в глубинах гарторія
 Панов сплавляем по рѣкам
А дочери ходим по рукам
 Была веселая пора
 И с ставкою большою шла игра

 Пани нам служит как прачка наймитка
А пан плѣвет и ему на лицо садится
 кичитка»
 Нѣт старче то негоже
 Парча отстоит от рогожи

Ларіоновъ

A Bird with a Twig in Its Beak
Illustration from Alexei Kruchenykh's and
Velimir Khlebnikov's lithographed book
Worldbackwards (Moscow, 1912)
Lithograph. 18.6 x 15 cm

A lithographic design is pasted on the bright crimson cover; handwritten pages alternate with illustrations on gold *passe-partouts* tinted with pure watercolour paints. As with the book prints the tinting often goes beyond the contours of the drawing. While repeating the main features, it is improvised in the details and this endows every copy of the book with the uniqueness and attraction of an original.

Today it is impossible to understand the indignation of Benois who called such works by Larionov "jester's booklets". Time has done its part and, as Nikolai Khardzhiyev justly noted with regard to *Lipstick*, "at the present time this miniature 'self-written' book, having already lost its shocking character, resembles some precious work of jewellery."[1] The impression of a "cottage industry", of non-mechanical methods of production, evoked by the Futurists' lithographed anthologies is no coincidence. This was a fundamental principle with the Russian Futurists that set them sharply apart from Marinetti with his cult of urban, machine-driven civilization. While the Italian Futurists broke with the past, the Russian artists on the contrary immersed themselves in national tradition, strove to get closer to folk art, and studied under folk artists.

The lithographed books produced by Larionov and his fellows not only altered the accustomed image of the book, but also changed the very principle of illustration. The artist stopped "retelling" the text by visual means. The illustrations in the anthologies are not "tied" to the text — they do not shadow, but develop and complement the poetic images or else contrast with them. In other words, the development of the literary theme or image is simultaneously attended by a distinctive emotional, graphical accompaniment. Describing Goncharova's drawings to his verses, Sergei Bobrov observed that "the heart of what is new lies in the fact that the kinship of aspirations between poem and drawing and the elucidation of the poem by the drawing are achieved not by literary means, but by painterly ones."[2] Consequently there is no illustrator in the customary sense of the word in these anthologies: the artist becomes a co-author of the poet or writer.

Larionov and his associates rejected the parallel imagery of verse and illustration, creating a synthesis of those two elements, a single image that is at once both poetic and visual. A new quality, a new means of employing imagery arose. The drawings cannot be "cut out" of a book like this without destroying the whole. Larionov's experiment, taken up by Goncharova, Chekrygin, Rozanova, Filonov and other artists, brought about a profound transformation in Russian book art, particularly in the 1920s.

[1] N. Khardzhiyev, "Pamiati Natalii Goncharovoi i Mikhaila Larionova", p. 316
[2] S. Bobrov, "O novoi illiustratsii" ["The New Illustration"], *Vertogradari nad lozami*, Moscow, 1913, p. 156

Portrait of Natalia Goncharove
From a series of lithographed postcards
published by Alexei Kruchenykh (Moscow, 1912)
Lithograph. Tinted print. 11.6 x 9 cm
State Library of Russia, Moscow

Self-Portrait. Ca. 1910
Oil on canvas. 104 x 89 cm
From the former collection
of A. K. Tomilina-Larionova collection, Paris

→
Palms
Illustration from Alexei Kruchenykh's
lithographed book *Lipstick* (Moscow, 1913)
Lithograph. Tinted print on a golden
passe-partout. 10.5 x 7.8 cm
Russian Museum, St Petersburg

→
Bather
Illustration from Alexei Kruchenykh's
lithographed book *Lipstick* (Moscow, 1913)
Lithograph. Tinted print on a golden
passe-partout. 11.5 x 5.3 cm
Russian Museum, St Petersburg

→
Fruit Vendor
Illustration from Alexei Kruchenykh's
lithographed book *Lipstick* (Moscow, 1913)
Lithograph. Tinted print. 7.5 x 5.1 cm
Russian Museum, St Petersburg

Гр42223

Гр42224.

←
Devil
Illustration from Alexei Kruchenykh's
lithographed book *Half-Alive* (Moscow, 1913)
Lithograph. Tinted print. 17.7 x 11 cm
State Library of Russia, Moscow

A Street
From a series of lithographed postcards published
by Alexei Kruchenykh (Moscow, 1912)
Lithograph. 13.5 x 9.5 cm
Russian Museum, St Petersburg

A City
Based on motifs from the 1911 painting
A City Street, now in the Nesterov Art Museum
of Bashkiria, Ufa
From a series of lithographed postcards published
by Alexei Kruchenykh (Moscow, 1912)
Lithograph. Tinted print. 9.2 x 14.2 cm
State Library of Russia, Moscow

A City Street. 1911
Oil on canvas. 72 x 94.5 cm
Nesterov Art Museum of Bashkiria, Ufa

Rayonism

[1] "Luchizm Larionova", *Vostok, natsional'nost' i Zapad*, leaflet distributed at the Target debate, 23 March 1913

Cockerel and Hen. 1912
Oil on canvas. 69 x 65 cm
Tretyakov Gallery, Moscow

Cover of Alexei Krychenykh's book
Old-Time Love (Moscow, 1912)
Lithograph. 14.5 x 9.7 cm

In 1913 Larionov put out a brochure entitled *Luchizm [Rayonism]* and published an article "Rayonist Painting" in the Donkey's Tail and Target anthology. It was, however, in the leaflet *Larionov's Rayonism* that was distributed to the public at the Target debate that the artist most precisely expressed the main propositions of his theory. Here is an extract from those theses: "The doctrine of radiation. The radiation of reflected light (coloured dust). Reflectivity. Realistic Rayonism, depicting existing forms. The rejection of forms in painting as existing apart from the image in the eye. The conventional depiction of a ray by a line. The erasure of boundaries by what is called the picture-plane and real life models. Rudiments of Rayonism in previous arts. Doctrine of the creativity of new forms. Spatial form, form that appears from the intersection of rays from different objects, that is picked out by the will of the artist. Conveying feelings of the infinite and the timeless. The structure of the paint layer according to the laws of painting (i.e., texture and colour). The natural fall of all previous art as something that, due to the Rayonist forms, like life itself, becomes only an object for the artist to observe."[1]

To Larionov's mind, Rayonism was supposed to tear painting away from the object, turning it into a self-sufficient art of colour with a value in itself.

The painting ceases to be "a pale reflection" of the objective world; it becomes an "object" itself, part of actual reality aesthetically ordered by the artist. We do not see objects themselves — they are a kind of Kantian *Ding an sich* — but rather perceive the bundles of rays coming from them, which in the painting are represented by coloured lines. Larionov subdivides Rayonism into the realistic, that retains traces of objectivity, and the non-objective, non-depictive, in which the outward ties with the visible world are broken. As we see, the main propositions of the theory are not particularly profound, even fairly naive, but the practice of Rayonism proved far more interesting and productive than its theory.

The earliest Rayonist constructions can be seen in the illustrations to Kruchenykh's book *Old-Time Love* that came off the press in early October 1912. Following that Larionov presented Rayonist canvases almost simultaneously at two exhibitions: in November 1912 in Moscow, two works at the World of Art exhibition: *Glass: The Method of Rayonism* and *Rayonist Study*; and at the Union of Youth exhibition that opened on 4 December *Rayonist Sausage and Mackerel*. The most representative displays of Rayonism were the Target exhibition (1913), "No 4. Futurists, Rayonists, the Primitive" (1914) and the exhibition of paintings called simply "1915", At the Target Larionov presented his most important Rayonist compositions: *Cock and Hen, Rayonist Sausage and Mackerel, Bull's Head, Portrait of a Fool* and *Glass: The Method of Rayonism*.

Researchers have caused quite a degree of confusion over when Rayonism first appeared, sometimes dating it to 1909. Yury Annenkov was the first to present in print a false chronology of Larionov's oeuvre, yet he was someone who knew the true picture very well. In 1966 he wrote: "The year 1909 was decisive in the artistic biography of Goncharova and Larionov and in the destiny of art. Both exhibited pictures that became the basis of the first abstract movement, called 'Rayonism', *Luchizm* is Larionov's term. ... Many Rayonist works by Goncharova and Larionov appeared at the avant-garde exhibitions Jack of Diamonds, Free Aesthetic and Donkey's Tail between 1909 and 1912."[1] Annenkov, confused, listed precisely those exhibitions at which there were no Rayonist works.

Mikhail Vrubel
A Lily. Sketch for a stained-glass window. 1895–96

Following him Waldemar Georges in his 1966 monograph on Larionov shifted the Rayonist *Glass* from the 1912 World of Art exhibition to 1909. We find the same error in the catalogue of the New York Larionov exhibition in 1969. The author, François Daulte, called one of the sections "The Rayonist Period (1909–12)".[2]
The 1976 exhibition in Brussels[3] featured an "Abstract Picture" by Larionov dated to 1907(!), when the artist was fascinated with shop-signs and painting his *Barbers* and *Provincial Dandies*. Executed in the spirit of painterly Purism, that canvas was obviously painted in the early 1920s and had nothing in common with the Primitivist works of the first decade of the century.

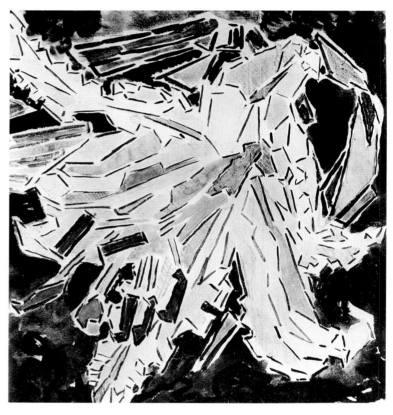

How did Larionov regard the misdating of his works? With complete tolerance — and he even played a part in it himself. Larionov was undoubtedly among the pioneers of non-figurative painting, but he was not averse to being reckoned the very first.

As early as the "Goncharova and Larionov" exhibition held in the Galerie Paul Guillaume in June 1914, he altered the catalogue dates of many works for earlier ones. The artist, for example, attributed *Glass* to 1909, thus misleading the first researchers into his work.[4]
After the Second World War there was a new wave of interest in abstract art and scholars began to search out the sources of this movement. Michel Seuphor wrote a book in 1949 that revived the memory of Larionov's by-then forgotten Rayonism.[5]

Critics looked on Rayonism as one of the varieties of abstract art, but in fact matters were more complicated. Impressionism with its fascination with the behaviour of light put plastic construction in second place; Cubism, on the contrary, developed the structural aspect at the expense of the painterly. Larionov was unwilling to sacrifice either. His Rayonism was an astonishing attempt to combine the seemingly incompatible — the scintillating colour of Impressionism with the structural clarity inherent in Cubism. The painterly, spiritual visionariness of Kandinsky and the avowed non-objectivity of Malevich's Suprematism were equally alien to Larionov.

[1] G. Annenkov, *Le journal de mes rencontres*, Paris, 1966, pp. 213f
[2] see *Michel Larionov*, Acquarella Galleries, New York, 1969
[3] *Rétrospective Larionov Gontcharova*, Musée des Beaux-Arts d'Ixelles, Brussels, 1976
[4] see *Exposition de Natalie Gontcharowa et Michel Larionow*, Galerie Paul Guillaume, Paris, 1914
[5] M. Seuphor, *L'Art abstrait, ses origines et ses premiers maîtres*, Paris, 1949

Despite their outward non-objectivity, Larionov's Rayonist works — with their motion towards nature, light-bearing quality and complexly vibrating painting — evoke associations with the natural world. This is true of his *Rayonist Landscape* in the Russian Museum collection. For Larionov, who always received his creative impulses from the visible world, it was difficult to sever all connections with nature. This peculiarity that sets Rayonism apart from abstractionism and Suprematism was spotted by Nikolai Punin in his time. He considered that Larionov had put forward his theory of Rayonism "as a barrier against certain rationalistic tendencies of Cubism" and was in practice "the fruit of very subtle realist juxtapositions".[1]

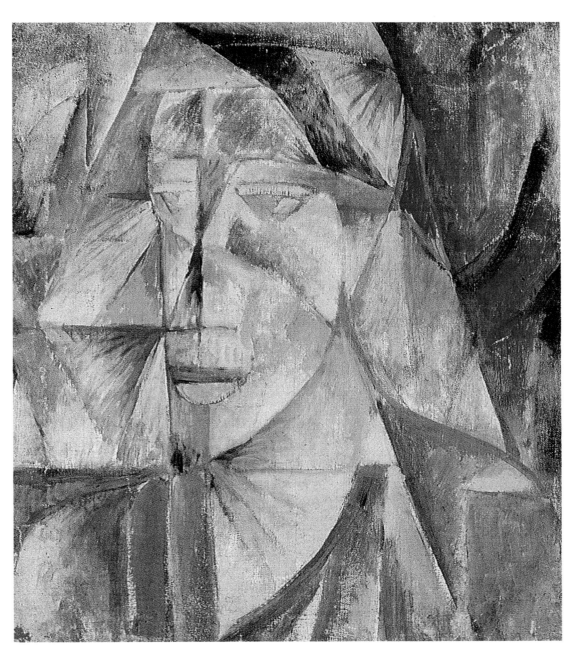

Mikhail Le Dantu
Portrait of Maurice Fabbri. 1912

It should be noted that Larionov was not alone in such searchings. In this same period two other artists, Yelena Guro and Mikhail Matiushin, strove to liberate painting from objectivity, while still retaining the natural, spatial, organic basis in a painting. The artists of Matiushin's school indicated a "third way" in non-figurative art, distinct from those of Kandinsky and Malevich.

[1] N. Punin, "Impressionisticheskiy period v tvorchestve M. F. Larionova", p. 291

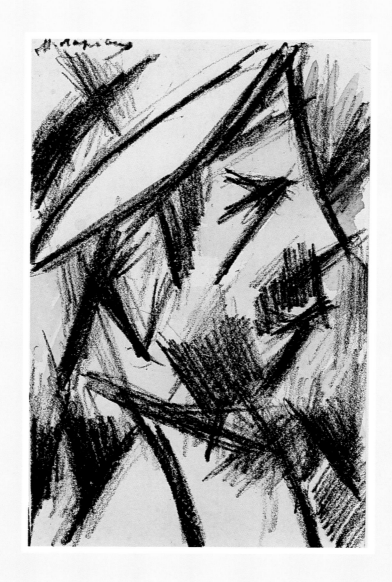

Head of a Soldier
Based on the 1910 painting of the same name,
now in a private collection, Paris
Lithograph. 14 x 9 cm
Russian Museum, St Petersburg

[1] "Luchisty i budushchniki" ["Rayonists and Futurists"], 1913 manifesto, included in "Osliny khvost" i "Mishen'"
[2] N. Tarabukin, M. Vrubel, Moscow, 1974, p. 111

Western researchers rarely distinguish between abstractionism and non-objectivity, placing them in apposition. It is not correct to define everything that possesses the quality of non-figurativeness as abstractionism. Kandinsky and Malevich are superficially united by their non-figurativeness; in essence, however, they are antipodes, their non-figurativeness grows from different roots. As Lev Yudin, one of Malevich's pupils, aptly observed, some artists are inclined to "construct" (Malevich, Picasso), others to "experience" (Kandinsky, the Expressionists).

There are in Larionov's outwardly non-objective Rayonism values and qualities that abstract art never knew. They are correcting "for naturalness" and the painterly "deduction" from visual reality. Rayonism was neither lyrical nor expressive abstraction. Larionov was indeed a trail-blazer but of other painterly and plastic undertakings that have yet to be studied in detail.

The Rayonist canvases, particularly those which came to be described as "realistic Rayonism", revealed the nature of Larionov's painterly gift, displaying a wealth of textures that conveyed what the artist called "coloured dust". With no plot and practically no subject, the picture leaves the viewer alone with the immediacy of the painting. Larionov himself pointed this out: "What is precious to the lover of painting is brought out in a Rayonist picture to the greatest degree. The objects that we see in life play no role here, while that which comprises the essence of painting itself — the combination of colour, its intensity, the relationship of coloured masses, depth, texture — can be shown here best of all. Those who are interested in the painting can concentrate on all that exclusively."[1] Non-objectivity can immediately reveal an artist's painterly poverty, but it is also capable of bringing out his artistic talent in stark relief and totally unobscured. Larionov's Rayonism did not appear on "virgin soil"; it had, as the artist himself stated, precursors. In Vrubel's late paintings and in many of his drawings (Six-Winged Seraph, the Prophets cycle) one can discover plastic structures that anticipate Larionov's Rayonist constructions. Nikolai Tarabukin reports that "N. A. Prakhov had at home a pencil drawing of a nude male body, executed in a 'Rayonist' manner. It follows that that short-lived tendency in painting 'invented' by Larionov was to a certain extent anticipated by Vrubel."[2] There are quite a number of such "Rayonist" drawings in the Russian Museum.

Pavel Mansurov connected the origins of Larionov's Rayonism even more definitely with Vrubel, reporting an unknown episode in the artist's biography. In 1899 Vrubel, who was then working on the ceramic decoration for the Hotel Metropole in Moscow invited several students of the College of Painting, Sculpture and Architecture to assist him. Among them was Larionov who worked under Vrubel's direction for about two weeks. We cannot find any direct

Natalia Goncharova
Rayonist Lilies. 1913

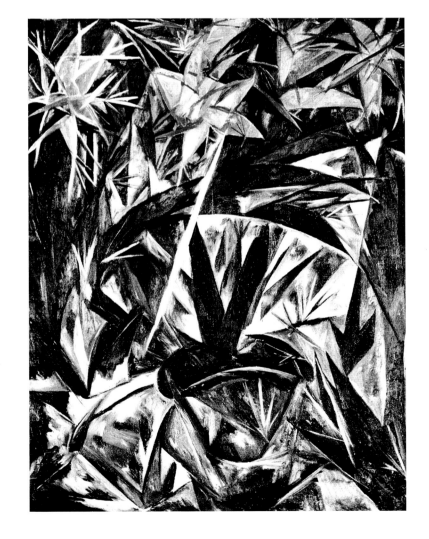

consequences of this contact in Larionov's work, but when relating the story, Mansurov made a telling remark about the backgrounds in Vrubel's paintings resembling "windows covered with frost".[1] Apparently a superficial characteristic, a chance resemblance, but in it one can divine the hidden tendencies in Vrubel's treatment of form that Larionov so sensitively detected.

Larionov himself set great store by Rayonism, the last stage in his artistic evolution on Russian soil. It was not without reason that he despatched the majority of his Rayonist canvases to Paris for the 1914 exhibition. That event was a tremendous success. It acquainted the West with a Russian artist whose manner of painting introduced new impulses into the creative atmosphere of Paris. Apollinaire rated the Rayonist works highly: "Mikhail Larionov, for his part, has contributed not only to Russian, but also to European painting a new refinement — Rayonism."[2]

In Russia, besides Larionov himself, Goncharova, Shevchenko, Le Dantu and Sergei Romanovich followed Rayonist principles in their work, but Rayonism did not give rise to a broad movement in painting like Cubism in France or Suprematism in Russia. The reasons for this were both internal and external. The First World War disrupted Larionov's work in painting and for many years, while wandering around Europe with Diaghilev's company, the artist was absorbed with theatrical work. The main cause, however, was that in a period of fascination with strict geometrization, Rayonism with its immersion in the natural, painterly element was out of place.

Street Noise (A Townscape)
Illustration from Alexei Kruchenykh's and Velimir Khlebnikov's lithographed book *Mirskontsa* [*Worldbackwards*] (Moscow, 1912)
Lithograph. Tinted print. 18 x 14 cm
State Library of Russia, Moscow

→
A Rayonist Landscape. 1913
Oil on canvas. 66 x 69 cm
Russian Museum, St Petersburg

[1] *Letter to Yevgeny Kovtun*, 28 May 1971. In the recipient's archive
[2] Guillaume Apollinaire, "Exposition de Nathalie Gontcharowa et Michel Larionov", *Les soirées de Paris*, No 26–27, 1914, p. 371

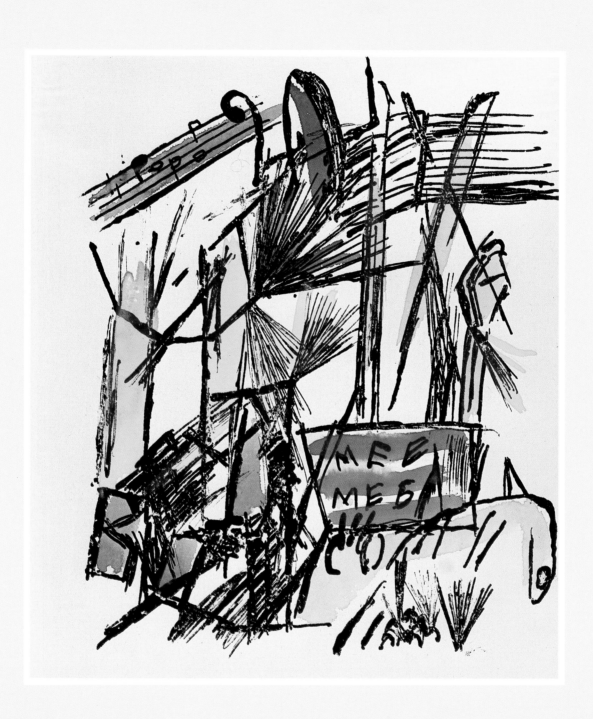

The Russian Museum and Larionov

A Fruit Shop. 1904
Oil on canvas. 66 x 69 cm
Russian Museum, St Petersburg

The Mikhail Larionov
and Natalia Goncharova Room
in the Russian Museum, Leningrad.
Photograph. 1927

In the late 1920s a steady relationship formed between Larionov and the Russian Museum which was interested in acquiring his works. In 1920 the museum had only three Larionov paintings in its collection: *The Barber*, *A Fish at Sunset* and *A Tree*. In 1926 the Russian Museum acquired a large collection of Russian avant-garde works from the defunct Museum of Artistic Culture, including canvases by Larionov: *Acacias in Spring*, *Venus. Study of a Woman*, *A Spray in a Jug*, and *Venus (Venus and Mikhail)*. This enabled Nikolai Punin and Vera Anikiyeva to begin preparing a separate display within the museum — the Department of the Latest Tendencies in Russian Art.

It happened that Punin, who had written extensively on "left-wing" tendencies, had passed Larionov by and only when organizing the new department did he realize the significance of Larionov's work and the true role that he played in the development of modern Russian art. In 1927, while selecting paintings in Moscow for a forthcoming Russian exhibition on Japan,

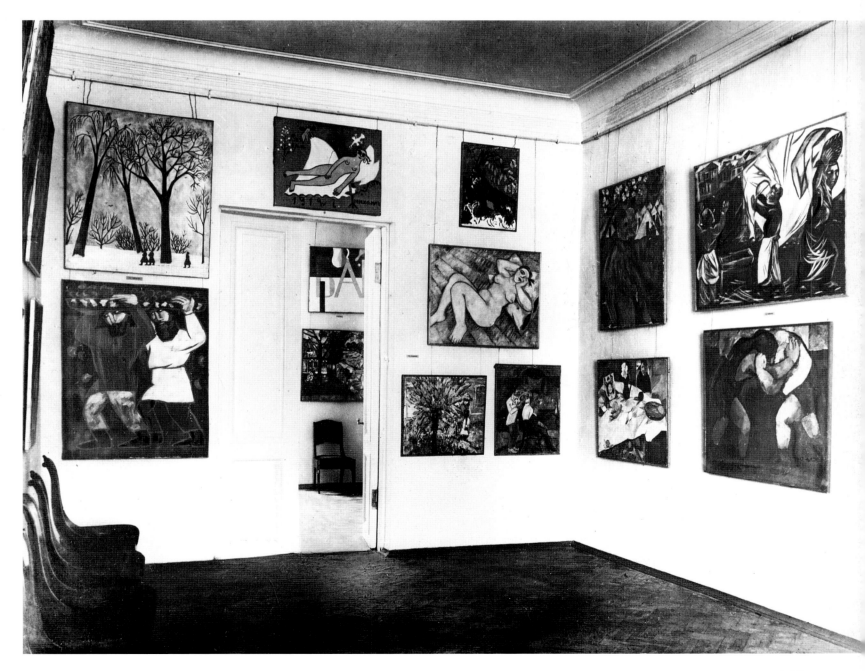

Punin became acquainted with a large number of Larionov's canvases. He was truly fascinated with the artist's work and wrote one of the best pieces of research on him — "The Impressionist Period in M. F. Larionov's Oeuvre" (1928).

By now Punin was seeking to acquire as many works by Larionov as possible for the Russian Museum and dreamt of organizing exhibitions of the artist. On 5 May 1927 he wrote to Neradovsky, the head of the museum's Art Department, from Tokyo: "Incidentally, Piotr Ivanovich, before leaving Moscow I had occasion to see many pieces by Larionov — first-rate painting. I asked those who act for the artist to allow the Russian Museum to give a Larionov exhibition in the autumn, and I shall be writing to Larionov in Paris about that. Some of the things simply must be bought, and on my return I shall definitely write a memorandum on the matter to the Board or the Administration. They are exceptional pieces — there can hardly have been anything better in the past 15–20 years."[1]

The works were acquired from Larionov with Lev Zhegin, a friend of the artist, acting as intermediary. Some canvases were obtained in exchange for books. An entry in the journal of meetings of the museum curators for 10 July 1928 reads: "The artist M. F. Larionov has approached the Art Department with a proposal to provide him, in exchange for two paintings by him (A Fruit Shop and Bouquet), with the following Russian Museum publications: 1) The Frescoes of the Church of the Saviour at Nereditsa; 2) The Iconography of Jesus Christ; and 3) Material for a History of Russian Painting. On discussion of this proposal the meeting recognized this exchange to be desirable and gave M. F. Larionov the publications listed above in exchange for his paintings."[2]

In the course of 1927 and 1928 the museum acquired fifteen works from Larionov, including Rayonist Landscape, one of the few Rayonist works now in Russian collections.

The Department of the Latest Tendencies opened in November 1927, for the tenth anniversary of the October Revolution. An entire room was allocated to Larionov and Goncharova. Among the works displayed were Venus (Venus and Mikhail), The Barber, A Tree, Venus. Study of a Woman and A Spray in a Jug.

In 1932 Vera Anikiyeva organized an exhibition entitled "Art of the Imperialist Era" that also featured Larionov's works.

Today the Russian Museum's Larionov collection is the largest in Russia. In 1974 it was expanded by a donation from Maria Spendiarova, the widow of Sergei Romanovich.

[1] MSS Dept., Tretyakov Gallery, fund 31, item 1279, folio 1
[2] Journal No 29, Art Dept., Russian Museum. Entry for 10 July 1928. MSS Dept., Russian Museum, archive of the institution, fund 6, item 560, folio 13

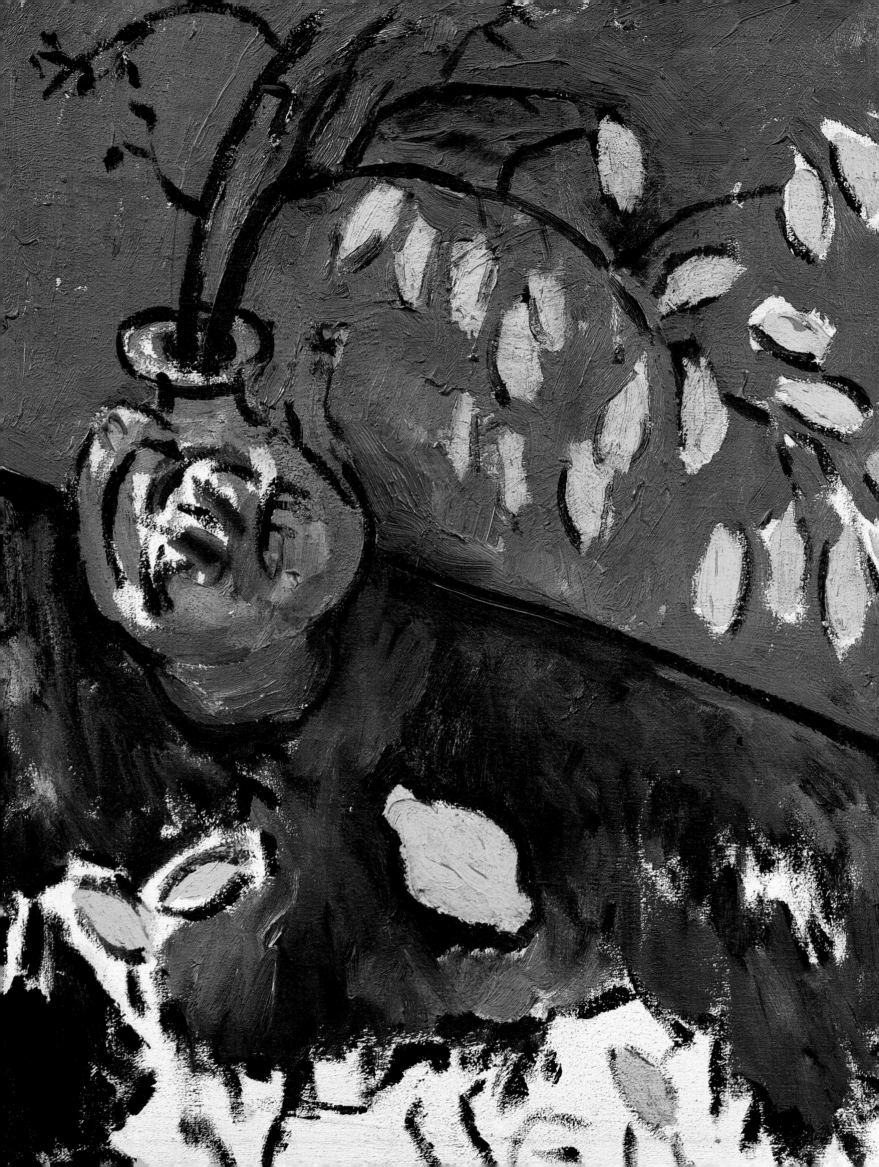

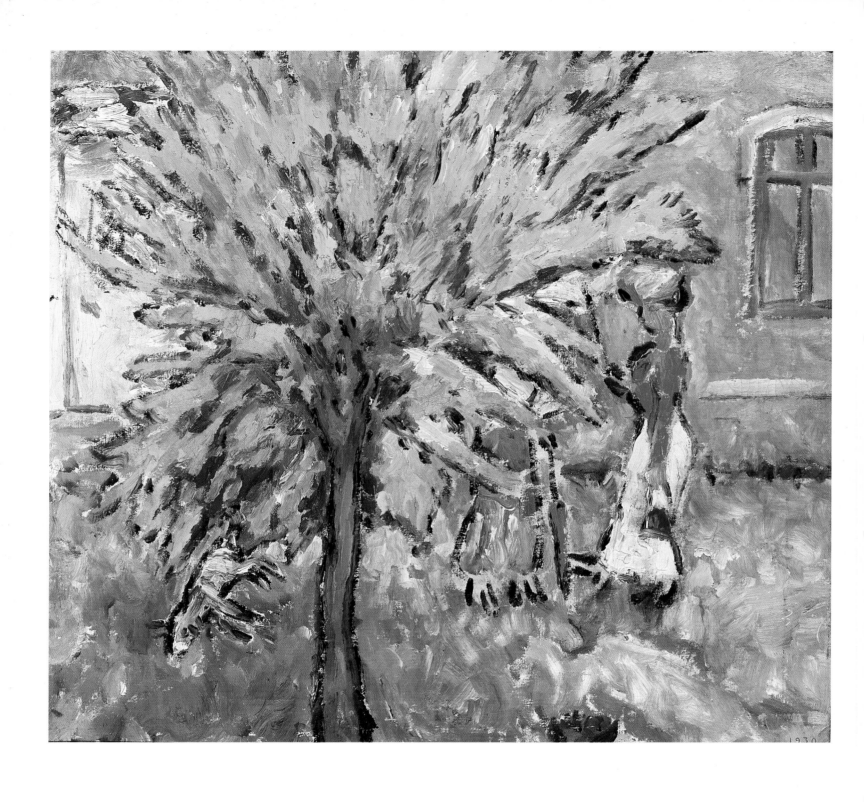

A Spray in a Jug. 1909–10
Oil on canvas. 69 x 50.5 cm
Russian Museum, St Petersburg

A Tree. 1910–11
Oil on canvas. 66.5 x 72 cm
Russian Museum, St Petersburg

A Bunch of Wild Flowers. Ca. 1900
Oil on canvas. 69.5 x 67.5 cm
Russian Museum, St Petersburg

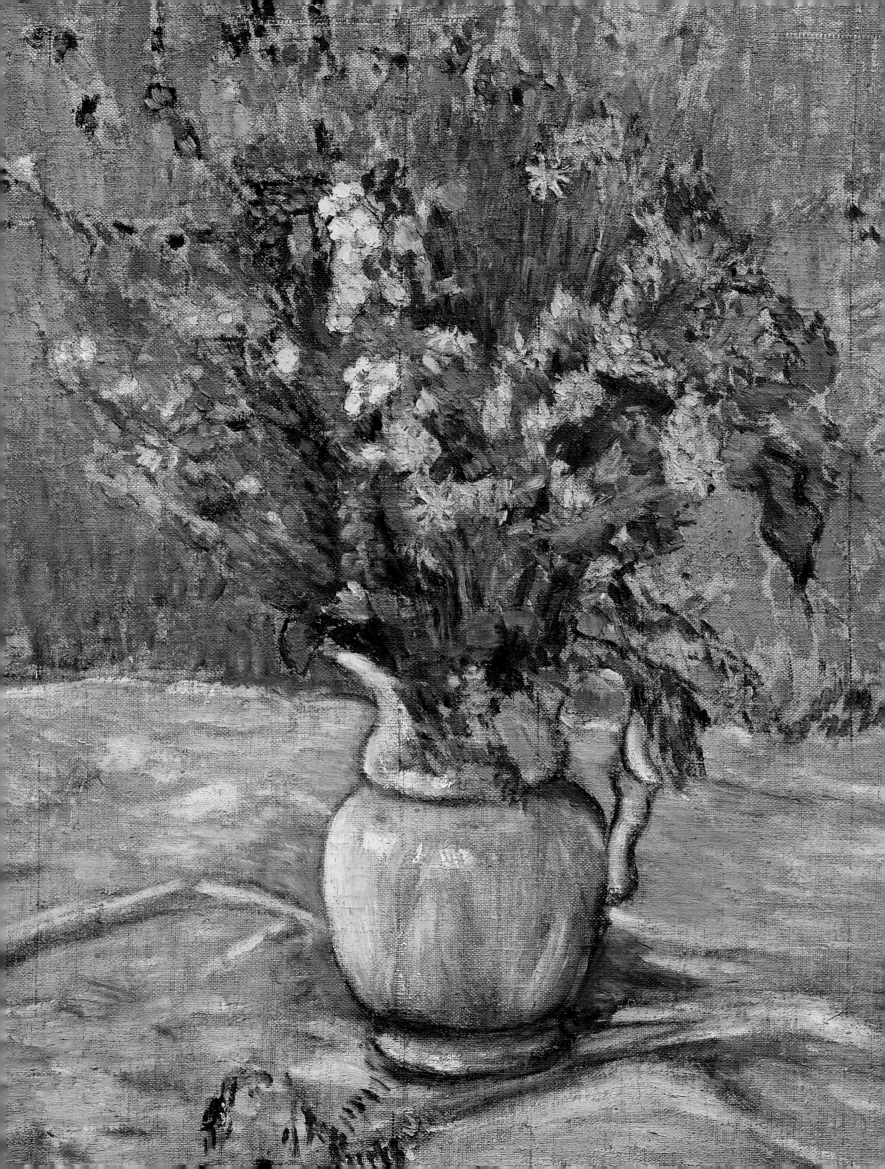

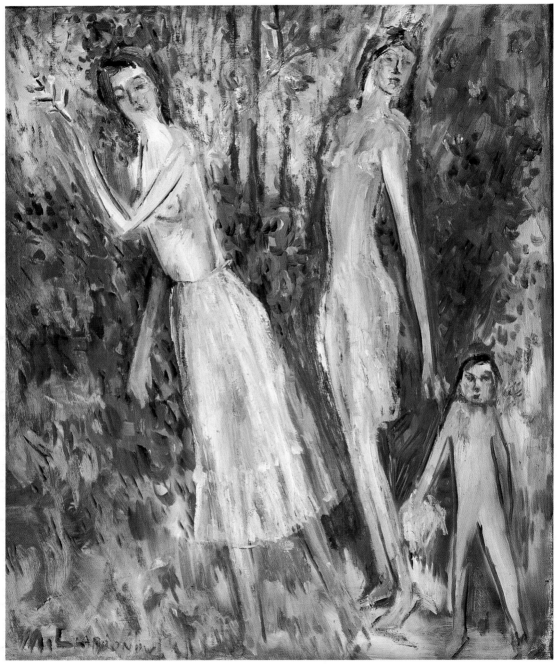

Conclusion. After 1914

[1] V. Mayakovsky, "Vravshim kistyu"
["To Those Who Have Lied with the Brush"],
Morning telegraph of the newspaper *Nov'*,
14 November 1914
[2] Larionov and Goncharova, *Poetry*, Paris, 1987
(no pagination)
[3] A. Lunacharsky, "K vystavke frantsuzskogo
iskusstva", *Sovremennoye frantsuzskoye
iskusstvo*, exhibition catalogue, Moscow, 1928

Spring. 1920s
Oil on canvas. 81 x 65 cm
From the former collection
of A. K. Tomilina-Larionova, Paris

**Cover of Vladimir Mayakovsky's
lithographed book *Solntse* [*The Sun*]**
Moscow – St Petersburg, 1923)
Zincograph. 16.5 x 12.5 cm
Russian Museum, St Petersburg

In 1914 Larionov and Goncharova went to Paris where they worked as theatrical artists for the ballet company organized by Sergei Diaghilev. The public regarded his production of Rimsky-Korsakov's *Golden Cockerel* with sets by Goncharova as a triumph of Russian art. At this same time, the exhibition of works by Larionov and Goncharova took place in the Galerie Paul Guillaume, bringing them European fame.

Larionov became acquainted with Picasso and other artists living in Paris. Apollinaire wrote an article about him. But the war interrupted the artist's European tour. As an officer of the reserve Larionov was subject to mobilization. He returned to Moscow and soon found himself at the front in the army of the Russian General Rennenkampf fighting in East Prussia. There he was badly contused: "Dear Larionov is lying, almost without legs and contused," Mayakovsky wrote.[131]

After his discharge from military hospital in 1915 Larionov rejoined Diaghilev. He travelled with the company around Switzerland, Spain and Italy, working on costume and set designs for the ballets.

In 1919 Larionov and Goncharova settled in Paris, on the Rue Jacques-Callot where they lived for the rest of their lives.

In the 1920s they continued to collaborate with Diaghilev. Larionov produced costume and set designs for ballets composed by Sergei Prokofiev, *Le Chout* (*The Buffoon*) in 1921, and Igor Stravinsky, *Le Renard* in 1922. In this period the visual character of Diaghilev's productions changed under the influence of Larionov and Goncharova. Diaghilev, who had been at the heart of the World of Art movement, was powerfully affected by Larionov and modern art in general. In the words of Nikolai Dronnikov, Larionov "is pulling him away at the end of his life from Bakst and Benois towards Picasso and Matisse, from retrospectivism to the new manner of painting."[1]

In 1920 Larionov illustrated Alexander Blok's poem *The Twelve*, which was published in separate editions in London and Paris. In November 1922 Mayakovsky, who always rated Larionov's painting highly, visited Paris. In the essay "A Seven-Day Inspection of Parisian Painting" he related his encounters with Russian artists. As a result of these meetings in 1923 the *Krug* (*Circle*) publishing-house produced Mayakovsky's poem *The Sun* ("An unusual adventure that happened to Vladimir Mayakovsky at the dacha") with illustrations by Larionov. In 1928 works by Larionov and Goncharova were shown in Moscow as part of an exhibition of French art. In an article entitled "On the Exhibition of French Art" Anatoly Lunacharsky asked "Is it not interesting to see what point our fellow countrypeople sadly surrendered for too long to France, Goncharova and Larionov, have reached in their art?"[2] The artists themselves, despite their many years in France,

147

Sergei Diaghilev and Léonid Massine:
At the Table. 1910s–1930s
Pen and ink on paper. 23 x 27 cm
From the former collection
of A. K. Tomilia-Larionova, Paris

Natalia Goncharova and
Mikhail Larionov in 1962. Photograph

never ceased to consider that they belonged to their native country and to Russian culture. They became naturalized in France only in 1938. In 1957 Larionov wrote to his friend Lev Zhegin in Moscow: "We have been working to leave everything to our homeland."[1]

Larionov's late painted works — still lifes in shades of ochre and silver, studies of nude models that seem fragile and somehow incorporeal — indicate that the artist had not lost his refined painterly culture, but something is irreplaceably missing from those works. They displayed aestheticism, mannerism and stylization so uncharacteristic of Larionov, a looking to "French tastes". The highly vocal painter he had been in Russia now spoke in a whisper of bleached ochry tones. The artist himself was conscious of the decline in his work and suffered because of it. This is evident from his nostalgic verses written in the French period:

> Wouldn't I really like to know
> Why in sorrow and in pain
> I have to senselessly wander the world.
> Why all joy and happiness
> All the dream of love and spring
> Has to be lost and scattered
> On the roads of Europe.[2]

Larionov's creative peak, which lasted until the middle of the 1910s, left an indelible mark on Russian twentieth-century art. Many of the artists who sought new ways of painting at the beginning of the century were strongly affected by Larionov's art. It can be sensed in the works of Natalia Goncharova, Alexander Shevchenko, David Burliuk and others. Traces of Larionov's influence are also noticeable in the early work of such outstanding figures as Kasimir Malevich and Vladimir Tatlin.

Larionov was able to create a kind of painting that does not age. This painting, at first sight profoundly Russian in its understanding of the world and its sense of colour, proved congenial, valuable and necessary to everyone who has within them a need for art. Larionov's creative legacy, as is often the case with artists ahead of their time, is slowly but surely coming to meet the viewer.

[1] M. F. Larionov, *Letter to L. F. Zhegin (Shekhtel)*, Shekhtel family archive, Moscow
[2] Larionov and Goncharova, *Poetry*, Paris, 1987 (no pagination)

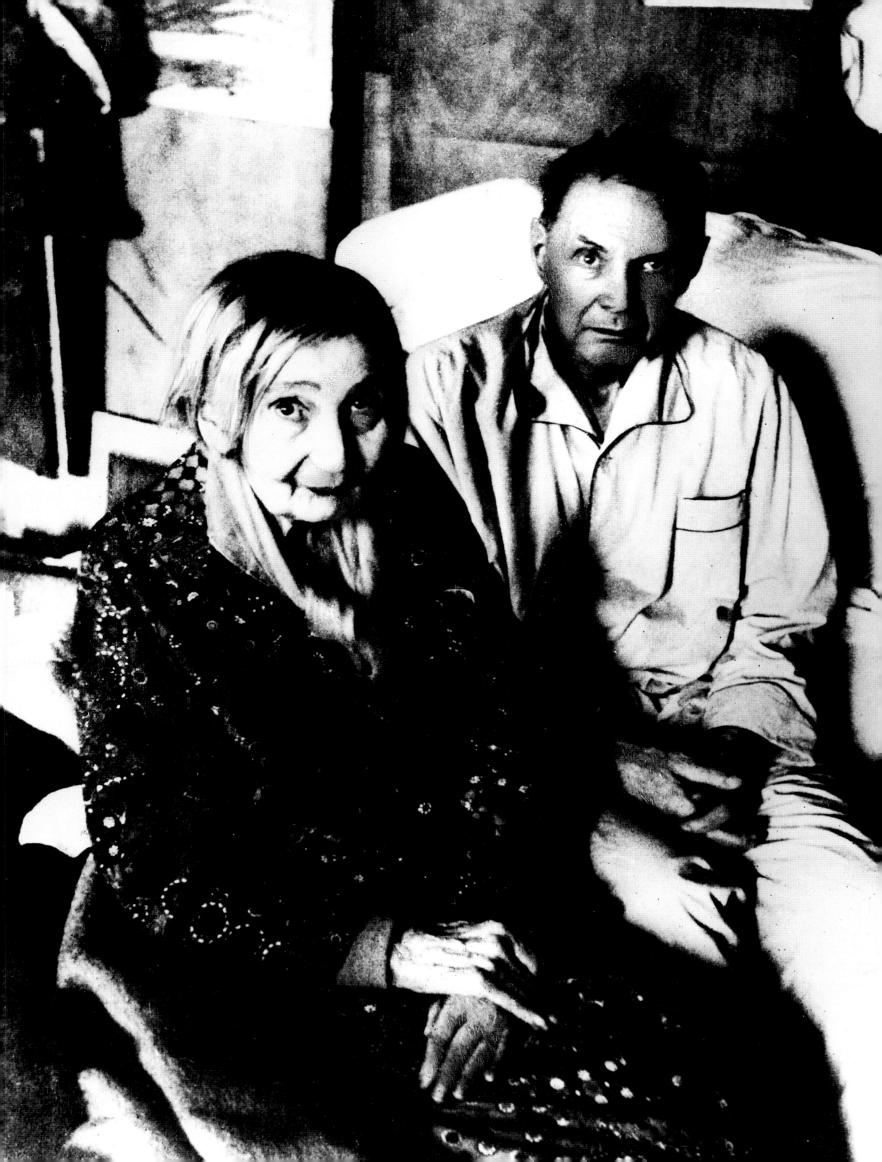

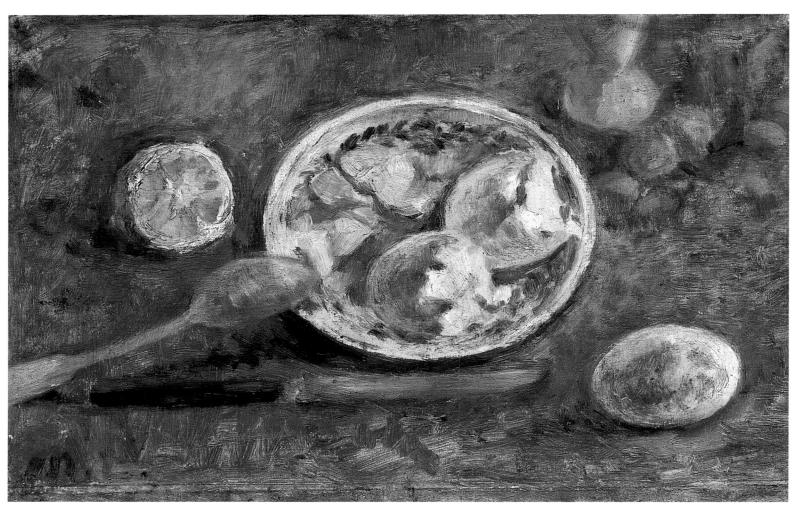

Still Life with a Lemon and an Egg. 1920s
Oil on canvas. 23.5 x 37.5 cm
Russian Museum, St Petersburg

Shrimps. 1934
Gouache on paper. 40 x 59 cm
From the former collection
of A. K. Tomilina-Larionova, Paris

Still Life with a Portrait. 1920s
Gouache on paper. 34.3 x 22.4 cm
Russian Museum, St Petersburg

*Two Girls on the Bank
of a Stream.* 1920s
Oil on canvas. 92 x 129.5 cm
From the former collection
of A. K. Tomilina-Larionova,
Paris

PAVLOVA

**Apollinaire and Diaghilev
in the Wings.** 1917
Pen and ink on paper. 21 x 17 cm
From the former collection
of A. K. Tomilina-Larionova, Paris

Anna Pavlova. 1920
Pen and ink on paper. 20.5 x 13.5 cm
From the former collection
of A. K. Tomilina-Larionova, Paris

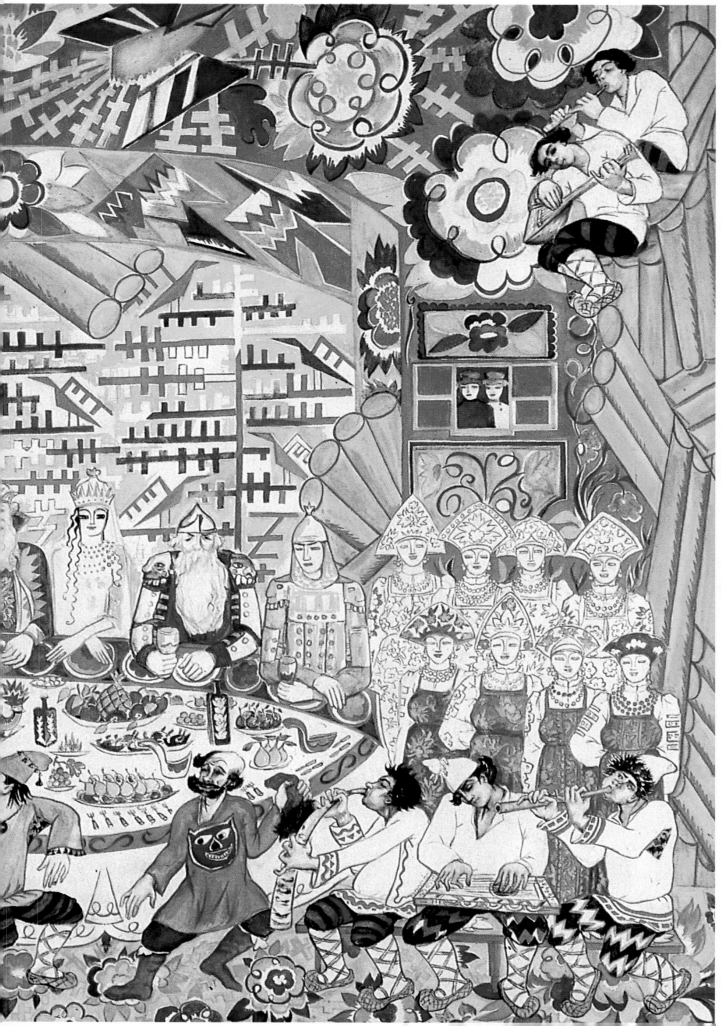

урядникъ
баранъ
М. 922.

ova

914. Sketch of an unrealized
a-ballet *The Golden Cockerel*
Nikolai Rimsky-Korsakov

Policeman Ram. 1922. Costume design
for Igor Stravinsky's ballet *Le Renard*
Watercolour on paper. 38 × 27 cm
From the former collection
of A. K. Tomilina-Larionova, Paris

Fox. 1921. Costume design
for Igor Stravinsky's ballet *Le Renard*
Watercolour on paper. 50 x 32.5 cm
From the former collection
of A. K. Tomilina-Larionova, Paris

→
Baba-Yaga. 1916–17. Curtain design
for Act II of the ballet *Russian Fairy-Tales*
to the music of Alexander Liadov. Le Châtelet
Theatre, Paris. 1917
Watercolour on paper mounted on cardboard.
455 x 700 cm (exposed area)
Tretyakov Gallery, Moscow

→
***Still Life. A Napkin and a Double
Portrait.*** 1920
Oil on canvas. 45 x 81 cm
From the former collection
of A. K. Tomilina-Larionova, Paris

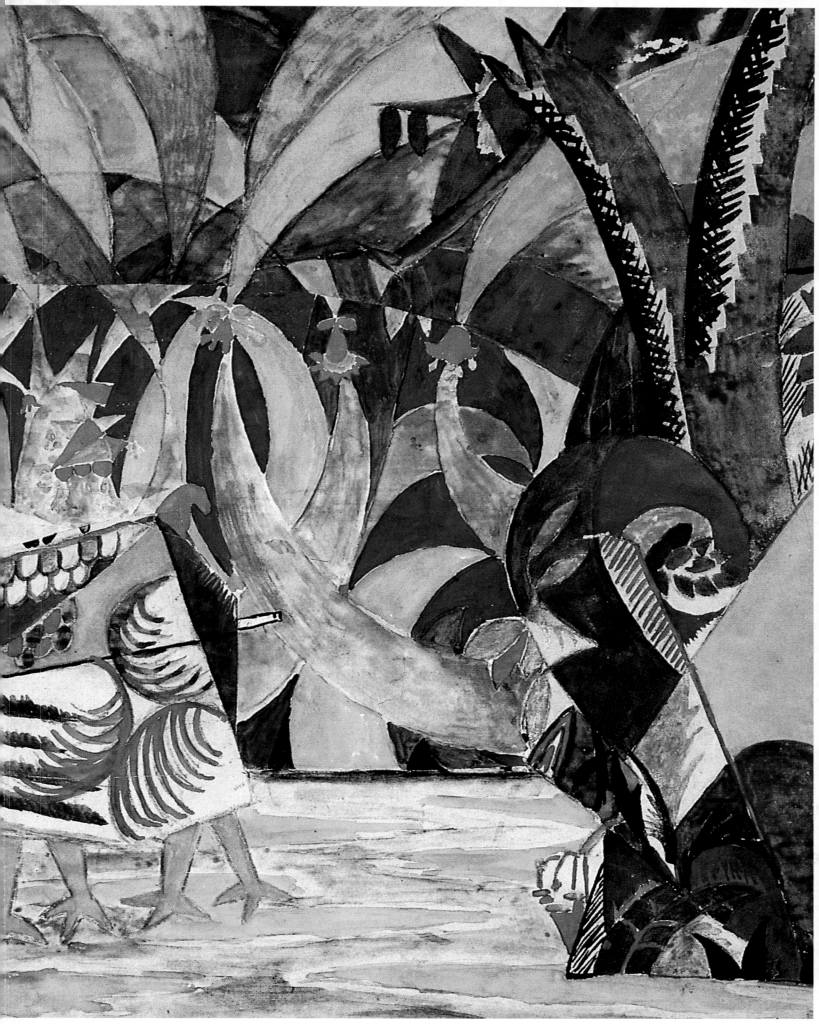

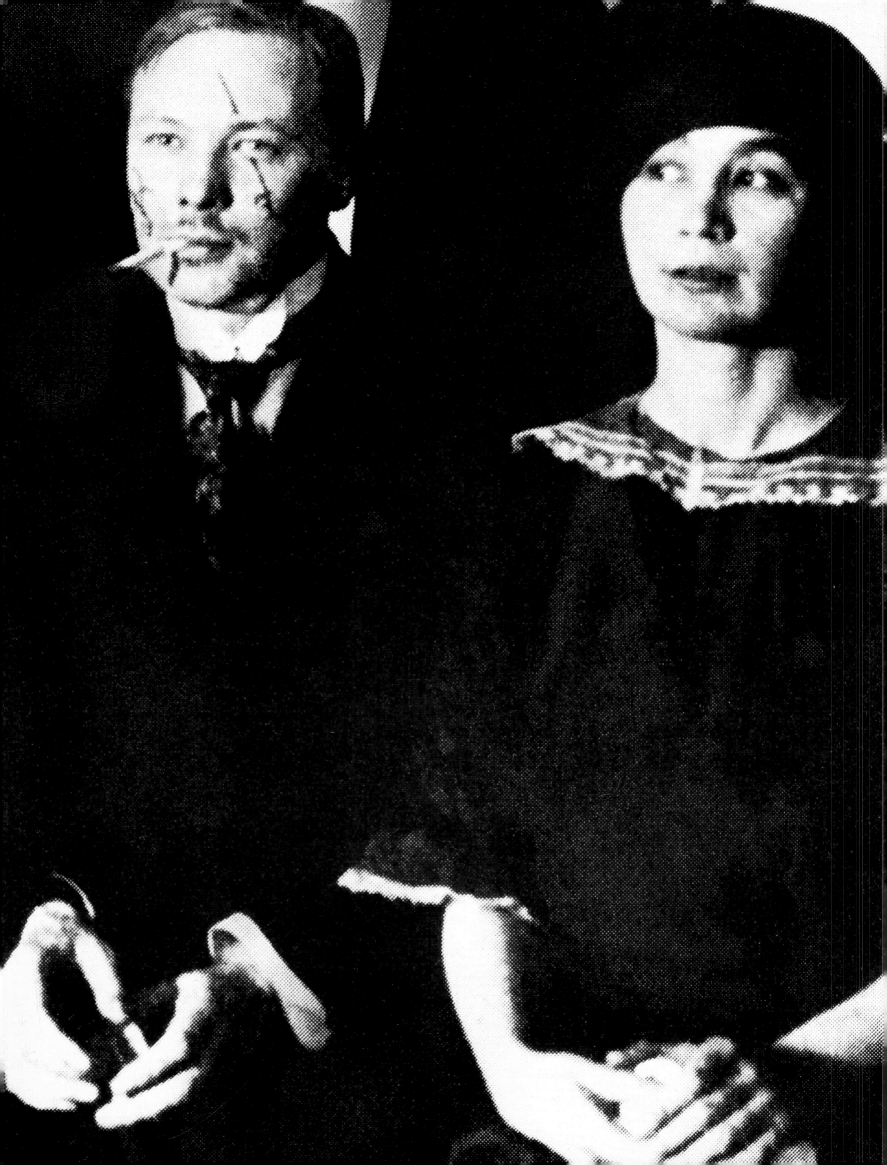

Chronicle of the Artist's Life and Work

1881

22 May (4 June New Style) Mikhail Fiodorovich Larionov is born in Tiraspol, Kherson Province, in the house of his maternal grandfather, Fedosei K. Petrovsky. His father is Fiodor Mikhailovich Larionov, a military pharmacist; his mother, Alexandra Larionova.

1891–95

After the family moves to Moscow, attends the Voznesensky secondary modern school.

1898

Enters the Moscow College of Painting, Sculpture and Architecture. Studies painting under Sergei Ivanov, Konstantin Korovin and Valentin Serov.

1899

Participates as Mikhail Vrubel's assistant in the decoration of the Hotel Metropole in Moscow.

1900

Makes the acquaintance of Natalia Goncharova. Their creative collaboration lasts until her death.

1903

July–August Sketches, together with Natalia Goncharova, in Tiraspol.
Makes the acquaintance of Sergei Diaghilev in Moscow.

1904

Lives and works in Tiraspol.
The 26th Exhibition of Painting of the Students of the College of Painting, Sculpture and Architecture in Moscow (Nos 71–84)*.

1905

January The 27th Exhibition of the Students of the College of Painting, Sculpture and Architecture, Moscow (Nos 51–80); Larionov displays a series of Impressionist canvases *A Corner of a Barn: Evening Hours, Rose Bush, A Sea.*
3–30 April The 3rd Union of Russian Artists exhibition in Moscow (Nos 148–150).

1906

14 January An exhibition of watercolours, pastels, tempera works and drawings in Moscow (Nos 134–142).
February – March The World of Art exhibition, St Petersburg (Nos 145–150).
6 October L'Exposition l'Art russe. Salon d'Automne, Paris (Nos 265–270); his *Garden* (1904, Russian Museum, St Petersburg) is reproduced in the catalogue.

October Visits Paris for the first time together with Sergei Diaghilev, Léon Bakst and Pavel Kuznetsov. On his way back to Russia visits London.
November–December Russische Kunst-Ausstellung, Kunsthandlung Eduard Schulte, Berlin (Nos 220–223b).

1906–07

27 December – 23 January The 4th Union of Russian Artists exhibition, St Petersburg. (Nos 153–156).

1907

11 February – 11 March The 4th Union of Russian Artists exhibition, Moscow (Nos 128–137).
March–May The 14th Society of Moscow Artists exhibition (three works).
22 April – 31 October VII Esposicione Internazionale d'Arte della citta di Venezia, Venice (No 23: *Blossoming Acacias*).

1907–08

26 December – 3 February The 5th Union of Russian Artists exhibition, Moscow (Nos 100–103).
27 December – 15 January The Stefanos exhibition, Moscow (Nos 122–130).

1908

24 March – ? The Wreath exhibition, St Petersburg (Nos 71–75)
5 April – 11 May The first *Golden Fleece* Salon, Moscow (Nos 34–54); at this exhibition Russian viewers were introduced for the first time to new French art — among the artists featured were Bonnard, Braque, Cézanne, Derain, Van Dongen, Gleizes, Van Gogh, Le Fauconnier, Marquet, Matisse, Metzinger, Pissarro, Renoir, Roualt, Signac, Sisley, Bourdelle, Maillol and Rodin.
2–30 November The Link exhibition, Kiev (Nos 146–155); visitors were given a leaflet by David Burliuk, *An Impressionist's Voice in Defence of Painting.*

1909

11 January – 15 February The second *Golden Fleece* Salon, Moscow (Nos 62–75).
28 February – 8 April The 6th Union of Russian Artists exhibition, St Petersburg (Nos 207–217).

1909–10

The first [V. A.] Izdebsky Salon: an International Salon of Paintings, Sculptures, Engravings and Drawings (Nos 290–296). From 4 December 1909 to 24 January 1910 the exhibition is in Odessa, from 12 February to 14 March in

* Here and below the numbers in brackets are those under which Larionov's works were listed in the catalogue of the relevant exhibition.

Kiev, from 19 April to 25 May in St Petersburg, and from 12 June to 7 July in Riga; Larionov displays his primitive works for the first time: *A Provincial Dandy, A Promenade in a Provincial Town*.
27 December 1909 – 31 January 1910 The 3rd *Golden Fleece* Salon, Moscow (Nos 45–66).

1910

16 February The Union of Youth, a society of St Petersburg artists, is organized.
20 February – 20 March The 7th Union of Russian Artists exhibition, St Petersburg (Nos 214–215). This is his last contribution to a Union of Russian Artists exhibition.
8 March – April The 1st Union of Youth exhibition, St Petersburg (Nos 71–80).
May Hylaea, a literary union of the Cubo-Futurists, is established, including David Burliuk, Nikolai Burliuk, A. Gey (Alexander Gorodetsky), Vasily Kamensky, Alexei Kruchenykh, Sergei Miasoyedov, Yekaterina Nizen (Guro), Benedikt Livshitz, Velemir (Victor) Khlebnikov and, later, Vladimir Mayakovsky. The first Hylaea collection, *A Trap for Judges*, is published.
June Visits David Burliuk in the village of Chernianka, Tauride Province (Crimea), and works there.
19 June – 13 August A Union of Youth exhibition organized by Voldemar Matvei is held in Riga (Nos 76–92).
25 September Graduates from the College of Painting, Sculpture and Architecture in Moscow and is given the title of second-class artist.

1910–11

10 December –January A Jack of Diamonds exhibition, Moscow (Nos 103–118), with Larionov as one of its organizers. He presents paintings from his *Soldiers* series for the first time: *Salvo, The Soldiers*.
December – January The 2nd Izdebsky Salon: The International Salon of Paintings, Sculpture, Engravings and Drawings, Odessa (Nos 254–276); Wassily Kandinsky's abstract works are shown for the first time in Russia.

1911

5 April – 10 May The 2nd Union of Youth exhibition, St Petersburg (Nos 164–168).
15 November – December The World of Art exhibition, Moscow (Nos 132–133).
8 December Mikhail Larionov: A One-Day Exhibition at the Society of Free Aesthetics, Moscow (Nos 1–124) — his only one-man show before the 1917 revolution; Larionov's works are dated in the catalogue for the first time.
December The "Moscow Salon" exhibition, Moscow (No 306).

1911–12

4 December – 10 January The 3rd Union of Youth exhibition, St Petersburg (Nos 21–27).

1912

12 January Der blaue Reiter. Die zweite Ausstellung, Munich (No 123).
January – February The World of Art exhibition, St Petersburg (one work).
12 February The first debate of the Jack of Diamonds artists in the Politechnical Museum in Moscow. A breach takes place between the Jack of Diamonds group and the Donkey's Tail.
11 March – 8 April The Donkey's Tail exhibition, Moscow (Nos 98–140), organized by Larionov. The exhibition included a display of works by Union of Youth artists.
April The 4th Union of Youth exhibition, St Petersburg (6 works).
May – June At military camp with the Yekaterinoslav Regiment.
Early October The first Futurist lithographed book, *Starinnaya liubov'* [*Old-Time Love*] by Alexei Kruchenykh, is published with drawings and hand-written text by Larionov.

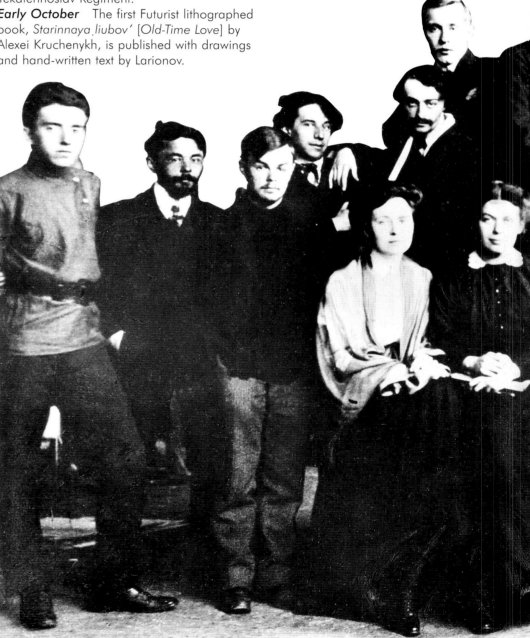

Students of the School of Painting, Sculpture and Architecture. Mikhail Larionov is the third from the right, seated. Photograph. 1909 or 1910

5 October – 31 December The Second Post-Impressionist Exhibition, Grafton Galleries, London (No 249: *The Soldiers*)
November – December The World of Art exhibition in Moscow (No 155 a, b, v); for the first time he shows his Rayonist canvases: *Glass: The Method of Rayonism, Rayonist Study*. The exhibition goes on to St Petersburg in January and February 1913 (Nos 205–207), and Kiev in March 1913.

1912–13

4 December – 10 January The 5th Union of Youth exhibition, St Petersburg (Nos 117–122).

1913

February Publishes an introduction to the catalogue *The First Exhibition of Lubok Prints* (19–24 February, Moscow) organized by the architect Nikolai Vinogradov.
6 March The literary group Hylaea joins the Union of Youth on a federative basis.
23 March A debate of the Target group, *The East, Nationality and the West* is held in the Politechnical Museum, Moscow; a leaflet is issued with summaries of the participants' speeches. Larionov expounded his theory of Rayonism. Simultaneously, in the Trinity Theatre in St Petersburg, a debate of the Union of Youth, *On the Present-Day State of Painting*, is held; papers are read by

David Burliuk (*The Art of Innovators and Academic Art in the 19th and 20th Centuries*) and Kasimir Malevich (*About the Jack of Diamonds and the Donkey's Tail*); the manifesto of the Union of Youth written by Olga Rozanova is distributed.
24 March A debate of the Union of Youth, *On the Latest Russian Literature* (Trinity Theatre, St Petersburg); papers are presented by Vladimir Mayakovsky, Alexei Kruchenykh, Nikolai Burliuk and David Burliuk.
24 March – 7 April The Target exhibition, Moscow (Nos 66–81), organized by Larionov; children's drawings and painted signboards are displayed.
24 March – 7 April The exhibition "Prototypical Icons and Lubok Prints" organized by Larionov is held in Moscow; the display mainly consists of icons and lubok prints from the Larionov collection.
May – June Called up to a training camp at Khodynka near Moscow.
June The book *Nataia Goncharova. Mikhail Larionov* by Ilya Zdanevich (under the pseudonym Eli Eganbiuri) is published in Moscow in 525 copies, 25 of them with lithographs tinted in watercolours by Larionov and Goncharova.
18–19 July Members of the Union of Youth, Matiushin, Malevich and Kruchenykh, hold the first All-Russian Congress of Futurists at Uusikirkko, Finland, and issue a manifesto about the transformation of the Russian theatre and the establishment of the new "Budetlianin" [Futurist] theatre.
July A collection of essays, *The Donkey's Tail and the Target*, is published in Moscow in 525 copies.
September Larionov tries to organize a Futurist theatre (the Futu Theatre) attempting to get ahead of the Union of Youth performances. The planned productions performances of three plays by Lotov (Konstantin Bolshakov) fail to materialize.
20 September – 1 December Erster Deutscher Herbstsalon, Galerie Der Sturm, Berlin (Nos 248–250).
29 September – 5 November One-woman exhibition of Natalia Goncharova, Moscow; the introduction to the catalogue is signed by Goncharova, although written by Larionov.
19 October Participates, together with Mayakovsky, Goncharova and Balmont, in the inauguration of the Futurist cabaret The Pink Lantern (Mamonovsky Lane, Moscow). Mayakovsky, who appeared in a striped jacket, called himself "the black sheep of Russian literature" and recited a pamphlet poem *Nate!* [*Take That!*]. Larionov, with his face painted, declares: "Ladies and gentlemen, you are the donkeys of the present days." The audience demands Larionov elucidate his credo "in five

minutes". "'You want me to tell you about my work in five minutes? I have been trying to teach the crowd for ten years already but it fails to understand me. <...> So how do you, a crowd, want to understand me in five minutes?'" Balmont climbs on a chair: 'Larionov! You're splendid! The design on your face is beautiful. <...> I've seen similar ones on the faces of old Maoris. <...> Long live Larionov! Long live the blockheads seated around him!' The evening ended in scandal and the opening of the cabaret was forbidden" ("Rozovoye mordobitiye" ["A Pink Punch-Up"], *Moskovskaya gazeta* [*The Moscow Gazette*], 21 October 1913).

5 November Ilya Zdanevich reads a paper at the closing of Natalia Goncharova's exhibition, devoted to *vsechestvo*, universality, a new aesthetic theory propounded by him together with Larionov and Goncharova.

2–5 December The Union of Youth stages two productions in the Luna-Park Theatre in St Petersburg: the tragedy *Vladimir Mayakovsky* (with stage sets by Filonov and Shkolnik) and the opera *Victory over the Sun* by Matiushin and Kruchenykh (the first elements of Suprematism can be discerned in Malevich's stage sets). The World of Art exhibition, Kiev (Nos 95–97).

1913–14

December – January The World of Art exhibition, Moscow (No 244).

1914

January The film *In Tavern No 13* featuring Larionov and Goncharova appears on the screen.

29 May Leaves for Paris together with Goncharova to take part in Diaghilev's ballet venture.

17 June – 30 June Exposition Natalie de Gontcharova et Michel Larionow, Galerie Paul Guillaume, Paris (nos 1–29 and 15 lithographs). Guillaume Apollinaire publishes an article about this exhibition *Soirée de Paris*, 1914, Nos 26–27).

August After war breaks out, returns to Moscow together with Natalia Goncharova, and is called up for active service.

Late September – October Serves in the army of General Rennenkampf on the East Prussian front. After a serious contusion is sent to a hospital in Moscow. Organizes the exhibition "No 4. Futurists, Rayonists, Primitives" in Moscow (Nos 87–102).

1915

5 January Leaves the hospital and is exempted from further military service.
5 April The exhibition of painting "The Year 1915", Moscow (Nos 59 a, b, 60, 60a–65).
23 June Leaves for Europe (Sweden, England, Switzerland) together with Goncharova at Diaghilev's invitation to work for his ballet company.

1916

1 January Arrives in Paris.
8 July – 9 October Stays in Spain with Diaghilev's troupe and creates set designs for the ballet *Kikimora* with music by Alexander Liadov. The first performance takes place at San Sebastian.
8 September Leaves for Italy.

1916–17

September – 4 April 1917 Works on set designs for the ballet *Russian Fairy-Tales* in Rome.

1917

Meets Marinetti
Spends the summer in Venice, Florence and Turin.
October Returns to Paris.

1918

15 April – ? Exhibition of Works by the Moscow Futurists, Tiflis (15 works).
16 April – 7 May Exposition des oeuvres de Gontcharova et de Larionow. L'Art Décoratif Théâtral Moderne, Galerie Barbazanges, Paris (Nos 231–358).

1920

April Alexander Blok's poem *The Twelve* is published in French and English with Larionov's illustrations in Paris and London. The First State Exhibition of Art and Science, Kazan (No 81).

1921

17 May The first performance of Sergei Prokofiev's ballet *Le Chout* with sets, costumes and curtain by Larionov is given in Paris.

1922

18 May The first performance of Igor Stravinsky's ballet *Le Renard* with sets, costumes and the curtain by Larionov is given in Paris.
24 November Attends a party given in honour of Mayakovsky at the editorial office of the *Udar* [Blow] magazine, where Mayakovsky recites his poems. The Goncharova–Larionov Exhibition, The Kingore Galleries, New York.

Apollinaire Writing a Religious Piece. Drawing. 1913

1923

23 February A ball for the benefit of Russian painters is held in Paris, with Larionov as one of the organizers; he also designed the posters and the invitation.
Mayakovsky's poem *The Sun* is published in Moscow with Larionov's illustrations.

1923–24

9 December – 15 May His works are shown at the exhibition "Russian Lithography over the past 25 Years" at the Russian Museum in Leningrad.

1924

11 July Participates in the organization of the Bal olympique as vice-president of the Union of Russian Artists in Paris.
8 November The exhibition "The Peasant in Russian Painting", Tretyakov Gallery, Moscow (Nos 131).

1927

1 March An exhibition of works by members of the Jack of Diamonds group, Tretyakov Gallery, Moscow (Nos 32–41).
1 November Larionov's works are included in the display of the Department of the Newest Trends in Russian Art at the Russian Museum in Leningrad.

1928

The "Modern French Art" exhibition, Moscow (Nos 185–188).
Nikolai Punin's essay "The Impressionist Period in M. F. Larionov's Oeuvre" is published.
The exhibition "Art russe ancien et moderne, organisée par le Palais des Beaux-Arts de Bruxelles" (Nos 782–784).
The Exhibition of Contemporary Russian Art, Birmingham (Nos 49–51).

1929

12 June The first performance of Igor Stravinsky's ballet *Le Renard* with new stage sets and costumes by Larionov in the spirit of Constructivism.
19 August Sergei Diaghilev dies.
September The Anti-Alcohol Exhibition, Moscow (No 47, *Dancers*).

1931

11–25 April The "Mikhail Larionov" exhibition is held in the Galerie de L'Epoque in Paris.

1936

Participates in the "Cubism and Abstract Art" exhibition at the Museum of Modern Art in New York. The museum purchases all Larionov's displayed works.

May–October Is awarded a silver medal together with Natalia Goncharova at the Triennale "Art décoratifs et industriels et architecture" in Milan.
September Contributes to the "Internationale Ausstellung fuer Theaterkunst" in Vienna. Larionov's works on display are purchased by the Nationalbibliotheke.

1938

Becomes, simultaneously with Natalia Goncharova, a French citizen.

1941

14 June – 13 July Takes part in the Salon des Tuileries and Salon des Indépendants in Paris.

1941–46

November 1941 – February 1942
Participates in the Exhibition of Russian Art at the Museum of Art, Philadelphia. The exhibition travels around the USA until 1946.

1943

12 June – 11 July Participates for the last time in the Salon des Tuileries in Paris.

1948

6–19 December The exhibition "Le rayonnisme 1909–1914 (peinture de Michel Larionov et de Nathalie Gontcharova)", organized by Michel Seuphor, is held in the Galerie des Deux Iles, Paris.

1949

May Contributes to the exhibition "Les Premiers Maîtres de l'Art Abstrait", Galerie Maeght, Paris.

1954

August The Diaghilev Exhibition, Edinburgh (Nos 211–247).

1955

2 June Officially marries Natalia Goncharova in the Mayor's Office of the 6th arrondissement in Paris.

1956

25 May – 13 June The exhibition "Michel Larionov, oeuvres anciennes et re/centes" is held at the Galerie de l'Institut in Paris.

1957

10 April – ? The exhibition "Art abstrait: les premières générations (1910–1939)" is held

Invitation to the Ball for the Benefit of Russian Artists (Paris, 1923)

169

at the Musée d'art et d'industrie, Saint-Etienne; a large number of works from the Rayonist period are displayed.

1960

Takes part in the Biennale at Venice.

1960–61

4 November – 23 January Contributes to the exhibition "Les Sources du XXe siècle" held at the Musée National d'Art Moderne in Paris.

1961

9 February - ? The exhibition "Larionow–Gontcharowa", Galerie Schwarz, Milan.
4 June Celebrates his 80th birthday.
July – September The exhibition "Larionov–Gontcharova", Galerie Beyeler, Basle.
9–30 September The exhibition "Larionov and Goncharova. A Retrospective Exhibition of Paintings and Designs for the Theatre", the City Art Gallery, Leeds.
14 October – 4 November The same exhibition is shown at the City Art Gallery in Bristol.

16 November – 16 December The same exhibition is displayed at the Arts Council Gallery in London (Nos 1–85).

1962

17 October Natalia Goncharova dies. She is buried on 22 October at the Ivry cemetery in Paris.

1963

23 April – 8 June He participates in the exhibition "La Collection d'un Amateur" at the Galerie Katia Granoff in Paris.
28 May He marries Alexandra Tomilina.
July–September The exhibition "La Grande Aventure de l'art au XXᵉ siècle", Chateau des Rohan, Strasbourg (one work).
27 September – November The last lifetime retrospective "Exposition Gontcharova–Larionov" is held at the Musée d'Art moderne de la ville de Paris (65 paintings and 21 graphic works).
1–15 December The exhibition of drawings "M. F. Larionov–Tegninger", Galerie Hybler, Copenhagen (30 drawings).
10 May Mikhail Larionov dies at Fontenay-aux-Roses near Paris. He is buried at the Ivry cemetery.

Mikhail Larionov on his birthday. Photograph. 1961

Events since 1964
EXHIBITION WHERE LARIONOV'S WORKS WERE DISPLAYED
AND THE MAIN PUBLICATIONS BY AND ABOUT HIM IN THIS PERIOD

1965

23–27 September Artists-Designers
of Mayakovsky's Works. The V. V. Mayakovsky
Museum Library, Moscow (book publications).
Organized by N. I. Khardzhiyev

1966

The Exhibition of Paintings, Drawings
and Watercolours by Russian Artists from
the Collection of Ya. E. Rubinstein
(the First Three Decades of the 20th Century),
Tallinn (12 works)
Waldemar George's book *Larionov*
is published in Paris, the first monograph
devoted to the artist

1967

Paintings and Graphic Works by Russian
Artists of the First Three Decades of
the Twentieth Century. From the Collection
of Ya. E. Rubinstein and T. S. Zhegalova
(Moscow), Novosibirsk (12 works)
Paintings and Graphic Works by Russian Artists
of the First Three Decades of the Twentieth
Century. From the Collection
of Ya. E. Rubinstein, Alma-Ata (12 works)

1968

February–March The Russian Print of the
Late 19th and Early 20th Century. The State
Russian Museum, Leningrad (lithographs)
Nikolai Khardzhiyev's article "To the Memory
of Natalia Goncharova and Mikhail
Larionov" is published (*The Art of the Book*,
Moscow, 1968).

1970

Larionov's book *Diaghilev et les Ballets Russes*
is published (La Bibliotheque des Arts, Paris)

1971

D. V. Sarabyanov, "Primitivistsky period
v tvorchestve Mihaila Larionova ["Primitivist
Period in the Work of Mikhail Larionov"],
in D. Sarabyanov, *Russikaya zhivopis' kontsa
1900-h – nachala 1910-h godov [Russian
Painting of the Late 1900s – Early 1910s*,
Moscow, 1971]

1974

M. A. Spendiarova, the widow of the artist
Sergei Romanovich, presents a number
of Larionov's paintings and graphic works
to the Russian Museum

1977

28 April – 7 July Book covers by Russian
Artists of the Early Twentieth Century. Russian
Museum, Leningrad (Nos 107–113)

1979

Russian Art of the First Three Decades
of the 20th Century. From the Collection
of Ya. E. Rubinstein (Moscow). Yaroslavl
(8 works)

1980

20 August – 15 September Mikhail
Larionov: 1881–1964. Russian Museum,
Leningrad. Larionov's largest one-man show
— 290 paintings and graphic works from
museums and private collections of the former
Soviet Union, as well as from the collection
of the artist's widow, A. K. Tomilina (Paris),
are displayed
3 September – October Mikhail Larionov.
Tretyakov Gallery, Moscow

1981

July – September Moscow–Paris:
1900–1930. Pushkin Museum of Fine Arts,
Moscow

1988

Russian Theatrical Decorative Art:
1880–1930. The Nikita and Nina Lobanov-
Rostovsky Collection. Pushkin Museum of Fine
Arts, Moscow – the Central Exhibition Hall,
Leningrad

1990

The Avant-garde and Tradition of the
Engraved Book in Russia. The Print
Department of the Saltykov-Shchedrin Public
Library (now the National Library of Russia),
Leningrad

1993

The Avant-Garde and Its Russian Sources.
Russian Museum, St Petersburg (Nos 31–37)

1996

April–June Moscow–Berlin: 1900–1950.
Pushkin Museum of Fine Arts, Moscow

Bibliography

Published texts by Mikhail Larionov

"Gazetniye kritiki v roli politsiyi nravov" ["Newspaper Critics in the Role of a Vice Squad"], *Zolotoye runo* [*The Golden Fleece*], Moscow, Nos 11–12, 1909

Cherry, "Ssora 'khvostov' s 'valetami' (Intervyu s Larionovym)" ["The Quarrel between the 'Tails' and the 'Jacks'(An Interview with Larionov)"], *Golos Moskvy* [*The Voice of Moscow*], 11 December 1911

"Mneniye o syezde khudozhnikov" ["An Opinion on the Congress of Artists"], *Protiv techeniya* [*Against the Tide*], 24 December 1911

Introduction to the catalogue *Vystavka kartin N. S. Goncharovoi. 1900–1913* [*Exhibition of Paintings by N. S. Goncharova. 1900–13*], Moscow, 1913. (The author of the article was Larionov, but it was signed by Goncharova. See *Letter from Larionov to I. M. Zdanevich* of 24 April 1913. Russian Museum Archive, St Petersburg

Introduction to *The Target* Exhibition Catalogue, Moscow, 1913

Introduction to the catalogue *Pervaya vystavka lubkov* [*The First Exhibition of Lubok Prints*], Moscow, 1913. Reprinted in the catalogue *Ikonopisniye podlinniki i lubki* [*Prototypical Icons and Lubok Prints*]. Moscow, 1913

M. Larionov, I. Zdanevich, "Pochemu my raskrashivayemsia" ["Why We Paint Ourselves"], *Argus*, St Petersburg, No 12, 1913

Luchism [*Rayonism*], Moscow, 1913

"Luchism Larionova: Tezisy" ["Larionov's Rayonism: Theses"], Leaflet for the *Target* debate on the subject "The East, Nationality and the West", Moscow, 23 March 1913

"Rayonist Painting", *Osliny khvost i Mishen'* [*The Donkey's Tail* and *The Target*], Moscow, 1913

"Luchisty i budushchniki: Manifest" ["The Rayonists and the Futurists: a Manifesto"] (signed by Larionov and ten artists of his group), *ibid.*

Introduction to the catalogue *No 4. Vystavka kartin — futuristy, luchisty, primitiv* [*An Exhibition of Painting: Futurists, Rayonists, Primitives*], Moscow, 1914

M Larionov, I. Zdanevich, "Da – manifest" ["Yes – A Manifesto"], Teatr v karikaturah [Theatre in Caricatures], Moscow, I January 1914

"K raspre futuristov" ["Regarding the Quarrel among the Futurists"] [Letter to the Editor], *Nov''* [*The New*], 29 January 1914

"Ob ideye vystavki vsekh obshchestv" ["On the Idea of an Exhibition of All Societies"], *Nov'*, 29 January 1914

"Letter to the Editor", *Nov'*, 31 January 1914

"Iz rasskaza ranenogo khudozhnika Larionova" ["From an Account Given by the Wounded Artist Larionov"], *Russkiye vedomosti* [*Russian Gazette*], Moscow, 16 September 1914

"Le Rayonnisme Pictural", *Montjoiei*, Paris, Nos 4–6, 1914

Larionov / Gonciarova: Radiantismo, Rome, 1917

N. Gontcharova, M. Larionov, P. Vorms, *Les Ballets Russes de Serge de Diaghilev et la décoration théâtrale*, Paris–Belvès, 1930

"Souvenir sur Diaghilev", *La Revue Musicale*, Paris, December 1930

"A Letter of 29 November 1922 to V. V. Mayakovsky", *Tridtsat' dnei* [*The Thirty Days*], Moscow, No 7, 1937

"The Art of Stage Decoration", *Continental Daily Mail*, 13 December 1949

N. Gontcharova, M. Larionov, P. Vorms, *Serge de Diaghilev et la décoration théâtrale (nouvelle édition revue et augmentée)*, Paris, 1955

"Malevich: Souvenirs de Michel Larionov. — Aujourd'hui", *Art et Architecture*, Paris, December 1957

"Michel Larionov: Première rencontre avec Diaghilev", *Art et Dance: Les Informations Chorégraphiques*, Paris, No 4, 1959

Le Rayonnisme: Larionov – Gontcharova, Galerie Bayeler: Catalogue Basle, 1961

"La Peinture rayonniste", in Waldemar George, *Larionow*, Paris, 1966

"Vospominaniya M. F. Larionova" ["Reminiscences of Mikhail Larionov"], *Russkiye novosti* [*Russian News*], Paris, 5 May, 12 May, 9 June, 1 September 1967

"Khudozhestvenniye zametki" ["Artistic Observations"], *Russkiye novosti*], Paris, 12 January 1968

"Iz posmertnykh zapisok M. F. Larionova" ["From Mikhail Larionov's Posthumous Papers"], *Russkiye novosti*, Paris, 20 January, 1968

"Iz dnevnika M. F. Larionova", *Russkiye novosti*, Paris, 9 August 1968

"Kontrasty (Iz zapisnoi knizhki M. F. Larionova)" ["Contrasts (From Mikhail Larionov's Notebook)"], *Russkiye novosti*, 9 August 1968

"Glavnaya liniya sovremennogo baleta: Iz arkhiva M. Larionova" ["The Main Trend in Contemporary Ballet: From Mikhail Larionov's Archive"], *Russkiye novosti*, 20 December 1968

"Pensées sur l'Art", in the catalogue: *Rétrospective Larionov*, Galerie de Paris, Paris, 1969

Reprinted in the catalogues: *Rétrospective Larionov*. Maison de la Culture de Nevers et la Nièvre

"Texte inédit de Larionov", *La Galerie des Arts*, Paris, 1 June 1969

Diaghilev et les Ballets Russes. Dessins et textes de Michel Larionov, Paris, 1970

"Luchism" ["Rayonism"], in *Mastera iskusstv ob iskusstve* [*Masters of Art on Art*], vol. 7, Moscow, 1970

Lausanne, 1972; Larionov, Gontcharova, rétrospective. Musée d'Ixelles, Bruxelles, Neuchâtel, 1976

"Rayonist Painting", in *Russian Art of the Avant-Garde. Theory and Criticism: 1902–1934*. Edited and Translated by John E. Bowlt, New York, 1976

"Pictorial Rayonism", *ibid.*

"La nouvelle exposition du groupe 'La cible'", in *Zabludivshiysia tramvai: Art et Poésie russes. 1900–1930* [*The Lost Tram: Art et Poésies russes. 1900–1930*]. Textes choisies, Paris, 1979

Literature on Mikhail Larionov

K. Siunnerberg, "Vystavka *Mir Iskusstva*" ["*The World of Art* Exhibition"], *Vesy* [*The Scales*], Moscow, Nos 3–4, 1906

Konst. S (Siunnerberg), "Parizhskiye gazety o russkoi vystavke" ["Paris Newspapers on the Russian Exhibition"], *Zolotoye runo* [*The Golden Fleece*], Nos 11–12, 1906

A. Rostislavov, "Vystavochnoye tvorchestvo" ["The Exhibition Art"], *Zolotoye runo*, No 1, 1907

I. Grabar, "'Soyuz' i 'Venok'" ["'Union' and 'The Garland'"], *Vesy*, No 1, 1908

P. Muratov, "Staroye i molodoye na poslednikh vystavkakh" ["The Old and the New at Recent Exhibitions"], *Zolotoye runo*, No 1, 1908

S. Glagol, "Moi dnevnik: Kartinnye vystavki" ["My Diary: Picture Exhibitions"], *Stolichnaya molva* [*Rumours around the Capital*], 2 February 1909

I. Grabar, "Moskovskiye vystavki: *Zolotoye runo*, *Tovarishchestvo i Peredvizhniki*" ["The Golden Fleece, The Association and The Itinerants Moscow Exhibitions"], *Vesy*, No 2, 1909

M., "O Salone Izdebskogo (Pis'ma iz Peterburga)" ["About Izdebsky's Salon (Letters from St Petersburg)"], *Zolotoye runo*, Moscow, Nos 11–12, 1909

A. Benois, "Khudozhestvennye pis'ma. Itogi" ["Art Letters. Review"], *Rech'* [*Discourse*], 26 March 1910

"Beseda s N. S. Goncharovoi" ["Interview with N. S. Goncharova"], *Stolichnaya molva*, 5 April 1910

G. Lukomsky, "Khudozhestvennaya zhizn' Moskvy" ["The Artistic Life of Moscow"], *Apollon* [*Apollo*], No 5, 1910

S. Makovsky, "Khudozhestvennye itogi" ["Art Review"], *Apollon*, No 7 1910

M. Voloshin, "Bubnovyi valet" ["The Jack of Diamonds"], *Apollon*, No 1, 1911

S. Makovsky, "Vystavka 'Mir iskusstva'" ["An Exhibition of the World of Art Society"], *Apollon*, No 2, 1911

A. Rostislavov, "Vystavka 'Soyuza molodiozhi'" ["An Exhibition of the Union of Youth"], *Rech'*, 24 April 1911

"Vystavka Larionova v Literaturno-khudozhest-vennom kruzhke" ["Larionov's Exhibition in the Circle of Literature and Art"], *Stolichnaya molva*, 14 November 1911

"Vystavka khudozhnika Larionova" ["An Exhibition of Works by the Artist Larionov"], *ibid.*, 21 November 1911

P. Ettinger, "An Exhibition of the World of Art Society", *Apollon*, No 20, 1911

F. Mukhortov, "Progressivniy paralich (Vystavka kartin M. F. Larionova)" ["Progressive Paralysis (An Exhibition of Works by M. F. Larionov)"], *Golos Moskvy* [*The Voice of Moscow*], 9 December 1911

Cherry, "Ssora 'khvostov' s 'valetami' (Intervyu s Larionovym)" ["The Quarrel Between the 'Tails' and the 'Jacks'(Interview with Larionov)"], *Golos Moskvy* [*The Voice of Moscow*], 11 December 1911

B. Shuisky, "M. F. Larionov", *Protiv techeniya*, 17 December 1911

I. Mavich, "Disput u 'Bubnovykh valetov'" ["A Debate among the Jacks of Diamonds"], *Stolichnaya molva*, 13 February 1912

B. Sh. [B. Shuisky]. "Khudozhestvenniy disput" ["An Artistic Debate"], *Protiv techeniya*, 18 February 1912

"Disput na vystavke 'Bubnovogo valeta' v Moskve" ["Debate at the Jack of Diamonds Exhibition in Moscow"], *Protiv techeniya*, 18 February 1912

V. Shuisky, "'Osliny khvost' i 'Soyuz molodiozhi'" ["The Donkey's Tail and the Union of Youth", *Utro Rossii* [*The Morning of Russia*], 12 March 1912

F. M., "Osliny khvost" ["The Donkey's Tail"], *Moskovskaya Gazeta* [*The Moscow Gazette*], 12 March 1912

A. K., "Osliny khvost" ["The Donkey's Tail"], *Utro Rossii*, 13 March 1912

Philograph, "Osliny khvost" ["The Donkey's Tail"], *Golos Moskvy*, 13 March 1912

Chernobeg, "Kopchoniye khvosty" ["Smoked Tails"], *Utro Rossii*, 22 March 1912

"Zakrytiye vystavok" ["The Closing of the Exhibitions"], *ibid*, 9 April 1912

"Sredi khudozhnikov" ["Among Artists"], *Stolichnaya molva*, 28 May 1912

V. Mak [Pavel Ivanov], "Luchizm" ["Rayonism"], *Golos Moskvy*, 14 October 1912

"'Venery' M. Larionova" [M. Larionov's Venuses], *Stolichnaya molva*, 29 October 1912

"Budushchaya mishen' dlia kritiki" ["The Future Target for Critics"], *Obozreniye teatrov* [*A Review of the Theatres*], 2 November 1912

"'Soyuz molodiozhi'. Zapiski molodogo provintsiala" ["The Union of Youth. Observations of a Naive Provincial", *Peterburgsky listok* [*St Petersburg Sheet*], 12 December 1912

A. Benois, "Vystavka 'Soyuza molodiozhi'" ["An Exhibition of the Union of Youth"], *Rech'*, 21 December 1912

M. Voloshin, "Osliny khvost" ["The Donkey's Tail"], *Apollon*, No 7, 1912

"An Interview with Larionov", *Moskovskaya gazeta*, 7 January 1913

F. M. [F. Mukhortov], "'Luchisty': (V masterskoi Larionova i Goncharovoi)" ["The Rayonists: In the Studio of Larionov and Goncharova"], *ibid.*, 7 January 1913

S. Khudakov, "Literatura. Khudozhestvennaya kritika. Disputy i doklady" ["Literature. Art Criticism. Debates and Reports"], *Rech'*, *ibid*.

A. Izmailov, "Rytsari 'Oslinogo khvosta'", ["Knights of the Donkey's Tails"], *Birzheviye vedomosti*, 25 January 1913

B. Anrep, "Po povodu londonskoi vystavki s uchastiyem russkikh khudozhnikov" ["About an Exhibition in London including Russian Artists"], *Apollon*, No 2, 1913

"Nashi 'futuristy' o svoyom skandale" ["Our 'Futurists' on Their Scandal"], *Moscovskoye utro* [*The Moscow Morning*], 25 March 1913

Ya. Tugendhold, "Moskovskiye vystavki" ["Exhibitions in Moscow"], *ibid.*, No 3, 1913

S. Glagol, "Po vystavkam" ["Around the Exhibitions"], *Stolichnaya molva*, 25 March 1913

"Skandal na sobraniyi khudozhnikov" ["A Scandal at a Meeting of Artists"], *Russkaya molva* [*Russian Rumours*], 25 March 1913

F. M., "Mishen'" ["The Target"], *Moskovskaya gazeta*, 25 March 1913

I. Nakatov, "Osiol iskusstva" ["A Donkey of Art", *ibid.*, 26 March 1913

A. Benois, "Ikony i novoye russkoye iskusstvo" ["Icons and New Russian Art", *Rech'*, 5 April 1913

A. Rostislavov, "Doklad o futurizme" ["A Report on Futurism"], *Rech'*, 9 April 1913

N. Goncharova, M. Larionov, "16 risunkov" ["16 Drawings", *Apollon*, No 6, 1913

"Raskrashenniy Larionov" ["The Painted Larionov"], *Moskovskaya gazeta*, 9 September 1913

"Rozovoye mordobitiye" ["Pink Punch-Up"], *ibid.*, 21 October 1913

F. Mukhortov, "Lider 'Oslinogo khvosta'" ["The Leader of the Donkey's Tail"], *Moskovskaya gazeta*, 28 November 1913

"Pis'mo v redaktsiyu gruppy 'vsekov'" ["A Letter to the Editor of the Group of 'Universalists'", *Birzheviye vedomosti* [*The Exchange Gazette*], 29 November 1913

Eli Eganbiuri [I. M. Zdanevich], *Natalia Goncharova, Mikhail Larionov*, Moscow, 1913

Varsonofy Parkin, "'Osliny khvost' i 'Mishen'" ["The Donkey's Tail and the Target"], in 'Osliny khvost' i 'Mishen' [*The Donkey's Tail and the Target*], A Collection of Articles, Moscow, 1913

S. Bobrov, "O novoi illiustratsii"
["On New Illustrations", in *Vertogradari nad lozami*
[*Gardeners over Vines*], Moscow, 1913

A. Kruchenykh, "Zametki ob iskusstve"
[Notes on Art"], in A. Kruchenykh, V. Khlebnikov,
Ye. Guro, in *Troye* [*The Three*], St Petersburg, 1913

"Futuristicheskaya fil'ma" ["A Futurist Film"],
Nov', 30 January 1914

V. Mayakovsky, "Zhivopis' segodniashnego
dnia" ["Painting of the Present Day"], *Novaya zhizn'*
[*New Life*], No 5, 1914

S. Bobrov, "Osnovy novoi russkoi zhivopisi"
["The Basic Principles of New Russian Painting"],
Trudy Vserossiyskogo syezda khudozhnikov
[*Transactions of the All-Russian Congress of Artists*],
vol. 1. Petrograd, 1914

G. A. [Apollinaire], "Exposition Natalie de
Gontcharowa et Michel Larionow", *Les soirées
de Paris*, Nos 26–27, 1914

G. Apollinaire, Introduction to the catalogue:
*Exposition Natalie de Gontcharowa et Michel
Larionow*, Galerie Paul Guillaume, Paris, 1914

Yevg. Adamov, "Zhivopis' 1915 goda"
["The Painting of 1915: A Letter from Moscow"],
Kiyevskaya mysl' [*Kievan Thought*], 6 May 1915

V. Mayakovsky, "Rossiya. Iskusstvo. My"
["Russia. Art. We", *Nov'*, 19 November 1914

Ye. G. Rodin, *Futurizm i bezumiye*
[*Futurism and Insanity*], St Petersburg, 1914

Ashkinazi, "Pis'mo iz Moskvy. Na vystavkakh"
["A Letter from Moscow. Visiting Exhibitions",
Apollon, No 2, 1915

N. Ya-o, "O vystavke '1915'" ["About the
Exhibition '1915'"], *Mlechny put'* [*The Milky Way*],
No 4, 1915

A. Benois, "Vystavka sovremennoi russkoi zhivo-
pisi" ["An Exhibition of Modern Russian Painting"],
Rech', 2 December 1916

N. Radlov, "O fururizme i 'Mire iskusstva'"
["About Futurism and the World of Art", *Apollon*,
No 1, 1917

Léon Bakst, "Choréographie et Décors
des nouveaux Ballets Russes", in *Ballets Russes.
Programme*, Paris, 1917

S. G. "Vystavki v 1918 g." ["Exhibitions
in 1918"], ARS, Tiflis, No 1, 1919

V. Parnack, "Gontcharova et Larionov",
L'art décoratif théâtral moderne, Paris, 1919

G. Lukomsky, "Mir iskusstva" ["The World of
Art"], *Zhar-Ptitsa* [*The Firebird*], Berlin, No 1, 1921

W. George, "Le Costume théâtral Gontcharowa,
Larionow. Leur costumes rigides et l'avenir du
costume théâtral", *Le Crapoullaz*, Paris, April 1921

A. Levinson, "Les Hommes des 'Ballets Russes':
Larionov", *Zhar-ptitsa*, No 12, 1923

V. Iving, "Russkoye iskusstvo za granitsei"
["Russian Art Abroad"], *Khudozhestvenniy trud*
[*The Artistic Labour*], No 2, 1923

G. I. Isarlov, "M. F. Larionov", *Zhar-ptitsa*,
No 12, 1923

Ya. Tugendhold, "'Vystavka kartin': Zametki
o sovremennoi zhivopisi", *Russkoye iskusstvo*
[*Russian Art*], [Moscow–Petrograd], Nos 2–3, 1923

Waldemar George, "Nathalie Gontcharowa
und Michel Larionow", *Das Kunstblatt*, Berlin,
vol. VIII, 1924

N. N. Punin, "Noveishiye techeniya v russkom
iskusstve" ["The Newest Trends in Russian Art",
in *Traditsiyi noveishego russkogo iskusstva*
[*The Traditions of the Newest Russian Art*], vol. 1,
Leningrad, 1927

A. Lunacharsky, "K vystavke frantsuzskogo
iskusstva" ["Regarding the Exhibition of French Art"],
in *Sovremennoye frantsuzskoye iskusstvo.
Catalogue*, Moscow, 1928

N. Punin, "Impressionisticheskiy period
v tvorchestve M. F. Larionova" ["The Impressionist
Period in Mikhail Larionov's Work"], in *Materialy
po russkomu iskusstvu* [*Materials on Russian Art*],
Collection of articles, vol. 1. Leningrad, 1928

A. Efros, "Russkaya gruppa" ["A Russian
Group"], *ibid.*

*Gosudarstvenniy Russkiy muzei: Kratkiy putevo-
ditel'* [*The State Russian Museum : A Short Guide*],
Leningrad, 1928

A. Kruchenykh, *5 let russkogo futurizma:
1912–1917. Materialy i Kommentarii*
[*Five Years of Russian Futurism: 1912–17. Materials
and Comments*], Moscow, 1928

V. Kamensky, *Put' entuziasta*
[*The Path of an Enthusiast*], Moscow, 1931

K. Otsup, "O Larionove" ["About Larionov"],
in *Chisla* [*Numbers*], Paris, vol. 5, 1931

B. Livshits, *Polutoraglaziy strelets*
[*One and a Half-Eyed Archer*], Leningrad, 1933

N. Khardzhiyev, "Mayakovsky i zhivopis'"
in *Mayakovsky: Materialy i issledovaniya* [*Materials
and Studies*]. A collection of articles, Moscow, 1940

M. Seuphor, *L'Art abstrai, ses origines
et ses premiers maitres*, Paris, 1949

D. Kobiakov, "Sovrememnnaya zhivopis'.
Larionov" ["Contemporary Painting. Larionov"],
Zemlia [*The Earth*], Paris, No 2, 1949

L. Degand, "Le Rayonnisme:
Larionov–Goncharova", *Art d'aujourd'hui*, Paris,
Series 2, No 2, November 1950

M. Chamot, "The Early Work of Goncharova
and Larionov", *The Burlington Magazine*, London,
vol. 97, No 627, 1955

N. Gontcharova, "Michel Larionov and Pierre
Vorms", in *Les Ballet Russes: Serge de Diaghilew
et la décoration théâtrale*, Belvès, Doridogne, 1955

W. George, Introduction to the exhibition
catalogue: *Michel Larionov, Galerie de l'Institut*,
Paris, 1956

F. Bogorodsky, *Vospominaniya khudozhnika*
[*Reminiscences of an Artist*], Moscow, 1959

*S. S. Prokofiev: Sbornik materialov, dokumentov.
Vospominaniya* [*Sergei Prokofiev: A Collection
of Materials and Documents. Reminiscences*],
Moscow, 1961

M. Fokine, *Protiv techeniya* [*Against the Tide*],
Leningrad–Moscow, 1962

M. Dane, Introduction to the catalogue:
*Gontcharova – Larionov, Musée d'Art Moderne
de la ville de Paris*, 1963

M. Chamot, *Russian Painting and Sculpture*,
London, 1963

E. Steneberg, "Larionow, Gontscharowa und
der Rayonnismus", *Das Kunstwerk*, Baden-Baden,
1963, vol. 16, No 8

I. Stravinsky, *Khronika moyei zhizni* [*A Chronicle
of My Life*], Leningrad, 1963

Annenkov, "Mikhail Larionov", *Vozrozhdeniye*
[*A Revival*], Paris, No 5, 1964

Vl. Lidin, *Liudi i vstrechi*,
[*People and Encounters*], Moscow, 1965

L. F. Dyakonitsyn, *Ideiniye protivorechiya
v estetike russkoi zhivopisi kontsa XIX – nachala
XX v.* [*Ideological Contradictions in the Aesthetics
of Russian Painting in the Late 19th and Early
20th Centuries*], Perm, 1966

W. George, *Larionov*, Paris, 1966

A. Troels, *Moderne rusisk Kunst: 1910–1930*,
Borgen, 1967

E. F. Kovtun, "Nekotoriye problemy predrevoliut-
sionnoi graviury. Russkaya graviura XX veka"
["Some Questions Regarding Pre-Revolutionary
Engraving. Russian 20th-Century Engraving"],
in *Tezisy dokladov k nauchnomu zasedaniyu*

[Theses of Papers Presented to a Scholarly Conference], Leningrad, 1967

E. Kovtun, Introduction to the catalogue: Russkiy estamp kontsa XIX – nachala XX veka [The Russian Print of the Late 19th and Early 20th Centuries], Leningrad, 1967

V. I. Tasalov, Prometei ili Orfei: Iskusstvo "tekhnicheskogo veka" [Prometheus or Orpheus: the Art of the "Technical Age"], Moscow, 1967

F. Daulte, "Michel Larionov", in Michel Larionov, Musée de Lyon, Lyons, 1967

P. Descargues, "Dubuffe. Larionov", Les Lettres françaises, Paris, January 1967

A. N. Benois, "Diagilevskaya vystavka" ["The Diaghilev Exhibition", in Alexandr Benois razmyshliayet... [Alexander Benois's Reflections], Moscow, 1968

N. Khardzhiyev, "Pamiati Natalii Goncharovoi (1881–1962) i Mikhaila Larionova (1881–1964)" [In Memory of Natalia Goncharova (1881–1962) and Mikhail Larionov (1881–1964)], in Iskusstvo knigi [The Art of the Book], Issue 5, Moscow, 1968

V. Markov, Russian Futurism: A History, Berkeley, 1968

A. A. Sidorov, Russkaya grafika nachala XX veka: Ocherki istoriyi i teoriyi [Russian Graphic Art of the early 20th Century: Historical and Theoretical Essays], Moscow, 1969

W. George, "L'epopée de l'art russe (1905–1925)" ["The Epic of Russian Art (1905–25)"], in the catalogue: Aspect de l'avant-garde russe: 1905–1925, Galerie Jean Chauvin, Paris, 1969

L. Schafran, "Larionov and the Russian Avant-Garde", Art News, New York, vol. 68, No 3, 1969

Yu. Annenkov, "Khudozhestvenniye vystavki" ["Art Exhibitions"], Russkaya mysl' [Russian Thought], Paris, 3 June 1969

R. Barratte, "La quatrième dimension selon 'le rayonniste' Larionov", Argus de la Presse, Paris, 30 July 1969

V. Markov, Russian Futurism: A History, London, 1969

E. Kowtun, "Litografowane ksiazki rosyjskich futurystow", Projekt, Warsaw, No 6, 1970

G. G. Pospelov, "Mikhail Fiodorovich Larionov", in Mastera iskusstv ob iskusstve [Masters of Art on Art], Moscow, 1970

N. I. Khardzhiyev, V. V. Trenin, Poeticheskaya kul'tura Mayakovskogo [The Poetic Culture of Mayakovsky], Moscow, 1970

Gontcharova et Larionov. Cinquante ans à Saint-Germain-des-Prés. Temoignages et documents recuieillis et présentés par Tatiana Loguine, Paris, 1971

D. Sarabyanov, Russkaya zhivopis' kontsa 1900-kh – nachala 1910-kh godov [Russian Painting of the Late 1900s – early 1910s], Moscow, 1971

Igor Stravinsky: Dialogi [Igor Stravinsky: Dialogues], Leningrad, 1971

J.-P. Poggi, "Larionov, dessins et peinture", Introduction to the catalogue: Larionov. Dessins et peintures, Saint-Etienne, 1973

V. Marcadé, "O vliyanii narodnogo tvorchestva na iskusstvo russkikh avangardnykh khudozhnikov desiatykh godov 20-go stoletiya" ["On the Influence of Folk Art on the Art of Russian Avant-Garde Artists of the 1920s"], in VIIᵉ Congrès International des Slavistes, Warsaw, 21–27 August 1973. Communications de la délégation française, Paris, 1973

Ivor Davies, "Primitivism in the First Wave of the Twentieth Century Avant-Garde in Russia", Studio International, vol. 186, No 958, September 1973

B. Kochno, Diaghilev et Les Ballets Russes, Paris, 1973

E. Kowtun, "Die Entstehung des Suprematismus" in Von der Fläche zum Raum, Cologne, 1974

E. Kowtun, "Das Antibuch der Warwara Stepanowa", ibid.

A. K. T. [A. K. Tomilina], "Larionov", Le club français de la médaille, Bulletin No 42, first trimester, Paris, 1974

John E. Bowlt, "Neo-Primitivism and Russian Painting", The Burlington Magazine, vol. CXVI, No 852, March 1974

A. Fiodorov-Davydov, Russkoye i sovetskoye iskusstvo. Ocherki i statyi [Russian and Soviet Art. Essays and Articles], Moscow, 1975

Ch. Douglas, "The New Russian Art and Italian Futurism", Art Journal, vol. 34, No 3, Spring 1975

M. V. Matiushin, "Russkiye futuristy" ["Russian Futurists"], in N. Khardzhiyev, "K. Malevich, M. Matiushin, K istorii russkogo avangarda [On a History of the Russian Avant-Garde], Stockholm, 1976

E. Kovtun, "Grafica cubofuturista", Realtà sovietica, Rome, Nos 9–10, 1977

E. V. Kovtun, Introduction to the catalogue: Knizhniye oblozhki russkikh khudozhnikov nachala XX veka [Book Covers by Russian Artists of the Early 20th century], Leningrad, 1977

T. Logina, "Larionov i Goncharova — osnovateli luchizma i russkogo avangarda", Russkaya mysl', 16 November 1978

Ch. Douglas, "Cubisme français / Cubo-futurisme russe", Cahiers du Musée National d'Art Moderne, Paris, No 2, 1979

G. G. Pospelov, "M. F. Larionov", Sovietskoye iskusstvoznaniye '79 [Soviet Art Studies '79], Moscow, Issue 2, 1980

"Pis'mo V. Chekryghina M. Larionovu" ["V. Chekryghin's Letter to M. Larionov", A–Ya, Paris, No 4, 1982

J. F. Kowtun, Die Wiedergeburt der künstlerischen Druckgraphik, Dresden, 1984

C. Gray, The Russian Experiment in Art: 1863–1922, London, 1986

"Pis'ma Natalii Goncharovoi i Mikhaila Larionova Ol'ge Ruznevich-Signorelli" ["Letters of Natalia Goncharova and Mikhail Larionov to Olga Ruznevich-Signorelli"], in Minuvsheye [The Past], vol. 5, Paris, 1986–87

A. Strigalev, "Kem i kogda byla otkryta zhivopis' N. A. Pirosmanishvili?" ["Who Discovered N. A. Pirosmanishvili's Painting and When?"], in Panorama iskusstv [Panorama of the Arts], No 12, Moscow, 1989

E. Kovtun, Russkaya futuristicheskaya kniga [Russian Futurist Books], Moscow, 1989

G. G. Pospelov, "Bubnoviy valet". Primitiv i gorodskoi fol'klor v moskovskoi zhivopisi 1910-kh godov [The Jack of Diamonds. Primitives and Urban Folklore in Russian Painting of the 1910s], Moscow, 1990

G. Pospelov, "Nasledstvo Goncharovoi – Larionova" ["The Legacy of Goncharova and Larionov"], Nashe naslediye [Our Heritage], No 1, 1990

Neizvestniy russkiy avangard v muzeyakh i chastnykh sobraniyakh [The Unknown Russian Avant-Garde in Museums and Private Collections]. Compiled and introduced by A. D. Sarabyanov, Moscow, 1992

A. Parton, "Mikhail Larionov and the Russian Avant-Garde", Princeton University Press, 1993

D. Ya Severiukhin, O. L. Leikind, Khudozhniki russkoi emigratsii. 1917–1941 [The Artists of the Russian Emigration: 1917–41], St Petersburg, 1994